Poetic Thinking Today

SQUARE ONE
First Order Questions in the Humanities

Series Editor: **PAUL A. KOTTMAN**

POETIC
THINKING
TODAY

An Essay

Amir Eshel

STANFORD UNIVERSITY PRESS ■ STANFORD, CALIFORNIA

STANFORD UNIVERSITY PRESS
Stanford, California

Printed in the United States of America on acid-free, archival-quality paper

Library of Congress Cataloging-in-Publication Data
Names: Eshel, Amir, author.
Title: Poetic thinking today : an essay / Amir Eshel.
Other titles: Square one (Series)
Description: Stanford, California : Stanford University Press, 2019. | Series: Square one : first-order questions in the humanities | Includes bibliographical references and index.
Identifiers: LCCN 2019005196 | ISBN 9781503608870 (cloth : alk. paper) | ISBN 9781503610514 (pbk.) | ISBN 9781503610521 (e-book)
Subjects: LCSH: Arts—Psychological aspects. | Arts—Political aspects. | Thought and thinking.
Classification: LCC NX165 .E84 2019 | DDC 700.1/9—dc23
LC record available at https://lccn.loc.gov/2019005196

Cover design: Kevin Barrett Kane

Cover photo: Amir Eshel, *The View from Hudson Drive*

Typeset by Kevin Barrett Kane in 10/14 Minion Pro

Contents

Foreword by PAUL A. KOTTMAN

It would be a mistake to read the word "today" in the title of this book as if it were followed by an exclamation point, as if something utterly new and unprecedented were being announced about poetic thinking—Today! as opposed to yesterday. Quite the contrary: the word "today" is meant to signal that we should not expect this book to present a new theory of poetic thinking.

While this may disappoint some readers, I want to signal this as a chief virtue of Eshel's book, which helpfully resists the idea that the humanities should be preoccupied with coming up with new theories. If the aspiration of the natural or social scientist is to make the "history of science" as irrelevant to contemporary scientific inquiry as the history of chemistry is to working chemists today, then poetic thinking starts by recognizing persistent meanings or needs, historical traumas or ethical ruptures, that we have not yet adequately understood. So it reminds us that we need to think about them some more, today.

This can easily be confused with a kind of perennialism, or the view that there is a set of "big questions" that do not go away and must be confronted again and again. Often, such perennialism tumbles into the view that we can institute a provisionally stable "canon" of works to which we might always turn for help in addressing such big questions— a view that lends itself, therefore, to a kind of conservatism that encourages us not to forget where we know wisdom already lies.

However, while Eshel does draw our attention to thinkers (Hannah Arendt, Richard Rorty) and artists (Paul Celan, Dan Pagis, Gerhardt Richter, Dani Karavan, and Laura Poitras)—as what he calls perspicuous "examples" of poetic thinking—he does so in a way that is more essayistic and openly experimental than it is canon affirming. Eshel sees Richter "reacting" to the Holocaust instead of "just bearing witness"—art practices are participatory as well as testimonial. Rather than send us back to established classics, Eshel notes that we are living through an explosion of poetic activity—the digital-driven supernova of a star that was born with Romanticism. If we want to understand the implications of modern surveillance technology, for instance, we have much to learn from the diagnoses offered in Poitras's 2016 *Bed Down Location.*

While attuned to "today," the basic question of Eshel's book is at least as old as Aristotle's famous remark about poetic works being more "universal" than historical records. *How* can a particular work, indexed to specific historical traumas, bear any general significance? Can anything of general significance—some truth or insight, some inference or recognition—be intimated by a particular poetic work, painting, or sculpture?

Poetic works are often nothing more than illustrations or depictions, mirrors held up to reality. Such works need not show any meaning that is not already intelligible in reality itself. Put another way, artworks can illustrate or depict without necessarily making intelligible anything about the reality they depict other than the fact of their *being* a depiction of it. Aristotle refers to such mimetic works as eliciting a kind of childlike intellectual pleasure—the pleasure of apprehending a mimetic work *as* a mimetic work rather than the pleasure taken in the work's sensible qualities.

But in addition to being mere depictions, fictional works can also *generate* new realities, not only the sense that their very existence alters, at least to some degree, the world in which they are made, but also in the sense that such works can intervene in the reality they depict. Artworks might also be considered a matrix for the understanding of such reality, unavailable in the same way without such works. Eshel's way of putting this is to suggest that poetic thinking opens "spaces of and spaces for open-ended reflection" that invite us to step out of "our daily, habitual manner of thinking." Like Northrop Frye before him, Eshel sees this as

the "motive for metaphor," which "begins with the world we (poetically) construct . . . with the imagination, and then works towards ordinary experience." Frye, in "The Motive for Metaphor," points out that this is what distinguishes the artist from the scientist:

> Science begins with the world we have to live in, accepting its data and trying to explain its laws. From there, it moves towards the imagination: it becomes a mental construct, a model of a possible way of interpreting experience. . . . Science learns more and more about the world as it goes on: it evolves and improves. A physicist today knows more physics than Newton did, even if he's not as great a scientist. But literature begins with the possible model of experience, and . . . doesn't evolve or improve or progress. We may have dramatists in the future who will write plays as good as *King Lear*, though they'll be very different ones, but drama as a whole will never get better than *King Lear*.

So, asks Frye, "Is it possible that . . . poetry is something that a scientific civilization like ours will eventually outgrow?"

Eshel answers: Perhaps, but not yet—at least, not where thinking remains possible. "Thinking in general, and poetic thinking in particular, is never separated from judgment," writes Eshel. In this book, poetic thinking is presented as an ongoing way in which knowledge is generated out of the interpretive judgment.

Prologue

This is an essay about disquieting feelings and my personal journey to make sense of them.

A few years ago, a book I had been writing for the past half decade finally appeared in print. I was delighted. The result of countless days of meticulous scholarly labor had finally taken shape in 350 pages. The front cover was adorned with a beautiful painting. The back displayed praise from colleagues I greatly admire. In the following months, my book received (mostly) favorable reviews. Colleagues from near and far expressed their admiration of the work.

But then I started to notice something: their compliments were often couched in vague terms that indicated, to my increasingly suspicious mind, a rather cursory reading. In teaching my university courses, I pointed my students to this newly published book when discussing relevant themes in class. I noticed, though, that like those of my colleagues, their reactions to the book were often a mixture of generic admiration and only an oblique familiarity with its details. Gradually, I had to accept an unsettling realization: I had written a respectable scholarly work, a book that followed a careful methodology, a book that was filled with countless verified details and a consistently rigorous argument. And I had written a book that hardly anyone actually read.

Or perhaps more accurately: hardly anyone read it from cover to cover as you would read a book that was enthralling. And even those people who did read it seemed to do so out of a sense of obligation rather than captivation.

I was convinced in those days (as I am now) that the book's driving idea is valuable: When remembering traumatic historical events, contemporary literature acknowledges the pain of the past, but that remembrance is also an expression of futurity—it presents us with an opportunity to imagine a better future. In the months after the book's publication I began to admit (mostly to myself) that this central argument had gotten lost in countless details—in the abundance of "evidence" that I was convinced was necessary to make a valid claim. This idea that I cared about so much was obscured by my desire for what Richard Rorty has called "knowingness": "a state of the soul which prevents shudders of awe . . . [and] makes one immune to romantic enthusiasm."[1] To be clear, Rorty is not suggesting that we should replace our wish to know with mere romance and wistful sensations. He cautions that we should not study a novel or any other work of art the way that we would, say, a geologic formation or the spleen—as objects of scientific knowledge. Because when we do so, we lose sight of the great capacity of art: the way that art renders us sensitive to ourselves, and to our world, precisely by *not* committing to the scientific method. We overlook its ability to afford us insight and wisdom, which art is able to do because it remains free from any restraining system of thought, any rigorous method. Whether my book—or any academic book, for that matter—can be considered a work of art is debatable. Nevertheless, the more I thought about Rorty's idea, the more dismayed I became.

The reasons Rorty gives for "knowingness" are the same that drove me to clothe my intellectual intuition with a thick layer of corroborated "proofs": I was lured by the wish to be regarded as a "rigorous" scientist, capable of demonstrating to those in and outside my discipline the validity of my "discoveries." Rather than offer a humanistic perspective on some of the novels I admire because they touch on memory and history and trauma, I wanted to be revered as a scientist is, emerging from the laboratory with an exciting new finding. I submitted my writing to the justifiable, yet often despotic, tendency in the sciences to follow a strict method, to present a systematically argued thesis and evidence, to base the analysis on rigor and logic.

My unease about the book increased in the following months, exacerbated by the growing debate about the future of the humanities,

particularly about the lack of interest in humanities scholarship and declining enrollment in humanities classes.[2] I couldn't resist the thought that my book's fate was somehow related to what I and many of my colleagues have observed in recent years: countless gifted students in North America and across Europe (the continents I am most familiar with) have started to avoid the humanities. Surely, I thought, these students' choices are related to the ever-growing demands of the so-called knowledge economy. They must be driven by pressure to spend their precious time in college pursuing their dream careers or the paths their parents have charted for them. I still had to account for the fact that the students I was meeting on campus were not merely blind followers of their parents' dreams or, worse, comatose slaves of neoliberalism. I couldn't resist the thought that some of them would choose to attend courses in the humanities, and perhaps even read my writings, *if only* . . . if only what?

Contemplating this question with unease, I remembered a set of conference panels I had attended the previous year. The lectures were grouped under the title "Poetic Thinking," a notion advanced primarily by Martin Heidegger and Hannah Arendt. They described how some of our most captivating writers—Montaigne and Kafka and Ingeborg Bachmann were the examples given—cultivate intuitions, insights, and wisdom in the process of crafting their work, whether it is an essay, story, or poem. In other words, thinking proceeds in some of our most admired literary works not by systematically arguing the points of a thesis but by inventing a moving metaphor or a stirring scene. There was something delightful, something of Rorty's "romantic enthusiasm," in the literary works these lectures described and, not surprisingly, in the talks themselves. Both highlighted the imaginative, playful, and ultimately uninhibited exploration of ideas afforded in literature and the arts. They showcased words and images that illuminate our lives by not being subjugated to the hallmarks of scientific thinking, by remaining free of rigor, method, or the pursuit of "Truth" with a capital "T."

Maybe, I thought, what humanities scholarship and education should be focusing on more attentively is precisely the cultivation of the very kind of thinking I experienced in those lectures. There is nothing wrong in striving for rigorous knowledge in the humanities. There

is much value in finding out, for example, all we can about the life and work of Franz Kafka in the years before and after the First World War. Yet, shouldn't presenting Kafka's work also aim at fostering the kind of uninhibited thinking his aphorisms exemplify: "The true path is along a rope, not a rope suspended way up in the air, but rather only just over the ground. It seems more like a tripwire than a tightrope"?[3] Isn't the value of humanistic writing and education not also, or perhaps even primarily, in the kind of free contemplation demonstrated in Kafka's words—in the open-ended reflection on such questions as "What is true?" and "What is the true path?" "Could the pursuit of the one true path be like walking on a tightrope?" Or, "Is it not actually like tripping over a tripwire?"

These questions have led me on a journey, metaphorically and physically. First, I reread some of the most moving poetry I have studied in the past three decades to consider how this genre—arguably the most free genre of the written word—can foster uninhibited thought and wisdom. It quickly became clear that this kind of thought is not restricted to poetry. I branched out from the written word to visual art. I traveled to several exhibitions to experience and reflect firsthand on artworks I had only read about and to interview the artists who created them. The result of this personal and intellectual expedition is this essay, which explores the manifestations and the necessity of this thing called poetic thinking. At its best, an essay, Georg Lukács and Theodor Adorno remind us, is poetry's sister. Free of the demands of "the academic guild," it has greater possibilities: it doesn't "strive for closed, deductive or inductive construction . . . [but] revolts against the doctrine—deeply rooted since Plato—that the changing and ephemeral is unworthy of philosophy."[4] The following pages are not an attempt to present a theory of poetic thinking. Such an attempt would be, in my view, contrary to the free forms of reflection and creation at its core. Rather, I wish to illustrate several (for me, telling and deeply moving) examples of what poetic thinking is.

To be clear, I do not wish to suggest that all literature and visual art, across era, language, genre, and medium, engage in poetic thinking; nor do I wish to offer a comprehensive account of all cases in which they do. We begin along the path that I took, and with the artists I

encountered, in the hope that each reader will further delineate and
grow the immense promises of poetic thinking. "He writes essayistically
who writes while experimenting," notes the philosopher Max Bense,
which is just what I aim to do.[5] I begin by reflecting on the potential
of poetic thinking, the way it can offer philosophical guidance in our
lives, focusing especially on what I see as poetic thinking's greatest of-
fering to us today in the realm of politics and ethics. I believe that poetic
thinking can offer us a crucial mode of reflection on how we treat the
people we love and the people we don't, and how we interact with life
around us, with the world at large.[6] I then describe specific works in
literature and the visual arts that can invoke those "shudders of awe" that
Richard Rorty describes: in other words, we see how poems, paintings,
and sculptures can become manifestations of poetic thinking and how
those manifestations can alter the ways we see the world.

The choice of genre and art forms is not accidental. Poetry is a
literary genre I practice, study, and teach. All the paintings and en-
vironmental sculptures I discuss are artworks I have seen firsthand.
My discussion is also informed by conversations on thinking in the
arts that I was fortunate to have with some of these artists: the painter
Gerhard Richter and the sculptor Dani Karavan. I believe that the ideas
I develop here have a broader reach than the specific artists and works
I discuss. I am confident that this essay can inform a broader view on
other works of art and other artistic mediums. Therefore, in the Coda,
I indicate how we may extend the scope of this essay beyond its inten-
tionally modest range.

As with all journeys, my exploration of poetic thinking did not
occur in a vacuum. I began writing this essay at a moment in which re-
pressive, in some cases plainly tyrannical, political tendencies gathered
momentum around the world. In some places—Russia and Egypt being
the most obvious examples—those tyrannies presented themselves
through the face of a single ruler, a self-proclaimed strongman who
controls all the tools of power. Elsewhere—from Turkey to Hungary, Po-
land to Venezuela—governments have been democratically elected, yet
once they assumed power, they began to exercise elements of tyranny:
the excessive use of authority, merciless supervision, the repression of
free thinking and expression, and the brutal clampdown of dissenting

voices. Even established democracies, as we have seen during and after the 2016 elections in the United States, are not immune from tyrannical tendencies. Writing this essay, I became convinced that setting our gaze on poetic thinking and cultivating an uninhibited intellectual life are beneficial not merely for writing more effective books or for enriching humanistic education. Poetic thinking, this essay suggests, has the potential to counter the rise of tyranny: poetic thinking is no less than a means to defend political freedom and foster truly meaningful cultural expression.

It is thus no coincidence that all the literature and art discussed here touch, in various ways, on the experience of tyranny in our time. Given my scholarly interests, the works I discuss turn mostly to the fascist regimes of the twentieth century and their aftermath, specifically but not exclusively to Nazi Germany. The Coda shows that artists of all kinds, and the rest of us as well, have the ability to use poetic thinking—even if we don't always name it as such—to understand any other occasion in which the freedom of thought, writing, and action is under duress. This essay suggests that the freedom encouraged by poetic thinking serves to counter the tyrannical tendencies we experience today. Two ideas drive me in this essay: the wish to promote poetic thinking as a path for renewing the writing and teaching of literature and the arts; and my conviction that cultivating poetic thinking will help counter the forces that strive to restrict our cultural and political freedom.

Poetic Thinking Today

Introduction

A CRUCIAL PROBLEM

Tyranny is often considered an outdated political form, a crass distortion of governance that will slip into irrelevance or, at worst, something that happens in other countries but not in our own. None of these things are true, however much we might want them to be. Tyranny is here to stay. It appears, as the *Oxford English Dictionary* reminds us, in the form of the tyrant or absolute rule, who amasses absolute sovereignty and employs oppressive, unjust, and severe government. Tyranny may also describe other oppressive but far less obvious forces. These are often even more insidious, but at the same time more damaging, and thus require equal vigilance.

Today, more than half a century after the collapse of Nazi Germany and three decades after the implosion of the Soviet Union, Hannah Arendt remains one of our most perceptive observers of modern tyranny in its various forms. With *The Origins of Totalitarianism* (1951), Arendt began a lifelong examination of various aspects of this oppressive form of rule. She argued that tyranny is not found in governance alone; she believed that thinking, specifically Western thought, is imbued with tyrannical tendencies. Shortly before the publication of *The Origins of*

Totalitarianism, Arendt reflected in her *Denktagebuch* (which roughly translates as "Thinking diary") on the affinity between philosophers and tyrants. Since Plato, Western logic has been "by definition" tyrannical—fixed on principles that are considered the outcome of "pure thought and reason."[1] The idea that understanding and sound judgment depend solely on logic, method, rigor, and system poses a constant threat to freedom. If in a political tyranny the sovereign alone decides between right and wrong in all realms of life, the Western notion of "thinking" is also governed by a despot of its own: logic. Arendt identifies, and then emphasizes, a crucial problem that accompanies us throughout this essay: "The question is: *Is there a way of thinking that is not tyrannical?*" (Die Frage ist: *Gibt es ein Denken, das nicht tyranisch ist?*).[2]

Having barely escaped Nazi Germany, Arendt was viscerally aware of the possible links between the Western philosophical tradition and the totalitarian regimes of her era. She was also undoubtedly thinking about her intellectual acquaintances who, in the 1930s, were willing to quickly align themselves with Nazism as it rose to power.[3] But I suggest that the implications of Arendt's question—Is there a way of thinking that is not tyrannical?—go far beyond the political realities of her own time. Her question continues to be timely, because how we think and what we think about the world are always framed by what we understand thinking to consist of. Most of us take for granted that thinking just is what it is—that mental pursuit we engage in all day every day—and give little heed to the various aspects of thinking or realize that it is hardly confined to the activities we usually associate it with: systematically attempting to understand our circumstances, solving problems, sensibly choosing among different professional options, and the like. Arendt's question offers another intriguing possibility: thinking encompasses much more than the particular forms of cognition that the Western tradition has sanctified, from Plato through the Scientific Revolution to transhumanism. What if there are other ways to think?

As the Prologue indicates, this essay suggests that there are. I believe that most of us—in some instinctive, and mostly unarticulated, way—ow that thinking can take numerous forms. Here I explore one such that I find particularly valuable in responding to Arendt's resonant ヿ, a way of thinking that I believe to be crucial in responding ヽ "Poetic thinking" is my name for this form, which I define

as the imaginative and uninhibited thinking that we typically (though not exclusively) find in literature and the arts.

Given my interest in modern oppressive forms of thought and politics, this essay concentrates on a few poets and artists whose work both addresses modern tyranny, specifically the Nazi era and its aftermath, and embodies poetic thinking: Paul Celan (1920–70), Dan Pagis (1930–86), Gerhard Richter (b. 1932), and Dani Karavan (b. 1930). Turning to the work of Laura Poitras (b. 1964) in the Coda, I show how contemporary art continues and expands on their poetic lines of thought regarding threats to human freedom. Even though Poitras is two generations younger than Arendt (and decades younger than Celan, Pagis, Richter, and Karavan), she experienced firsthand some of the tyrannical political forces Arendt examined in *The Origins of Totalitarianism* and throughout her work. Touching on the experience of modern tyranny, their art engages our capacity to think through our senses, without relying on logic and reason, and thus allows us to identify poetic thinking as a distinctively uninhibited mode of our intellectual life. It is precisely because the works I present here are unconstrained, both in content and in form, by our typical vision of thinking—by rigor, system, and method—that they help defend and cultivate individual and communal freedom. As much as we might like to believe otherwise, a poem is just words, and a painting is just paint. Artworks alone are hardly sufficient to combat tyranny; a piece of art, in and of itself, cannot change the world. Yet the way we engage with that art can effect change—both within ourselves and eventually within the public worlds we inhabit. I believe that the works of art discussed here, the ways we encounter them, and the debates they engender foster a nuanced and unconstrained community—a dynamic and thoughtful public sphere—that is more resilient than what we have experienced in recent years from Beijing to Manila, from Moscow to Jerusalem and Washington, D.C., to the rising threat of tyranny in our time.

THINKING WITHOUT A BANISTER

Throughout her life Hannah Arendt explored modes of uninhibited thought, what she called "thinking without a banister" (*Denken ohne Geländer*).[4] The resulting assessment of our time is both modest and sharp: Our historical moment (she focused on Western civilization)

is marked by a fundamental break with the intellectual and institutional frameworks we inherited from antiquity and the Middle Ages. Considering this caesura, Arendt points to Alexis de Tocqueville, who made an observation more than a hundred years before the catastrophes of the world wars, that still resonates with piercing insight: "The past has ceased to throw its light onto the future, and the mind of man wanders in darkness." With this sense of confusion and need for a new direction in mind, Arendt concludes, "I always thought that one has got to start thinking as though nobody had thought before, and then start learning from everybody else."[5]

Proceeding without a banister—whether of tradition, norm, or system—is an idea indebted to a line of thought that emerged much earlier than Tocqueville and the nineteenth century. It is at work in the writing of most pre-Socratic Greek philosophers. We find it in Ecclesiastes, in Seneca, and in Marcus Aurelius. Following the Renaissance, this mode of thinking is at work in Montaigne, La Rochefoucauld, and Pascal. It resonates in Novalis and Friedrich Schlegel, the German Romantics who sought to undo the strict division between philosophy and poetry. Schlegel states in his critical fragment 115, "The whole history of modern poetry is a running commentary on the following brief philosophical text: all art should become science and all science art; poetry and philosophy should be made one."[6]

As we move into the nineteenth century, "thinking without a banister" calls to mind the letters of Rahel Varnhagen von Ense (the Berlin *salonière* and writer to whom Hannah Arendt dedicated her first book); the aphorisms of Schopenhauer, Kierkegaard, and Nietzsche; and Heidegger's open-ended question, "What is called thinking?" (*Was heißt Denken?*). This tradition continues, more recently, in Susan Sontag's succinct mantra, "Philosophy is an art form—art of thought or thought as art." We also encounter it in Jan Zwicky's notion of "lyric philosophy": the welding of the poetic and the philosophical into a unity of "clarity, informed by the intuition of coherence. . . . Thought . . . conditioned by a sensibility that can experience exhaustion in the face of the welter of stimuli."[7] Poetry, as it touches our thinking, gives birth even to "phenomenal concepts," Antonia Peacocke convincingly shows: "concepts of feelings, sights, sounds, tastes, and so on."[8]

Thinking without a banister, thinking poetically, is not, of course, a guarantee of freedom or ethical consciousness. Heidegger, who perhaps like no one before him in the twentieth century urged us to think through our notion of thinking, is also, in a sardonic twist of events, an example of "blatant thoughtlessness" and, as we know today, of anti-Semitism. In the late 1920s and in the 1930s he embraced some of the crudest anti-Semitic ideas. In 1933 he willingly bowed to Nazi tyranny when he joined the party, enthusiastically posed in Nazi uniform as the Führer-rector of the University of Freiburg, and produced lines that bear no trace of thinking in any shape or form, such as "Let not theories and 'ideas' be the rules of your being. The Führer himself and he alone is German reality and its law, today and for the future."[9]

As she seeks to enrich our notion of thinking, to force reason and logic to cede some of their claim to universal domination over our intellectual lives, Arendt also uses language that is very similar to my idea of poetic thinking. In a 1968 *New Yorker* essay, she enlists the work of Walter Benjamin to discuss this idea, suggesting that as a writer he "thought poetically," though he was "neither a poet nor a philosopher."[10] We consider Arendt's essay since it distills elements of Benjamin's work that also serve us as we further explore what poetic thinking means and affords. For Benjamin, Arendt writes, criticism was never confined to philology or cultural history. An avid reader with a gargantuan appetite for collecting beautiful quotations, Benjamin established the critic as "an alchemist practicing the obscure art of transmuting the futile elements of the real into the shining, enduring gold of truth."[11] Such enduring truths emerged throughout his essays, in which he fused the words of others, visual images, and his own prose: for example, using a quotation from a poem by Gershom Scholem read alongside Paul Klee's painting *Angelus Novus*, Benjamin crafted his famous "angel of history"—a pictorial view of humanity as it is thrust through time, looking back at its history as nothing but "wreckage upon wreckage" while being blown into the future by a storm "we call progress."[12]

Benjamin's many metaphors—his primary creative medium—Arendt notes, were far from mere lyrical ornaments. Invoking Homer, she reminds us that metaphors such as "the angel of history" bear "that

element of the poetic which conveys cognition"; these metaphors are "the means by which the oneness of the world is poetically brought about."[13] These word images have the capacity as imaginative artifacts to bring new, at times profound, insight into the worlds we inhabit and shape. Metaphors such as Benjamin's "angel of history" are thus "poetic" in the word's original, Greek meaning: poiesis (ποίησις) means "creating," "making."[14] As created, made objects, metaphors such as Benjamin's offer crucial insight and push us toward further thinking. They are entities that, according to Arendt, unveil the "oneness of the world"; they prompt insights into the interconnectedness of our natural, personal, and communal circumstances.

This essay discusses three, interrelated aspects of this idea that expand on Arendt's notion of poetic thinking. First, I see poetic thinking as insight, recognition, or inference as it is *embedded in* or *emerges from* a crafted metaphor—from a poem, a painting, or a sculpture.[15] Poetic thinking thus includes both the artist's thoughts that have found their way into the artwork and the thoughts that we, as readers, beholders, critics, or students, develop while reading, viewing, and hearing.

Second, transpiring from or caught in such creative artifacts, poetic thinking refers to artworks whose creation is not confined by our typical way of thinking—rational, rigorous, and methodical. Systematic thought may have informed the works we encounter; and it may be impossible for us to think without using our frontal cortex at all. What is key, I suggest, is that rigor and reason did not restrict these artists; the works that I reflect on were not solely determined by logical, systematic thinking.

Third, poetic thinking refers to artworks that open up *spaces of* and *spaces for* open-ended reflection. I am interested here in artworks that encourage us to speculate unhindered on some of the most important questions of our lives, such as "Who are we?," "How should we live?," and "How shall we chart our future path?" The spaces these works unfold may be physical. But I also suggest that a poem or a painting can offer such spaces. Dwelling there, spending some time on a page in a book or standing in front of a canvas to freely reflect, we step out of our daily, habitual manner of thinking.

Yehuda Amichai's poem "The Place Where We Are Right" is an uncanny illustration of all three elements.[16] It exemplifies Arendt's thinking without a banister, both in what it says and in what it does:

The Place Where We Are Right

From the place where we are right
flowers will never grow
in the spring.

The place where we are right
is hard and trampled
like a yard.

But doubts and loves
dig up the world
like a mole, a plow.
And a whisper will be heard in the place
where the ruined
house once stood.

The poem offers a bold revelation by the speaker (who is, perhaps, also the poet): "From the place where we are right / flowers will never grow." Amid this intriguing insistence, these words prompt us to reflect freely on the difference between two fundamental realms of human experience: one defined by certainty and the other by uncertainty. The first two stanzas link our epistemological and ethical conviction (the belief in being "right") with a place that is barren and without blossom. The third stanza offers an alternative and describes the fertile realm of flux. No rigorous argument is being offered, no rational articulation of this tension-laden apposition. These spare lines instead mobilize our senses of touch ("hard and trampled") and sight ("mole," "plow," "house"), offering an opportunity to sense and then possibly to reflect on what it means—or, perhaps more important, on what it *feels like*—to be "in the right," to be certain that we are correct, to be certain that we know the truth.[17]

Amichai's repeated use of the first-person plural encourages us to relate to the "we" of the poem. And his lines, as evocative as they are sparse, seem to encourage us to develop our own thoughts. We may

weigh, for example, the risks of dwelling in "the place" the poem describes—the point where conviction and righteousness become a dead end. The belief in our own truth is surely satisfying, but as Amichai hints so beautifully, it is also bleak and ultimately infertile. But the alternative is full of possibilities. Amichai's poem, however, is hardly prescriptive. It is a string of verbal images offering us an opportunity to think. Inviting us to dwell in, to feel, "the place where we are right," the poem doesn't demand that we adopt any particular position, including its own. It describes what would happen if we were to accept unconditionally the claims of the first two stanzas. If we were to think that flowers will *never* grow in the place where we are right, we run the risk of wanting, yet again, to be unconditionally certain about what is to come. Instead of leading us to certitude, the first two stanzas encourage us to always try to step outside our habitual ways of thinking, in which we operate as if we are correct in our perceptions, values, or choices. Allowing us to shed the safety of our own certitude, the poem affords us an entrance into a far riskier domain, a place where the world is "dug up," where we must tirelessly reconsider any set notion, any idea we hold dear.

Amichai's poem thus exemplifies Arendt's thinking without a banister, an approach to the world that is hardly free of hazard, as we have seen in the case of Martin Heidegger. Thinking that lacks any kind of ethical mooring can lead to absurd irrationalism; and when irrationalism and politics converge, as they did in European fascism, and as they arguably are doing with each passing day of an era characterized by the likes of Vladimir Putin, Recep Tayyip Erdoğan, Viktor Orbán, and Donald Trump, the consequences may be catastrophic. But I believe that we can avoid such pitfalls and at the same time embrace the possibilities of thought unconstrained by dogma. We can think poetically and think ethically at the same time.

The approach advocated by Arendt, Amichai, and me—thinking "as though nobody had thought before, and then start learning from everybody else"—certainly comes with risks. The mole of doubt will likely destroy the crops of our convictions and the sense of safety and order those convictions give us. And as Amichai makes clear, such a world contains ruin. Embracing ambiguity is most certainly less efficient and exposes us to all the uncertainty that comes with whispers. Yet leaving

behind us the place where we are unconditionally right—and perhaps even more important, leaving behind the place where we are convinced that there is always a right answer and thus a wrong answer—can yield new and perhaps richer mental nourishment for tomorrow. Amichai's metaphoric "place where we are right" encourages us to pause when we find ourselves believing without hesitation that we are correct. It prompts us to relinquish our cherished certainties and creeds, even if only for the briefest moment as we read the poem. Thinking unhindered can begin anywhere, at any moment.

THE CONVERSATION OF HUMANKIND

My belief that poetic thinking is both a valuable means of engaging with our circumstances and a possible guard against oppressive manners of thought and action is a very old idea. Our explorations in these pages build on a long arc of writing, reaching back to the wisdom books of the Old Testament. (Consider the lament of Ecclesiastes: "Vanity of vanities, . . . vanity of vanities; all is vanity" [1:2].) Poetic thinking is also the distant inheritor of the ancient Greek understanding of poiesis, which denoted a broad array of phenomena involving the human act of forming and transforming matter.[18] The effects of such transformative acts—the influence of a poem, for example— have been widely acknowledged since antiquity. At times, they even aroused grave concern. Plato worried about the consequences of such acts when he discussed, in book 10 of *The Republic*, the dangers to politics and morals posed by poetry. He alleged (ironically, in the form of a literary dialogue), "Like sex, anger, and all the desires, pleasures, and pains that we say accompany all our actions, poetic imitation has the very same effect on us. It nurtures and waters them and establishes them as rulers in us when they ought to wither and be ruled, for that way we'll become better and happier rather than worse and more wretched."[19] Plato and, later, Christian theologians rightly saw the destabilizing potential of poetry and the arts to generate both free thinking and transformation, to be a force that disputes authority, whether that of the Platonic ideals or of church doctrines.[20]

Plato identified the imaginative capacity of poetry and the arts as a possible source of dangerous communal chaos, and every tyrant in

human history has attacked, in one form or another, that imaginative capacity. Thus, my discussion of poetic thinking centers on its affordances—on what it offers us in spite of, or perhaps because of, those forces that rail against it. My discussion of poems, paintings, and sculptures is informed, more specifically, by the critique of Platonism during and after the Renaissance: from Michel de Montaigne's conscious choice of the essay as the most suitable form for philosophical mediation to François de La Rochefoucauld's elegant (rather than prescriptive) *Maximes*; from Blaise Pascal's fragmentary theological *Pensées* to Giambattista Vico's *Scienza nuova* (*New Science*, 1725), which suggested that poiesis exceeds the realm of imitation or mimesis and that "poetic wisdom" (*sapienza poetica*) is not restricted to the achievements of our faculty of reason but always involves our creative faculties.[21] Immanuel Kant's *Critique of the Power of Judgment*, particularly via Michel Chaouli's brilliant reading of it, further inspires my approach. Art gives, Kant suggests, "more to think about than can be grasped and made distinct" by reason alone.[22] Art stimulates, in what is a fitting portrayal of poetic thinking, "so much thinking that it can never be grasped in a determinate concept."[23]

I view this constant expansion of existing thoughts—the desire and ability to leave behind any place where we are right and with it all sorts of Platonist anxieties regarding political chaos—as the hallmark of poetic thinking. This line of thought was radically enhanced in the decades after Kant's death in Friedrich Schlegel's and Novalis's philosophical aphorisms, but also in Percy Bysshe Shelley's "A Defence of Poetry" and Friedrich Nietzsche's radical attack on platonic metaphysics in *Thus Spoke Zarathustra*. These writers and thinkers have paved, in multiple ways, the path for twentieth-century thinkers like Martin Heidegger to suggest that while thinking does not "make poetry," it is, at its best, "close to poesy" (*dem Dichten nahe*).[24] About fifteen years earlier, Ludwig Wittgenstein noted, perhaps even more radically: "I think I summed up my attitude to philosophy when I said: philosophy ought really to be written only as a *poetic composition* [Philosophie dürfte man eigentlich nur *dichten*]."[25]

In recent decades, Wittgenstein's "ought" has emerged in the work of a much wider array of thinkers and writers. Taken together, their work has come to exemplify the notion of philosophy as "poetic composition."

Often their succinct, imaginative words have made meaningful for a diverse population what is often in Nietzsche, Heidegger, or Wittgenstein an expression of an elitist, white, and male-dominated culture. I am thinking here of the poetic core in feminist and queer thought from Gertrude Stein through Simone de Beauvoir to Luce Irigaray and Judith Butler.[26] I also have in mind the place of the poetic in altering our discourse regarding race and empire: for example, James Baldwin's existentialist aphorism on human agency: "To act is to be committed and to be committed is to be in danger."[27] Or consider Frantz Fanon's meditation on imperialism and its impact, encapsulated in a sentence that pinpoints in just a few words what entire books often fail to: "Imperialism leaves behind germs of rot which we must clinically detect and remove from our land but from our minds as well."[28] Refuting the semantic narrowness of "exile" as marking the condition of living outside one's own "homeland," the Palestinian poet Mahmoud Darwish poetically defines "exile" as "more than a geographical concept." "You can be an exile in your homeland in your own house, in a room."[29] Seeking a powerful synecdoche for the sacredness of *any* human life, Judith Butler turned recently to the poetic adjective "grievable": "Precisely because a living being may die, it is necessary to care for that being so that it may live. Only under conditions in which the loss would matter does the value of the life appear. Thus, grievability is a presupposition for the life that matters."[30]

In gestures such as "to act is . . . ," metaphors such as the "germs of rot," and images of what it means to be an exile in one's own home or to be "grievable," we encounter what thinking looks like when it is not committed to the systematic, logic-governed argumentation that has been central to the Scientific Revolution and its heirs in our time. Yet in claiming a place for poetic thinking in our intellectual pursuits, I am not seeking to enthrone it in place of scientific thought. Nor do I have any desire to celebrate irrationality or Romantic enthusiasm. I believe that we must acknowledge the affordances of a kind of cognition that is often ignored or undervalued, the kind captured in Amichai's "The Place Where We Are Right"; we must distinguish the world of thought that lies beyond the systematic rationalizing in the tradition of the Scientific Revolution. I have no desire to minimize the profound and ongoing value that scientific thinking has in shaping and advancing our

understanding of life. But I believe we must not fall prey to the easy fallacy that all thinking must be reason *driven* or that logic is the only kind of thought that matters. As physicist Carlo Rovelli beautifully lays out, some of the most complex discoveries of modern physics found an initial expression in the philosophical and poetic intuitions of Democritus and Lucretius.[31] Cultivating poetic thinking is thus not an alternative to scientific thinking but a vital and indispensable component of a truly dynamic intellectual life.[32]

Both the artist and the scientist, Michael Oakeshott similarly suggests, equally participate in the broad, diverse intellectual discourse he calls "the conversation of mankind." Like Heidegger, Arendt, and Dewey, Oakeshott is suspicious of thinkers "who assure us that all human utterance" is in one mode: reason driven, goal oriented, practical.[33] Offering an alternative to this systematic, logical, and utilitarian thrust, Oakeshott urges us to acknowledge that poetry and the arts have the unique capacity to capture and engender "contemplative images,"[34] or, in my terms, "poetic thinking."

Any progress we hope to make in understanding our natural, individual, and communal conditions comes from, Richard Rorty claims (as I do in this essay), both the accomplishments of our scientific-technological innovations and poetic thinking, or "our imagination."[35] Rorty never tires of suggesting that the sciences and the arts alike give us insight and means for orientation. In their own, distinctive manners, they both develop contingent, historical, ever-evolving vocabularies with which we describe and better our lives. Yet that commonality is often not the story we are told. Plato's discomfort with the transformative, and thus chaotic, potential of poetry—his notion that there is "an old quarrel" between poetry and philosophy[36]—has been adopted by many thinkers ever since: Rorty argues that his bias against the poetic has become central to the claim of the rationalists, the empiricists, and, later, the positivists, all of whom insist that logical argumentation alone grants us lasting insight. "To take side with the poets in this quarrel," he rightly points out, "is to say that there are many descriptions of the same things and events, and that there is no natural standpoint from which to judge the superiority of one description over another. Philosophy stands in opposition to poetry just insofar as it insists that there is such

a standpoint."[37] Like Arendt, Oakeshott, and Rovelli, Rorty views the cultivation of the imagination as precisely what enriches our understanding of natural phenomena and of human circumstances. And, like them, he sees in poetic thinking a force for enhancing human freedom when it comes under pressure. He puts it succinctly by suggesting that "the imagination is the principal vehicle of human progress" and that if we "take care of freedom," "truth will take care of itself."[38]

In our age of "fake news" and the wide-ranging attack on the concept of truth, it is crucial to note that Rorty does not suggest that we give up our distinction between true and false, fact and fiction, altogether. He believes that what ultimately protects our ability to detect a mistake— or, worse, a lie—is not holding up Truth as *the* progressive idea of our age but instead the struggle to maintain a free public sphere. It is, after all, in such a free sphere that we can debate with others our various observations, conclusions, insights, and ideas. It is only in such spaces of conversation and debate that we can determine if what we hold on to as true is plausible, unlikely, or merely bizarre.[39] Poetic thinking contributes, I believe, to the very constitution of this open and critical space.

THINKING AND JUDGING

Artists—from poets to painters, from novelists to sculptors—think poetically in many ways. They alter and broaden our verbal and visual vocabulary and transform how we see the world in endless variations. Given my interest in literature and the arts as they touch on and confront modern tyranny, however, my emphasis is on one expression of poetic thinking: works that address ethical and political concerns, art as it explores how we relate to and treat each other. These works do not present any one system of ethics or any consistent political theory; what characterizes each of these works is that they avoid striving to arrive at the place where they are "right." They doubt the benefits of chasing after a timeless, metaphysical Truth in the realms of politics and ethics; they run from any clear-cut vision of what is Right or Good; they avoid safe, simple solutions to ethical and political dilemmas. The only thing that these works seem to be sure of is that insisting on any ultimate truths in politics and ethics is at best counterproductive and, at worst, oppressive.

Invoking in word or image difficult historical circumstances, reshaping a cityscape, or inviting visitors to inhabit a contemplative space, the works discussed thus explore what Richard Rorty and Hilary Putnam call "ethics without principles" and "ethics without ontology."[40] I return to this notion in various ways throughout the essay, but for now I stress the core of this idea: When faced with an ethical challenge, Rorty and Putnam suggest, we should not seek to resolve it by appealing to a single abstract metaphysical concept such as "Justice," "Right," or "Good." We should instead employ "many different kinds of discourses." That is, we must wrestle with the ethical challenge by considering a variety of questions surrounding the issue, such as "Who is suffering, and why?" and "How can we help limit the pain?" and "How would different courses of action affect the various people or groups involved?"[41]

To explain this approach, which Putnam calls "pragmatic pluralism,"[42] we return to Yehuda Amichai's poem, specifically to its enigmatic ending: "And a whisper will be heard in the place / where the ruined / house once stood." An Israeli who fought in the 1948 Arab-Israeli War, Amichai witnessed the destruction the war had caused to countless Palestinian villages and lives. The poem is, among other things, Amichai's appeal to his Israeli Jewish audience to not believe that they are "in the right," to reflect on their own standpoint from the perspective of others, specifically those who once lived in houses that are now in ruins. The war of 1948 may have begun, as many Israeli Jews believed, with acts of aggression toward Palestine's Jewish population. Yet after the war has ended and countless Palestinians have been forced into exile and their houses destroyed, the issue is not who is right and who is wrong but how to bring back a whisper, a sign of life, to the homes that were devastated, like those of Palestinians who were defeated in the war. In other words, faced with the question of how we Israelis should deal with the ethical and political dilemma of the Israeli-Palestinian conflict, we should not appeal to metaphysical ideas about Right, Wrong, Good, and Justice. Implicit in this poem is a bold definition of ethics: What kind of moral discourse, what vocabulary, can we use to limit the pain? Instead of striving to articulate a definitive argument or a clear answer, we should be looking for the sort of ethics and politics that allows some common ground—beyond "right" versus "wrong"—so the destroyed homes can be rebuilt.

At the heart of such a pragmatic approach to ethics and politics lies the capacity to avoid hurried moral and political judgment and to stop, to dwell for a while in uncertainty—to think. And it is precisely this affordance that I find in the works I present in this essay. At the same time, although they avoid the temptation of being in the right, they hardly leave us in a moral limbo, unable to come to a judgment and then to act. The uninhibited thinking that they promote enhances a more reflective, nuanced conscience; and this, in turn, leads us to decide and potentially to act. Again, I follow Arendt, who in her posthumously published *The Life of the Mind* offers a compelling way to think about our own thinking, or lack thereof, as it is tied to politics and to ethics. Arendt wonders if great evil—like that which Adolf Eichmann embodies—is more closely linked to thoughtlessness than to some kind of ingenious master plan. Considering Eichmann's language, choices, and actions, Arendt suggests that it was "absence of thinking"—Eichmann's incapacity "*to stop* and think"[43]—that may explain his monstrous acts. "Could the activity of thinking as such," she wonders, "the habit of examining whatever happens to come to pass or to attract attention, regardless of results and specific content, could this activity be among the conditions that make men abstain from evil-doing or even actually 'condition' them against it?"[44] She notes that the very word "con-science" "points in this direction insofar as it means 'to know with and by myself,' a kind of knowledge that is actualized in every thinking process."[45]

We may have reservations regarding Arendt's judgment of Eichmann as an ordinary, thoughtless nobody. We may also doubt the strong connection that she attempts to draw between thinking and ethical consciousness, thinking and moral choice. Nevertheless, her questions are fruitful for our discussion, since they help us better grasp the specific experience the artworks discussed here afford: their capacity to open up *spaces of* and *spaces for* open-ended reflection or their capacity to allow us "*to stop* and think." When we think, she contends, we are (metaphorically speaking) stepping outside the physical and temporal spheres we usually inhabit. Thinking "interrupts all ordinary activities and is interrupted by them."[46] In this unique domain of time and space we engage in "remembering, collecting and recollecting what no longer

is present out of 'the belly of memory' (Augustine), anticipating and planning in the mode of willing what is not yet."[47]

When we think and thus step outside the spheres we habitually occupy, we are, in Arendt's view, not focused on establishing universals out of the concrete phenomena we absorb through our senses. Rather, thinking is the very activity by which we question our established, inherited concepts, our current worldview. Thinking is the mental pursuit that relaxes and often dissolves our preconceived ideas. It is what allows us to arrive at our own judgments without resorting to already-present, often-fixed lines of thought. Thinking thus conceived is the mental condition of conscious reflecting, weighing, exploring, and questioning where we stand on any given issue. It is not "a prerogative of the few but an ever-present faculty in everybody; by the same token, inability to think is not a failing of the many who lack brain power, but an ever-present possibility for everybody."[48]

There is a striking affinity between thinking as Arendt conceives it and the literature and the art discussed here. For example, arguing against a military operation to defeat Hamas in Gaza in 2014, Israeli journalist Tal Niv turns to Yehuda Amichai's "The Place Where We Are Right": "Amichai thought that being dogmatic to the point of death did not allow room for forgiveness and rebirth. He thought that being right was not everything."[49] With his image of *a place*, his poetic thinking, Niv suggests to her Jewish Israeli readers, Amichai endeavors to mitigate the inflexibility many of them express regarding their rights to the land and the future of its disputed borders.

Amichai's invitation to dwell in the poem, to reflect on our current position, is emblematic of what we experience when we view some of Gerhard Richter's most iconic paintings, Dani Karavan's public spaces, or Laura Poitras's installations. Like Amichai's poetry, their works offer us opportunities to think poetically—to step outside the confining physical and temporal spheres we habitually occupy, the places where we are right, and to allow our doubts to guide us to a more nuanced, reflective conscience. As we do so, we are—again invoking Arendt's helpful discussion in *The Life of the Mind*—not focused on establishing universals out of the concrete phenomena we experience. Dwelling in and with them, we engage in the mental activity by which we question and consider our established, inherited worldviews.

This essay presents poetic thinking as a mental pursuit that dissolves our habitual ways of thinking, our set ideas. Yet "thinking," as I use the term, does not mean refraining from making judgments or choices or from proceeding to action. Like Arendt, I believe that thinking, "the silent intercourse (in which we examine what we say and what we do)," is crucial for what we call conscience.[50] Ethics without principles and without ontology does not mean for me the relativism of "I'm OK—you're OK" or, even worse, moral decisionism: the belief that in matters of ethics the validity of a moral decision is not its content but that a proper "authority" made it. We overcome the pitfalls of relativism and decisionism in poetic thinking by holding on to two interrelated ideas regarding judgment that Arendt adopts from Immanuel Kant's *Critique of Judgment*: the notion of "reflective judgment" as opposed to "determinant judgment" and the idea of "common sense" (*sensus communis*).

Thus, Arendt believes that judgment emerges from *reflecting* on a particular. For example, it is not that we have a *determined*, abstract, knowledge of what is beautiful in general and then apply it to the particular. The beautiful instead emerges from pointing to what we sense as such when we encounter a landscape, poem, painting, or sculpture and say, "*This* is beautiful." Striving to reach our own aesthetic judgment, we engage with common sense; we include in our inner deliberation what we believe would be the viewpoint of others.[51] Aiming to judge the beauty of a poem, a painting, or a sculpture, we consider the outlooks of others, how they *may* view the same, by putting ourselves in the position of others. As we formulate our own position, we do so in full awareness that we also need to make our judgment ("*This* is beautiful") intelligible to them. Kant's hope for a civilized humanity—a vision of a united people living in eternal peace—is based on his belief, which Arendt shares, in our common sense, our principal capacity to judge while taking others' perspectives into account.[52]

Thinking in this essay "will not find out, once and for all, what 'the good' is. . . . Its political and moral significance comes out only in those rare moments in history when 'Things fall apart; the centre cannot hold.' . . . At these moments, when everybody is swept away unthinkingly by what everybody else does and believes in, those who think are drawn out of hiding because their refusal to join is conspicuous and thereby

becomes a kind of action."[53] Thinking in general, and poetic thinking in particular, is never separate from judgment. The working of both fosters our ability "to tell right from wrong, beautiful from ugly." Arendt concludes with words I find especially important in the face of present-day tyranny, that the enhancement of both thinking and judging together may indeed "prevent catastrophes, at least for myself, in the rare moments when the chips are down."[54]

Poetic thinking has always been a central feature of our mental capacity to stop, to step outside ourselves, to reflect without a banister before we come to judgment and, possibly, turn to action. The tyrannies of the twentieth century have given poetic thinking a potent sense of necessity, one that is evident in the literature and the art I present here. Yet today's new technologies, and with them the emergence of multiple new avenues for tyranny in thinking and politics, give poetic thinking an even greater importance. The need to slow down, to stop, and to think without a banister is hardly a matter of luxury. In this age of ever-growing haste, raging discussions on social networks, and pervasive tracking and surveillance, poetic thinking is an imperative if we wish to protect our freedom. According to poet and critic Susan Stewart, "Artworks can slow and even stop the frantic activity that characterizes most of the rest of contemporary existence—not in the sense that they help us rest for another onslaught or distract or amuse us but, rather, in that they provide time for the evaluation of intention and consequence. Even more significantly, they provide time for those extensions of memory into the past and imagination into the future by means of which our lives acquire their genuinely intersubjective and moral dimension."[55] In the footsteps of Arendt and Stewart, this essay asserts that we need poetic thinking today because protecting and cultivating the diversity and richness of our intellectual lives is crucial for withstanding current attacks on our freedom and our humanity around the world. As I write in the summer of 2018, I fear that the chips are indeed down.

Thinking Poems

On Paul Celan and Dan Pagis

situates this in interaction between audience - poem

THE POETIC EVENT

How do poems think? How do poets express their ideas in theme, image, or metaphor? How does our thinking evolve when we read poems that present us with insight and wisdom? How do poems participate in what we may call, following Michael Oakeshott, the conversation of humankind? As poems partake in this conversation, how do they imagine an ethics for our time? I considered these questions when starting to write this essay. The choice to begin with poetry was not accidental. Poetry, as we have seen through our reckoning with Plato, Heidegger, Wittgenstein, and others, is a prime expression of poetic thinking in the arts since its primary medium is language—the very means by which we express our ideas. Starting with poetry, however, also has a more personal rationale: I have written poetry for as long as I can remember and draw on my intuitions both in reading and composing poetry to answer the previous questions. As I wrote and rewrote, my conversations with the many students I have been fortunate to teach have inspired me, and those discussions have confirmed that poetry expresses and engenders thinking, that it opens up spaces of and for reflection.

Considering the relationship between poetry and thinking, we turn to Paul Celan and Dan Pagis—poets whom I have read and studied for some thirty-five years.[1] Both are what we may call, following Helen Vendler, thinking poets: their work displays a vast intellectual appetite and subtle philosophical sensitivities.[2] Their work is also exemplary for our discussion since it touches on the modern experience of tyranny, specifically on Nazism and the Holocaust. Through this historical prism they raise ethical and political questions that make their poetry both brutally specific and, in many regards, timeless.

Thinking, in general, and ethical considerations, more specifically, are expressed in many of the poems we read over the course of our lives as a part of a broad creative experience. Celan's and Pagis's work, in particular, reflects what Jonathan Culler calls "lyric enunciation": As "linguistic event[s]," their poems often require participants, as do a ritual or a performance.[3] Employing formal elements such as rhythm, verse structure, and repetition, as well as rhetoric—images, metaphors, and personal pronouns such as "I" and "you"—Celan's and Pagis's poetry draws us into a poetic event, renders us sensitive to our historical and moral circumstances, and thus prompts thinking on the choices we have made and may make in the future.

The poems I discuss here do not present, however, a rigorous or edifying moral framework; they offer no clear guidance regarding how we should act. I suggest that they present a "multilayered communication between author and audience, one that involves the engagement of the audience's intellect, psyche, emotions, and values."[4] It is as poems that they cause us to experience what Richard Rorty has described as "shudders of awe" and give us the opportunity to stop, think, think again, perhaps talk with others. It is as marvelous words on the page that they relax our preconceived ideas and may even influence our judgment, choices, and actions.

Both Celan and Pagis create the complex interaction James Phelan describes by drawing on their traumatic biographies. They grew up in middle-class German-Jewish families in Bukovina, the former eastern province of the Austro-Hungarian Empire, in which Germans, Jews, Ruthenians, Roma, Ukrainians, and others had, until fascism seized Europe, lived for centuries in relative peace. Emerging from this milieu,

their poetry reflects an intimate familiarity with some of the richest sources of both Jewish and German thinking. Celan and Pagis were exposed to the narratives and moral codes of the Torah and to the biblical books of wisdom: Ecclesiastes, Psalms, and Job. Both poets were also well versed in Goethe's and Schiller's blend of enlightened humanism and aesthetic passion, as well as in the Romantic tradition epitomized by Friedrich Schlegel's wish to wed poetry and philosophy.

Celan and Pagis both bore witness to modernity's calamitous history. Ten years older than Pagis, Celan survived the Second World War and the Holocaust as a prisoner in a forced-labor camp in eastern Romania. His father died of typhus, and his mother was murdered by the SS in the Ukrainian forced-labor camp Michailovka. Living in Paris and writing in German after the war, Celan became a major voice of German poetry.

Pagis was a child when war broke out and was deported, along with his grandparents and thousands of other Jews, to a concentration camp in the Transnistria Governorate, where his grandfather died. After the war, Pagis left Europe for British Mandate Palestine. A native speaker of German, he chose to leave this language behind and adopted a newly acquired Hebrew for both his poetry and, eventually, his parallel career as a leading scholar of medieval Hebrew poetry.

It is no coincidence that in exploring ways to bring together his modernist poetics, historical experience, and intense interest in the German cultural and philosophical heritage, Paul Celan developed, starting in the early 1950s, a growing interest in Martin Heidegger's philosophy. Unlike most other contemporary philosophers, Heidegger strove to blur the ostensible border between poetry and philosophy. Drawn to Heidegger's work yet suspicious of him as a person (specifically, his allegiance to Nazism), Celan remained consistent in following the philosopher's emphasis on the kinship between poetic language and philosophy.[5] It was this idea that probably brought Celan to read, and then creatively weave into his poetry, words and concepts he had discovered in the work of philosophers such as Heraclitus, Spinoza, Kierkegaard, Nietzsche, and Benjamin.[6] Celan shared Heidegger's belief, expressed in "The Origin of the Work of Art," that art has the capacity to help us reach "truth," to "unconceal," to grant us in word and image

new and productive perspectives on our lives, especially regarding those areas of our existence that we tend to ignore or neglect.[7]

WHAT COUNTS

Two of Celan's canonical poems, "Zürich, Zum Storchen" ("Zurich, at the Stork") and "Psalm," are exemplary in this regard. The two are closely linked, written within six months of each other, in May 1960 and January 1961. Both appeared, only a few pages apart, in the first cycle of poems in Celan's 1963 collection, *Die Niemandsrose* (*The No-One's-Rose*).[8]

ZURICH, AT THE STORK

For Nelly Sachs

Our talk was of Too Much, of
Too Little. Of Thou
and Yet-Thou, of
clouding through brightness, of
Jewishness, of
your God.

Of
that.
On the day of an ascension, the
Minster stood over there, it came
with some gold across the water.

Our talk was of your God, I spoke
against him, I let the heart
I had
hope:
for
his highest, death-rattled, his
wrangling word—

Your eye looked at me, looked away,
your mouth
spoke toward the eye, I heard:

We
really don't know, you know,
we
really don't know
what
counts.[9]

Celan first drafted "Zürich, Zum Storchen" on May 30, 1960, in Paris
soon after returning from Zurich, where he met the German-Jewish
poet Nelly Sachs for the first time. They met on May 26, Ascension Day
on the Christian calendar and almost exactly twenty years since Sachs's
dramatic escape from Nazi Germany to Sweden.[10] Sitting in the Zurich
Hotel Zum Storchen, they could see the sunlight ("gold") reflecting
off the water of the Limmat River and, in the water, a mirror image of
Zurich's great church, the Münster (minster).

The poem's imagery re-creates a specific time and place. It also testi-
fies to the conversation between Sachs and Celan. After returning to his
hotel, Celan noted in his calendar: "Hotel Zum Storchen| 4 o'clock, Nelly
Sachs, alone. 'I am a believer.' When I said that I hope until the very
end to blaspheme [*lästern zu können*]: 'we do not know what counts'
[*Man Weiß ja nicht, was gilt*]."[11] From Celan's note we can conclude that
they discussed belief in God, or a lack thereof. While Sachs expressed
confidence in the existence of God, Celan stated his profound doubt—
even anger—that one might still believe in God in light of what had
recently transpired in Europe. For Sachs, however, belief was a way of
grappling with her traumatic experiences during and after the 1940s.[12]

In "Zurich, at the Stork" Celan transformed this conversation into
a complex artwork. We also hear echoes of that discussion with Sachs
in "Psalm," a poem Celan wrote half a year after returning from Zu-
rich. Rather than merely represent the conversation with Sachs and the
thoughts Celan may have had before, during, and after that spring day
in 1960, these poems constitute a "lyric enunciation," "a linguistic event"
in which we are invited to participate. The first four stanzas of "Zurich,
at the Stork" prepare the ground through sight ("clouding," "bright-
ness," "gold across the water") and sound ("I spoke," "death-rattled . . .
wrangling word") for the dramatic shift: What reads in the beginning

of the poem almost like a report of a set of circumstances between an I and a You changes to a thought about what we may or may not know. Readers may choose to read the "we" as external to us. However, the poem invites us to become participants in the poetic event by viewing the "we" as encompassing us as well.

Although the poem begins by accounting for the past, it shifts to third-person plural and transforms in the fifth stanza to a conversation taking place now ("We / really don't know, you know, / we / really don't know / what / counts"). Since we happen to have, from Celan's notes, an indication of what was said in the conversation (we do not know what counts), we can also trace the poetic process by which he composed these words into a rhythmic, ritualistic event, rendering doubt as a bodily experience. Celan's verse structure breaks the sentence up into individual words and phrases; the word "really" (the equivalent to the German *ja*) is injected into the flow and, along with "don't know," is repeated. Culler suggests that the lyrical use of the present tense increases a poem's ritualistic affect: the poem becomes an occurrence of the present.[13] Celan's "Zurich, at the Stork" is exemplary: we are drawn, corporeally, into the poetic event by uttering, twice, in Celan's consciously employed, broken verse structure, "we / really don't know." It is not that we are compelled to accept this utterance as expressing our own conviction. Even if we reject it wholeheartedly, we have still thought about these words and their meaning: we are reading or uttering twice a profound doubt about any certain knowing.

The poetic forms found in "Zurich, at the Stork"—movement in time, personal pronouns, and rhythmic-liturgical repetition—are similarly accentuated in "Psalm," especially in the first three stanzas.

PSALM

No one kneads us again out of earth and clay,
no one incants our dust.
No one.

Blessed art thou, No One.
In thy sight would
we bloom.
In thy
spite.

A Nothing
we were, are now, and ever
shall be, blooming:
the Nothing-, the
No-One's-Rose.

With
our pistil soul-bright,
our stamen heaven-waste,
our corona red
from the purpleword we sang
over, O over
the thorn.[14]

Here, the reader and the lyrical I form a unity beginning in the first verse. In the German original and the English translation the poem presents a radical nowness: "No one kneads us again" encompasses the memory of the no one who had kneaded us in the past, the no one who does so now, and the no one who will not knead us in the future *again*. The rhythm of the repetition of "no one" is both ritualistic and literally breathtaking. In the second stanza the poem recalls the rhythm of the basic Jewish liturgical form, found at the start of nearly every Jewish prayer: "Barukh ata Adonai Eloheinu, melekh ha'olam" (Blessed are You, Lord our God, king of the universe). Yet Celan uses this familiar rhythm not to pay homage to God the creator but to mark a gaping absence. Every reader who utters the words "Blessed art thou, No One" becomes implicated in blasphemy or is afforded the opportunity to blaspheme.

Both poems ponder and engender further reflection on religious identity (Jewishness) and, more perilously, on belief in God following the watershed events of the Second World War and the Holocaust. They also reflect the intense uncertainty that countless modern thinkers and writers have expressed when considering the retreat of our inherited moral traditions, the shift Hannah Arendt expressed, via reference to Alexis de Tocqueville: with the dawn of the modern age "the past has ceased to throw its light onto the future, and the mind of man wanders in darkness."[15] Both poems create on the page a space of, and for, reflection on their historical moment, a time marked by the caesura of

modern tyranny and the world wars and, thus, on our own historical moment. But both poems also move beyond merely marking the doubts of our time. Ultimately, they raise a much broader question, implied in the first verse of "Psalm": "No one kneads us again out of earth and clay." They ask, "What do we turn to now?" In a time when we can no longer hold on to the image of a God-creator who endowed the world with a stable framework for human behavior, what can we count on or refer to or use to justify our choices and actions? The poems relentlessly question the typical view of ethics based on external metaphysical entities such as God, Good, and Justice. "No one kneads us again" implies that nothing—not the Platonic ideas, a Kantian categorical imperative based on human rationality, or any metaphysical sovereign—can serve as an ultimate ethical framework.

The biblical book of Psalms collects devotional poetry that affirms God's supremacy in the universe, as well as humanity's boundless commitment to the creator and the ethical code passed on to us through the books of the Torah. Rather than present a devotional statement, "Psalm" seems to be a rebuttal to the very possibility of such devotion. It offers not zealous commitment but a radical questioning of God's role in shaping an ethical framework for humankind. Genesis 2:7 states: "And the LORD God formed man of the dust of the ground, and breathed into his nostrils the breath of life; and man became a living soul." "No one kneads us again," however, suggests a shift in human history: no one *will* knead us again as the God of the Torah once did. A second reading is that an entity that goes by the name No One creates us *again* out of earth and clay. We were and are now again modeled by a creator who is pure absence, defined not by omnipresence but by its opposite, who is No One. The God of the biblical tradition, the God who struck a covenant with his people and gave them the Ten Commandments as the foundation of monotheistic ethics, is a nobody, a void, perhaps even a perpetrator. The second strophe of "Psalm" goes further in registering our age as an ultimate turning point in history by presenting a feeble humankind facing a hollowed divinity. We, all of us, are a mere nil, as transient as we are gorgeous: "A Nothing / we were, are now, and ever / shall be, blooming: / the Nothing-, the / No-One's-Rose."[16]

In both readings, we find an expression of the deep skepticism Celan referred to in his notes on his conversation with Sachs. Celan's "no one" embodies the notion that what had been possible in monotheistic religion—the founding of a moral code predicated on the existence of an all-knowing creator-God—is no longer valid in light of what God's creation, humankind, has perpetrated in the modern age, especially during the Holocaust.[17] "Psalm" offers, however, more than a sacrilegious inversion of the biblical creation story. At the end of the poem, the reader is left to ask what she—merely "A Nothing"—may still rely on and relate to as she attempts to chart the course of her individual and communal life. The poem renders us sensible to the abyss, yet it also presents us with the question of what or who we can trust in a world and at a time in which no one and nothing reign supreme. What can address the void we face and give an existence of nothing any meaning at all?

"Psalm" and "Zurich, at the Stork" afford us a verbal space and a gap in time in which to *stop* and *step back* to explore where we are and where we might go. Our historical moment is characterized by the retreat of the certitude that was once ubiquitous, a world no longer ruled by the ultimate authority of God or by absolute notions of Good, Evil, Reason, and the like. What shall we do? How shall we proceed? Even if we didn't know about the conversation between Celan and Sachs, we can see how "Zurich, at the Stork" engenders thinking through the positions of the I and the You. Regardless of what was said in the conversation between Celan and Sachs, in the poem we encounter an I that avows the desire to doubt and even blaspheme and a You that gives expression to faith. In addition, we overhear the plea of the addressee to abolish the conflict between religious belief and skepticism in favor of coexistence. The poem captures the discordant positions of the I and the You at the outset and articulates the need not for a synthesis of their ideas, for an illusion of agreement, but for envisioning a radically new ethics for our time. Finally, and crucially, the poem raises the question "What counts?" and challenges us to think about it in the broadest terms.

The arrangement of the words on the page makes this challenge evident. For example, the last two words are spread across two full verses, signaling how a sentence and, by extension, language itself—our capacity to make sense of the world and to communicate with others—dissolve

under the burden of such unanswerable queries. In her editorial an-notations to "Zurich, at the Stork," Barbara Wiedemann remarks that in the first published version (in the daily newspaper *Neue Zürcher Zeitung*, August 7, 1960), the last six lines were enclosed in quotation marks.[18] Celan dropped the quotation marks in the later version: instead of merely recording the original conversation, he created a poem that is both historical-biographical and philosophical. What started out as a record of two opposing positions—Sachs's certainty of the existence of God and Celan's conviction of God's absence—became in the final ver-sion a more ambiguous rendering of two equally valid lines of thought, appropriate for a time itself marked by ambiguity. By stating, in the present tense and in the first-person plural, that "we" "don't know," the poem invites readers into a community whose members are united by their shared sense of uncertainty about what counts. The present tense makes the question timeless: it is not only the lyrical I and You who don't know what counts but all of us, at all times, who should feel compelled to ask "What counts?" and search for answers.

Celan's verse structure also considers what counts as "knowing" in the first place. The German verb *wissen* (to know) also evokes the noun *Wissenschaft* (science), and with it the metaphysical creed of the mod-ern era, the belief, which many cling to like a religion, in the power of our faculty of reason, specifically in the capacity of the modern sciences to penetrate the realm of "the real," to fully explain and thus control nature, humankind, and the course of history. The poem's We suggests a way to encompass the I and You: these two figures may hold oppos-ing opinions about belief in God, yet they share something perhaps just as important—a suspicion of reason and a belief in the inability to *fully* know, to grasp in a finite manner. Holding on to one of the two original positions—certainty in the existence of God or commitment to skepticism in the tradition of the Scientific Revolution and the En-lightenment—implies succumbing to what Arendt charts as the tyranny of logic, the often despotic desire to reach Truth. The great minds of modern science may have given us technical progress and economic prosperity, but as the events surrounding the conversation between Sachs and Celan clearly show, they did not help us at all in answering that most fundamental question: "What counts?"

IN THE IMAGE (בצלם)

It took Dan Pagis, ten years younger than Celan, some fifteen years from the end of the Second World War to develop a poetic language that would convey his experiences and give voice to his insights into the events. Unlike Celan, Pagis did so in Hebrew, a language he fully mastered only after he arrived in prestate Palestine in 1946.[19] After more than a decade of struggling to find expression for his traumatic experiences during the Holocaust, the Adolf Eichmann trial (1961–62) served as a trigger, enabling Pagis to create an aesthetic that blends the personal and historical with philosophical reflection.[20] That aesthetic is embodied in two poems—"Edut" ("Testimony") and "Edut aheret" ("Another Testimony")—part of Pagis's cycle "Qaron hatum" ("Sealed Railway Car") from his 1970 book *Gilgul* (*Metamorphosis*). These two stand in striking proximity to Celan's "Zurich, at the Stork" and "Psalm" in their melding of the biblical creation narrative with the question of ethics in our time.

Testimony

No no: they definitely were
human beings: uniforms, boots.
How to explain? They were created
in the image.

I was a shade.
A different creator made me.

And he in his mercy left nothing of me that would die.
And I fled to him, rose weightless, blue,
forgiving—I would even say: apologizing—
smoke to omnipotent smoke
without image or likeness.[21]

Another Testimony

Thou art the first and Thou remain the last.
If there arise a matter too hard for thee in
 judgment, between plea and plea,
between blood and blood,
 listen to my heart that can't decide, see my hardship.

Your collaborators, Michael, Gabriel,
Stand and admit
That you said
Let us make man,
And they said amen.[22]

Whereas "Testimony" reports on past events, "Another Testimony"
conveys a radical nowness. It is not *about* a past testimony but draws the
reader into a presently occurring poetic event through the use of the first-
person singular: "listen to my heart that can't decide, see my hardship."
The poem's *now*—the time that Jonathan Culler calls the "most salient in
lyrics"—provides what Culler aptly refers to when he speaks of poetry's
"somatic quality that novels and other extended forms lack."[23] The first
verse confronts us with a startling, eternal condition: a sort of ontology
that does not give any indication of who or what *is*. We may surmise that
an entity that is the first and remains the last can only be God. But as in
Celan's "Psalm," what characterizes "Another Testimony" is not the presence
of the divine but gaping vacuity and the absence of any divinity.

Presented as a testimony, the first poem reads like a truncated
dialogue in which we hear the witness negating the claim that all hu-
mans were created, as the biblical narrative of Genesis 1:26–27 reports,
"in the image" (*betselem*) of God. Instead, the "I" suggests, humans
were made as warriors and are defined by their armor, while a "dif-
ferent creator" shaped the witness as an ephemeral being whose life
spans merely that the journey from earth to heaven. The poem is rife
with images that evoke the Nazi concentration camp: the "uniform"
and "boots" of the Nazi guards, the "smoke" emitted by the infamous
crematoria. But more than simply bearing witness to the traumas of
the Holocaust, the poem, through its invocation of the biblical story
of creation and the word of God, opens up a broad space of and for
reflection on ethics in our time. Genesis 1:26–27 states, "Then God
said, "Let Us make man in Our image, according to Our likeness. . . .
So God created man in His own image; in the image of God He created
him." Employing the notion of the creation of humankind in the image
of the divine, the poem gestures toward a theological discourse that
considers human beings to be directly connected to, and observed and
controlled by, the divine.[24] Justice, according to this view, is the result

of our efforts to follow the directives of the divine as they are mediated through religious representatives and institutions. With its piercing irony ("They were created / in the image"), "Testimony" signals that we can no longer hold on to this idea; we live in an age when the biblical conception of justice no longer holds true. If those who perpetrated genocide were created in his image, the poem seems to suggest, then it is incumbent on us to find a new ethical framework to replace the divine, which has failed us miserably.

We get a sense of this ethics in the two poems through the attributes of the I. These poems consider (think poetically) the appearance on the world stage of a new type of human being: someone who is first stripped by a tyrannical political system of all rights as a citizen and then becomes a "shade," defined by the lack of any human feature that "would die." Deprived of all rights, the person is first metaphorically "weightless," always "apologizing" to a faceless sovereign and its servants ("uniform," "boots"), and then literally and dreadfully the subject of murder, the body becoming mere "smoke," lacking any trace of God's "image" or a "likeness" to a human being. During the Nazi era, the I who speaks in Pagis's poem invites us to consider countless individuals—Jews, but also Roma and Sinti, the mentally disabled, and homosexuals—who were robbed of their status as citizens. These various groups, as we well know, became members of what was considered a subhuman class utterly subjected to the tyrant's will. The language Pagis employs, however, invites us to think in much broader terms. Reading his verse, I am also reminded of the millions of victims of the Communist Eastern Bloc, who by the decrees of tyrants became weightless, deprived of all legal and political rights, and were killed by the regime. I am also reminded of Mao's China, where countless people were declared to be without rights and in need, against their will and judgment, of "reeducation" before being sent into exile or simply murdered. Pagis's shade also testifies to countless others who were robbed of their citizenship and civic rights during the post–Second World War era, becoming mere shadows—the vulnerable subjects of genocide or mass-murder campaigns in places such as Biafra, Cambodia, Rwanda, the former Yugoslavia, Sudan, and Syria.

The charge in "Testimony" to reflect on the meaning of "in the image" in light of recent history and the present is emphasized in

"Another Testimony." Here, the noun "testimony" goes beyond the connotation of a witness report and conjures a spatial setting: a courtroom and a trial, a procedure in which we have a plea, an admission of guilt, and then "judgment." This physical space has a temporal quality as well, since the first verse, "Thou art the first and Thou remain the last," is an almost verbatim quotation from the Jewish Morning Prayer in a siddur. The poem suggests itself as one of the first things one says and meditates on during the day. While a siddur establishes God as the ultimate arbiter—"Let all that come into the world understand and acknowledge that thou alone art God over all the kingdoms of the earth"—Pagis dismantles this order. The poem points to a fundamental perversion of justice perpetrated by God in collaboration with the archangels: "That you said / Let us make man, / And they said amen." The archangels, which in the Judaic tradition are members of God's divine entourage, are reduced here to frivolous criminals.[25]

More than simply an affront to the God of the Torah, this poem casts doubt on the ethical and judicial system established in Deuteronomy, which states in 17:8–9, "If there arise a matter too hard for thee in judgment, between blood and blood, between plea and plea, and between stroke and stroke, being matters of controversy within thy gates: then shalt thou arise, and get thee up into the place which the LORD thy God shall choose. And thou shalt come unto the priests the Levites, and unto the judge that shall be in those days, and inquire; and they shall shew thee the sentence of judgment." In "Another Testimony," the biblical command that the Israelites defer in all legal matters to the authority of the religious court is inverted. Instead, the lyrical I commands (with the imperatives "listen" and "see") that God turn to him, the nameless castaway, the one who was shaped by "another creator." It is to the lyrical I and to his "heart," his emotional faculty (rather than to his faculty of reason), that all must attend.

"Testimony" and "Another Testimony" are not a mere theodicy in the tradition of the book of Job, although echoes of Job (particularly 10:2–4, "shew me wherefore thou contendest with me"; and 10:15, "see thou mine affliction") reverberate in Pagis's poems. In the poems the lyrical I pushes further, beyond doubt and toward faithlessness. The speaker seems convinced that the biblical creation narrative is

a myth and that there is no divine authority on which we can depend for our ethical bearings. Like Celan's "Zurich, at the Stork" and "Psalm," Pagis's "Testimony" and "Another Testimony" question ethics as metaphysics and consistently avoid the temptation of advocating for one particular ethical protocol.[26] Both Pagis's and Celan's enigmatic poetry goads us to think, debate, and push beyond the most common version of our role as a passive reader, beholder, and consumer of artwork. Instead of giving us ethical directives, Pagis's poems urge us to come up with our own. In a world and a time in which we don't know what counts, they weaken preconceived ideas about right and wrong as they prod us to consider what a new ethical framework might look like. By pointing to the vacuity of our traditional reliance on metaphysics, they compel us to take responsibility for setting up an ethical system capable of negotiating "between plea and plea, / between blood and blood."

ETHICS WITHOUT PRINCIPLES

Celan's and Pagis's poems urge us to resist the temptation of a fixed ethical framework. As artworks, they challenge the age-old desire to anchor ethics in a system based on metaphysics: faith in God, belief in absolute notions of Good and Evil, Right and Wrong, and so forth. They thus offer the lyrical equivalent of the pragmatist ethics of John Dewey, Richard Rorty, and Hilary Putnam, among others. The question for Dewey is not how to solve the matter by asking, "What would God want me to do?" or "Who is categorically right and who is wrong?" Faced by ethical challenges, we should orient ourselves not according to metaphysical principles but in relation to those people specifically affected by the circumstances.[27] For Dewey the path to ethical judgment and action runs through the circumstantial conditions of the issue at hand, so those called on to judge should first listen, acknowledge, weigh, and negotiate the needs of those involved rather than attempt to resolve the issue by recourse to abstract principles.[28] Pagis expresses this thought with the gesture "*listen* to my heart that can't decide, *see* my hardship."

Richard Rorty, as noted earlier, refers to his articulation of this same concept as an "ethics without principles." Rorty likens the metaphysical

quest to discover "the intrinsic nature of physical reality"—the idea that there is a capital "T" Truth "out there" that the sciences can discover—to the notion that ethics should unveil and set "our unconditional moral obligations." Epistemology, based on the Platonic idea that people can penetrate with their faculty of reason the "appearance" of matter and arrive at finite knowing, is the equivalent of a metaphysical approach, whether based on belief in an all-powerful God or, in the secular, modern version articulated by Immanuel Kant in *Critique of Practical Reason*, on reason as capable of providing access to universal truths.[29]

Moral philosophers who follow the metaphysical line of thought believe in the human capacity to establish, through the faculty of reason, a "strictly moral point of view"—an objectively verifiable, universally valid, and ageless perspective from which the right course of action can be deduced. The problem with the metaphysical approach to ethics, Rorty contends, is the same as the problem with metaphysics itself: it presupposes the existence of "something nonrelational, something exempt from the vicissitudes of time and history, something unaffected by changing human interests and needs." Such a presupposition is either terribly optimistic or hopelessly naïve. The reality, Rorty argues, is far different. Scientific progress relies not on the discovery of an ultimate Truth or on "penetrating appearance until one comes upon reality" but on the integration of "more and more data into a coherent web of belief." Similarly, ethics does not depend on absolute notions of Justice or an always apparent distinction between Good and Evil; rather, it requires a willingness to engage in ongoing negotiations around human values, norms, and beliefs.[30]

Such negotiation, Rorty contends, is always relational: it takes place among individuals and groups who do not share the same convictions, customs, and ideologies (for example, Celan's I and You in "Zurich, at the Stork"). "You cannot aim at being at the end of inquiry in either physics or ethics. That would be like aiming at the end of biological evolution—at being not merely the latest heir of all the ages but the creature in which all ages were destined to culminate. Analogously, you cannot aim at moral perfection, but you can aim at taking more people's needs into account than you did previously." In this view (with which, I believe, Celan and Pagis, as they think poetically, would agree),

"moral progress is a matter of wider and wider sympathy. It is not a matter of rising above the sentimental to the rational. Nor is it a matter of appealing from lower, possibly corrupt, local courts to a higher court which administrates an ahistorical, incorruptible, transcendental moral law."[31] Accepting that "we do not know what counts," as suggested in "Zurich, at the Stork," or attending to the "heart that can't decide," noted in "Another Testimony," implies that no exalted legal authority can serve as the ultimate arbiter in moral questions and that sentiment and compassion are crucial features of ethical deliberation.

Rorty's metaphor of the court brings us directly back to "Another Testimony" and its crucial verses: "If there arise a matter too hard for thee in / judgment, between plea and plea, / between blood and blood, / listen to my heart that can't decide, see my hardship." In matters of ethics and justice it is not God's code of law alone that ensures justice but the careful negotiation between the code of law and the needs of individuals and communities, a negotiation that depends on the ability and willingness to listen to the hearts of those who have a stake in the matter. It is important to note that our long-standing legal codes—such as the Ten Commandments and Deuteronomy—have a lot of heart of their own and often are very useful expressions of our moral norms and habits. Thus, I think Pagis and Rorty would both agree that we should take such codes into consideration, but they must not function as the only source, transcendental and unimpeachable, of ethical and moral authority.

Pagis's metaphor for a nuanced, nonmetaphysical ethical deliberation—"*listen* to my heart that can't decide, *see* my hardship"—is a close relative to what Rorty presents as pragmatist ethics: "the search for adjustment, and in particular for that sort of adjustment to our fellow humans which we call 'the search for acceptable justification and eventual agreement.'" In Pagis's poem the relational listening to another's heart helps us arrive at a more humane justice. And in Rorty's philosophical discourse, "moral progress" is "a matter of increasing *sensibility*, increasing responsiveness to the needs of a larger and larger variety of people and things. . . . Moral progress [is] . . . a matter of being able to respond to the needs of ever more inclusive groups of people."[32]

Being more inclusive is, in the abstract, a worthwhile goal and easy to agree with. Yet that effort is always harder in practice. How do we

react, for example, to the seemingly religiously grounded wish of Orthodox Jewish men to prevent women from performing music in public?[33] What would we do if we listened to another's heart and heard questionable desires or utterly incompatible moral positions, such as those of the believing You and the blasphemous I in Celan's poem? "There is no such thing as intrinsically evil desire," we can reply, following Rorty. "There are only desires that must be subordinated to other desires in the interest of fairness. . . . Moral progress consists in enlarging the range of those whose desires are taken into account. It is a matter of what the contemporary American philosopher Peter Singer calls 'enlarging the circle of the "we,"' enlarging the number of people whom we think of as 'one of us.'"[34] This is precisely the movement Celan's "Zurich, at the Stork" exemplifies: the skeptical, blasphemous I enlarges his own circle to include the perspective of the believing You as something that *could be* valid. And he does so without submitting himself to the worldview of a speaker who holds on to "Jewishness" or to belief in a God. The conviction of I that one should blaspheme is thus counterbalanced by the desire to respect even what the I finds worthy of blasphemy and—one may even surmise—by the insight that one's convictions and values may prove too hasty or limited for a diverse community in which Orthodox and secular Jews try to live side by side.

Pagis's "Testimony" and "Another Testimony" also gesture toward an ethics based on the idea of "enlarging the circle of the 'we.'" Employing the legal and mythological language of the Bible, they confront us with the fact that genocide and mass murder are not only phenomena of history; we live in an age in which tyrants, time and again, spare no effort in making entire groups into "shades," defined by the lack of any human attribute that "would die." Reading these poems, we are invited to think how it was possible, for example, for the Syrian tyrant Bashar al-Assad to decide that the citizens of the city of Ghouta were outside the circle of people endowed with rights and thus brutally gas them. If we consider such thoughts, then the poems also encourage us to think about what it would take to ensure that tyrants like al-Assad can never again act in this manner and what it would take to reintroduce the countless Syrians who have lost all their civic rights or, worse, were murdered, into the "circle of the 'we.'"

What Rorty and Singer see as enlarging the circle never occurs by striving to establish a finite, metaphysical sphere, a place where we all agree on an abstract ethical concept that resolves all conflicts between differing needs, desires, and convictions. The skeptic and the pious in "Zurich, at the Stork" will never agree on how they should respond to the Holocaust or how they should live their lives. What they do is listen to each other and share a single space in which their opposing views coexist. The poem thus enlarges what was originally the rather restricted circle of blasphemy of the lyrical I and models a painstaking striving for cohabitation among individuals and groups that hold incompatible points of view.

The procedural negotiation between conflicting ethical convictions is not only a matter of moderating among separate individuals and groups. It also occurs within the same person: each of us may find ourselves conflicted, torn among several sets of appealing ethical systems. In *Ethics without Ontology* Hilary Putnam suggests a compelling way to address this situation, a path echoed in the poems presented here. Putnam proposes that "ethics" (which he deliberately sets in scare quotes) is *not* "a system of principles," in contrast to the long tradition epitomized by Kant's *Critique of Practical Reason*, with its rejection of sentiment as ethical motivation and its rigid reliance on the categorical imperative. Ethics is instead "a system of interrelated concerns" that are both "mutually supporting" and "in partial tension" with each other. Putnam's stress is on ethics as a concern with "alleviating suffering regardless of the class or gender of the sufferer," a motivation he sees as having deep roots in the great religious traditions of the world, both in those of the West and "in Islam, Confucianism, Hinduism, and Buddhism."[35]

Putnam, like Dewey and Rorty, doesn't believe in ethics as a single set of principles, "a noble statue standing at the top of a single pillar," but as akin to "a table with many legs." "We all know that a table with many legs wobbles when the floor on which it stands is not even, but such a table is very hard to turn over, and that is how I see ethics: as a table with many legs, which wobbles a lot, but is very hard to turn over."[36] When we find ourselves torn among several appealing ethical frameworks, we may decide that it is best to accept that our ethical table wobbles, that although it is not perfect, it should not be fixed—we

should not aim for perfection or finality. Pagis's line "see my hardship" in "Another Testimony" is a translation of *reè et onyi*. The Hebrew original makes use of the multivalence of the noun עָנְיִי, which means "my affliction" as well as "my poverty." The verse thus suggests both a recognition of one's pain (hardship) and an acceptance that there is nothing grand in ethics, which is just the humble, imperfect pillars of a wobbly structure, but which nevertheless reflects and best addresses the contingencies of humankind.

A BASIC WORD: I-THOU

Throughout his work, Rorty, like Dewey before him, expressed the belief that the arts have the capacity—what I call poetic thinking—to allow us to increase our sensibilities and responsiveness to the needs of others, to enlarge the circle of the "we": "Pragmatists see both intellectual and moral progress not as a matter of getting closer to Truth or the Good or the Right, but as an increase in imaginative power. We see imagination as the cutting edge of cultural evolution, the power which—given peace and prosperity—constantly operates so as to make the future richer than the human past. Imagination is the source both of the new scientific pictures of the physical universe and of the new conceptions of possible communities." Rorty also contends that "great leaps forward" occur "only when some imaginative genius puts a new interpretation on familiar facts." In this view, which I share throughout this essay, ethics "arranges the elements which poetry has created."[37]

"Imagination" in this sense is precisely what we encounter in the poems by Celan and Pagis. For example, the first lines of "Zurich, at the Stork," "Our talk was of Too Much, of / Too Little. Of Thou / and Yet-Thou," imagine Celan engaged in two metaphoric conversations with "imaginative geniuses" besides the one with Nelly Sachs. Both of these other imagined conversations, I suggest, reveal what Rorty calls "possible communities," imaginable new formations of I, you, and others; they make tangible what makes a community possible in the first place. In these conversations Celan invokes two thinkers, Margarete Susman and Martin Buber, who were keenly interested in cultivating interpersonal exchange as an ethical foundation for a better human future.

The German-Jewish philosopher Margarete Susman lived in Zurich after her escape from Nazi Germany in 1933. John Felstiner points out that Celan was familiar with Susman's work, and the opening line of "Zurich, at the Stork" echoes Susman's statement that, in the face of the Holocaust, "every word is a Too Little and a Too Much."[38] Thomas Sparr notes the connection between Celan's lines "I had / hope: / for / his highest, death-rattled, his / wrangling [*haderndes*] word" and Susman's interpretation of the book of Job as a "wrangling" (*hadern*) with God and an expression of Job's hope that he would hear a word from God that would acknowledge his righteousness. For Susman, hope is of the highest importance.[39] The concluding section of her meditation on the book of Job is titled "Die Hoffnung" (The hope). When our belief in reliable knowledge and our striving for reassurance through religion or science reach a dead end (as they did during the Holocaust), Susman contends, we are left only with that most fragile but most essential human emotion—we have not faith, and not fact, but we may have hope. Like Susman, Celan juxtaposes knowledge (*Wissen*)—the certainty we strive for in the realm of religious conviction or in the realm of science—with hope.

As Sparr has pointed out, Celan's final verses, "We / really don't know, you know, / we / really don't know / what / counts," echo two differing tendencies in Nelly Sachs's thought expressed during the conversation with Celan in Zurich—"We don't know what counts"—and in the acknowledgment speech she delivered on receiving a prize from the German city of Merseburg later that same year. She asserted, "Everything counts. Everything is active ferment. And we—bursting with fault and error—try to determine what is good, what is bad" (*Alles gilt. Alles ist Ferment, das wirkt. Und wir—vor Irrtum rauchend—versuchen ob gut ob schlecht*).[40] Celan's poetic transformation of the ongoing tension between "what counts" and "everything counts" also encompasses the last sentences in Susman's book *Das Buch Hiob und das Schicksal des jüdischen Volkes* (The book of Job and the fate of the Jewish people): "We, who know so endlessly much, so much too much, we know nothing. We know nothing about what really counts for us; of the plan that we are a part of and that charts the course of our lives. But this is why we also don't know if our dark, unsalvageable world stands at the same

time very close to redemption."[41] The poem doesn't strive to settle the tension, to undo the enigma of a confusing world, of a reality that defies both certainty and a clear, commanding ethical framework. Rather, as Sparr suggests, the poem turns with its questions and doubts to the reader: use of the first-person plural makes the question ours.

"We, who know so endlessly much, so much too much, we know nothing" echoes Hannah Arendt's uncertainty about the status of our inherited values, traditions, and institutions that emerged after the two world wars. For Arendt this insecurity necessitates rethinking the realm of politics and the human capacity to act, but Susman's cautious gesture regarding "redemption" is close to what Rorty calls "possible communities." If we indeed know nothing" then how can we navigate our lives? Celan's poem gives a partial answer in "Of Thou / and Yet-Thou," which references Martin Buber's major philosophical work *I and Thou* (1923).[42] Both Celan and Sachs were familiar with Buber's book, which begins with the philosopher's statement regarding the most crucial "basic words" humans use:

> The world is twofold for man, in accordance with his twofold attitude.
>
> The attitude of man is twofold in accordance with the two basic words which he can speak.
>
> The basic words are not single words but word pairs.
>
> One basic word is the word pair I-Thou.
>
> The other basic word is the word pair I-It; but this basic word is not changed when He or She takes the place of It.
>
> Thus the I of man is also twofold.
>
> For the I of the basic word I-Thou is different from that in the basic word I-It.[43]

Seeking ethical orientation in light of the horrors of the First World War, Buber wanted to establish in *I and Thou* a vision of life based on the recognition of all people as equally valuable participants in an ongoing conversation. Buber takes as his point of departure the human condition of plurality, which is, according to Arendt, "the fact that men, not Man,

live on the earth and inhabit the world."[44] While Arendt thinks that the condition of plurality leads to a concentration on the public sphere (i.e., politics), Buber insists on the intersubjective realm of ethics, specifically the importance of recognizing in the Thou an individual utterly unlike yet no less valuable than the I. The basic word "I-It" refers to those cases in which we fail to acknowledge the unequivocally identical value of I and Thou and, as a result, treat a fellow human being as a mere It—as a means to an end or, even worse, as "human material."

Celan's "Zurich, at the Stork" frames the debate between the believer and the skeptic and its outcome not only as an acknowledgment of our inability to arrive at certainty but also as an expression of the I-Thou relationship Buber had charted. One crucial way to think with the poet and the poem about the question "What counts?" is to consider the I-Thou relationship as one of reverential cohabitation in the face of profound difference. The challenge is not to simply accept those who surround us as equals, the poem seems to suggest, but to accept those whose views are utterly different from ours as unvaryingly entitled to chart their own paths in regard to what counts.

BREATHTURN

Many of Celan's and Pagis's poems express an acute interest in the relationship between I and Thou—the very condition to which Arendt points when she speaks of plurality. Her belief is that humans thrive as individuals only when they act in concert with others in the public sphere while accepting each other's individuality and negotiating their differences. For Celan, to perceive poetically the condition of plurality meant a poetics that blends a theory of the lyric with an attentive turn to people who are distinctively other than oneself. The breakthrough in establishing this link occurred in the spring of 1960 when he received a letter from Hermann Kasack, president of the Deutsche Akademie für Sprache und Dichtung (German Academy for Language and Literature), informing him that he was the recipient of the 1960 Georg Büchner Prize, Germany's most prestigious literary award. Before his trip to Zurich (i.e., before drafting "Zurich, at the Stork"), Celan collected quotations and aphorisms and frantically noted down his thoughts for an acceptance address. He read Spinoza's

Ethics, Husserl's *Lectures on the Phenomenology of Internal Time Consciousness,* and Heidegger's *Being and Time.* He reflected on Buber's *I and Thou,* on the widespread discussion of "engagement" (this was, after all, the heyday of existentialism), and on Adorno's amalgamation of aesthetics and ethics. One such note reads: "Art—I quote here, following Th. W. Adorno . . . , art doesn't come from being able to, it comes from having to."[45] Many of these poetic meditations eventually found their way, in highly stylized form, into his Büchner Prize acceptance speech, "The Meridian."

Celan's description of poetry in "The Meridian" follows Husserl's phenomenological method—he "brackets." He begins by considering what modern poetry is *not.* Step by step, Celan rejects the idea of poetry as an expression of the idiosyncratic, lonesome genius of the poet, in the vein of Gottfried Benn and the tradition of "l'art pour l'art"—the wish to defend art's independence by claiming that it is and should always be utterly divorced from historical, social, or moral concerns.[46] At the same time, Celan rejects the desire to return poetry to the realm of didactic instruction, as promoted by Bertolt Brecht and others.

"The Meridian" instead posits that modernist poetry is experiential in nature, an artistic event (one is reminded here of Jonathan Culler and James Phelan)—an occurrence that involves the poet, the poem, and the reader. Taking his cue from Georg Büchner's expressive, provoking, and often hermetic language, Celan views "poetry, like art," as an experience and an agent: poetry is moving "toward the uncanny and strange" (6), trying to "see the direction shape takes" (6), creating "an encounter" precisely by maintaining "distance and strangeness" (7).[47] At this crucial point in "The Meridian," Celan suggests:

> Poetry: that can mean an *Atemwende,* a breathturn. Who knows, perhaps poetry travels this route—also the route of art—for the sake of such a breathturn? Perhaps it will succeed, as the strange, I mean the abyss *and* the Medusa's head . . . , perhaps it is exactly here that the Medusa's head shrinks, perhaps it is exactly here that the automatons break down—for this short moment? Perhaps here, with the I—with the estranged I set free *here* and *in this manner*—perhaps here a further Other is set free? (7)

Atemwende, "breathturn" in John Felstiner's and Pierre Joris's attentive translations, is a multifaceted metaphor, a powerful amplification of what Culler describes as "lyric enunciation." In "The Meridian" *Atemwende* names what Celan's poetry was committed to from the mid-1950s: the idea of poetry as "a linguistic event," similar to a ritual or a performance. Starting with his fourth collection, *Sprachgitter* (*Speech Grille*, 1959), Celan increasingly employs key elements of poetry—rhythm, verse structure, images, metaphors—in ways that are both formally and thematically "strange." He explores poetic moments that in their obscurity (expressed in language that is radically different from everyday language) provoke us—moments that force us to *turn*, shift, change the course of our breath. *Atemwende* embodies his poems' "somatic quality."[48] Writing, reading, or reciting poetry is for Celan a somatic experience that involves a shift in one of our most basic and instinctive activities: breathing. Fundamentally different from our mundane discourse, poetry—like the figure of Medusa—brings about an experience of both beauty and shock, so it has the capacity to literally and metaphorically bring our breath and, by extension, our customary being to a halt: "the automatons break down—for this short moment." Not by merely depicting human circumstances but rather by being a poetic event (that offers new insight into those circumstances), poetry specifically and art in general have the capacity to change our habitual patterns of thought and action. As an occurrence, they may cause us to take—even if only for the briefest moment—a new path, a novel direction.

Atemwende is a multilayered experience. It begins with poetry's bodily and formal interruption of our daily discourse: for example, the sentence in Celan's notes that "we don't know what counts." "Zurich, at the Stork" turns it into four separate verses, thus creating, if we read the poem aloud, a distinct respiratory pattern; if we read it silently, it changes the direction of our gaze ever so slightly. *Atemwende* also points to the brief or more substantive shudder we may experience when we absorb the irony, if not sarcasm, of a line such as "Blessed art thou, No One" in "Psalm"—words that may be taken to obliterate a centerpiece of Jewish and Christian creed. The somatic and mental experiences of *Atemwende* may also cause us *"to stop* and think."[49] As noted in the

Introduction, Arendt asks, "Could the activity of thinking as such, the habit of examining whatever happens to come to pass or to attract attention, regardless of results and specific content, could this activity be among the conditions that make men abstain from evil-doing or even actually 'condition' them against it?"[50] Celan's *Atemwende* seems to point in a similar direction and to answer Arendt's question with a yes: both literally and metaphorically, the final verses of "Zurich, at the Stork" halt our customary modes of "breathing," our routine ways of thinking and acting, and cause us to ponder what may indeed count. Grappling with this question, the poem gives us an opportunity to distinguish between what is, for us, right and wrong, good and evil, and thus we may avoid the danger of evildoing. Experiencing the poetic artifact *Atemwende*, we are invited to pause, to contemplate, to ponder, and possibly to change our direction.

Celan believes that the capacity of poetry to be a turning of breath, a means of bringing about this shift in experience, is not confined to the realm of the lonesome poet or the single reader. *Atemwende* has the chance to be a perpetual occurrence and an active force in the interpersonal realm. "Poems written today," Celan says in "The Meridian," poetry written *after* the experiences of the world wars and the Holocaust, are mindful of history and of what it has brought to our attention: the consequences of fascism. "But the poem does speak! It stays *mindful of all its dates* [*seiner Daten eingedenkt*], but—it speaks" (8, emphasis added). Poetry is an attentive reservoir of the human experience and never only the expression of the poet's virtuosity, never merely a source of aesthetic delight. As poiesis, the poem bears the mark of all that has led to its creation: from the poet's life and historical setting to all the historical layers of the language being used. As Celan makes clear in "The Meridian," the German of his poetry stands in the tradition of the language Georg Büchner used when writing his prose fragment "Lenz," a work that begins when the rejected poet Jakob Michael Reinhold Lenz embarks on his journey to the house of the priest Johann Friedrich Oberlin on January 20, 1778. Yet Celan's German is also mindful of another moment of rejection, of radical exclusion and persecution: January 20, 1942, the day on which German bureaucrats met in Wannsee in southwestern Berlin to facilitate the murder of European Jewry.

By stating that the poem is not only "mindful of all its dates" but also "mindful of all our dates," Celan includes those who read his poetry, who experience and relate themselves to his work, in his concept of the artwork. The poem is never limited to the poet and the poet's context. When we read and experience poetry, "our dates"—the dates of all who encounter it—are a facet of what the artwork is.

Echoing Percy Bysshe Shelley's Romantic notion that poets are "the influence which is moved not, but moves,"[51] Celan sees modernist poetry as advocating on "behalf of *a totally other*" (8). Poems "want," "head toward," and need "an opposite"; they "seek it out" (9). The poem is also a space of encounter, of "conversation" (9), and even of dispute between the I of the poet and all that surrounds her or him, including, crucially, other people. Celan clearly charts the outline of the space poiesis affords: "Only in the space of this conversation does the addressed constitute itself, as it gathers around the I addressing and naming it. But the addressed which through naming has, as it were, become a you brings this otherness into this present" (9). In this poetic space much may occur; for example, the otherness of what the poem names may emerge, become visible, audible—a facet of human consciousness.

Situating himself against a philosophical and theological tradition that reaches back to Plato's *Republic* (2.10) and sees poetry as a danger to order and communal peace, Celan celebrates poets—in their idiosyncratic and, ultimately, unhindered way of thinking and speaking—as those who defend and cultivate freedom. Addressing the worry about poetry's subversive powers, he highlights its capacity to acknowledge, connect, and react to people, especially to those who are utterly different from the poet, whose language—literally and metaphorically speaking—is radically different from the poet's own language. But the poem always remains free of any strict logic, system, reasoning, conclusive knowledge, commitment, prescription, ideology: always lonely, committed to and accepting the idiosyncrasy of the poet and of all people, and always en route.

Although Celan does not say so explicitly in the final version of "The Meridian," we know from his posthumously published notes that this idea of poetry—as moving and not moved, as an encounter with an "other," and as an experience of otherness—is a stylized transformation of an earlier and similarly provocative idea: poetry as the "jewification"

(*Verjudung*) of language. In his extensive notes we find the following comment: "Not by speaking of offense, but by remaining unshakably itself, the poem . . . becomes offense—becomes the Jew of literature— The poet is the Jew of Literature—One can jewify . . . I believe jewifying to be recommendable—hooknosed-ness purifies the soul. Jewification that to me seems to be a way of understanding poetry" (131). Fusing poetry and Jewishness does not mean an affirmation of Judaism as a religious affiliation or the reduction of poetry to a spiritual pursuit. Rather, jewification is for Celan the cultivation of autonomy from the demands of proper language, of everyday reasoned discourse—freedom in relation to the industrious modernity he refers to when he speaks of "the automatons" (5).

Like many modernist poets, Celan was often criticized because of his frivolous disavowal of convention and norm; he saw this criticism as akin to the rejection of the Jew in anti-Semitic discourse as the ultimate "other." Rather than rebuff this discriminatory view of modernist poetry in the name of an enlightened aesthetics, Celan suggests in his notes that the poem should celebrate and further cultivate its "Jewishness." Holding on to its distinctiveness and strangeness is like paying respect to the ultimate outcasts of modernity: the "yiddy and goitery dead of Auschwitz and Treblinka" (127; *mauschelnden und kielkröpfigen Toten von Auschwitz und Treblinka*). "Respect for the secret of the hooknosed creature—that is one way to the poem" (130). Like the hooknosed, cast-out, and then murdered Jew, modern poetry should never submit itself to hegemonic discourse and to the brutal powers of modern lockstep thinking. It should concentrate on discovering or creating ever-new terrains of our language.

The opaqueness of Celan's poetry—images such as "With / our pistil soul-bright, / our stamen heaven-waste"—is surely an expression of the hermetic aesthetic tradition, from Novalis and Schlegel through Mallarmé to Adorno and beyond.[52] It is also what Celan calls in "The Meridian" a *Gegenwort*, a "counterword" (10), a poetic breaking away from worn-out metaphors and trite vocabulary. Hence, we find in Celan's poetry many "yiddy," "jewified" words and expressions, such as "'s mus asoj sajn,"[53] "Hawdala,"[54] "Kaddisch,"[55] "Tekiah!,"[56] and "Kumi, ori."[57] These words are not merely Hebraic expressions of a

fixed Jewish identity, nor are they Jewish ornaments of a fundamen-
tally German poem. Rather, they are the poetic expansion of what is
regarded as lexically correct, points on the new territories his poetry
seeks to discover.

On August 19, 1960, two months before delivering "The Meridian"
address, Celan summarized these ideas in his notes. He suggested the
poem's ability to educate its readers, not by edification of its ideas but
by its strangeness, its idiosyncrasy: "The poem is the place where the
synonymous becomes impossible: it has only its language . . . and thus
meaning-plane. . . . That is why the poem is by its essence and not first by
its thematics—a school of true humanity: It teaches understanding of the
other as the other, i.e. in its otherness. It demands brotherliness with . . .
respect for this other, a turning toward this other, there too where the
other appears as the hooknosed and the misshapen" (130). Speaking
in a language that remains as radically strange and foreign sounding
as the odd and strange-sounding language of the Jew in anti-Semitic
discourse, poetry confronts us with the vast possibilities of language,
with modes of expression that are as distant as possible from what we
may be familiar or comfortable with. Expanding through its eccentricity
the range of what we are willing to listen to, poetry also prompts us to
consider our willingness to broaden the circle of our experience, to view
those people who were expelled from or were never a part of the circle
of the "we" as part of what Celan calls "humanity." It is in this sense
that poetry can be a "school": Paying close attention to its form and
content, we may learn something new. For example, we may recognize
those whom modern tyrants have classed as subhumans, deprived of
any rights, as full members of the circle of humanity. We may also ask
ourselves how we should react to the existence of such a class.

Remaining free from lexically normed language and convention,
Celan's poetry in the final decade of his life, following his "Meridian"
address, offers many moments of breathturn.[58] Speaking on behalf of
"a totally other" serving as "an opposite," his poems resist almost any
attempt to be subsumed into daily language. Celan increasingly avoided
the thematic in favor of verses that often left his readers in the dark,
wondering how to read them. His late poetry constituted, precisely
through its opacity, "a school of true humanity" by providing us with an

opportunity to experience radical otherness and thus cultivate respect for those who are utterly different from us.

THE PAST AS FUTURE

While Celan's later work expresses an ever-growing aesthetic hermeticism—a celebration of poetry's radically free, inimitable, opaque language—Dan Pagis's later work took a different trajectory. He increasingly used colloquial language and even experimented with prose. Pagis's poetics does share some of the most critical driving ideas found in Celan's "The Meridian." For Pagis, poetry is always attentive to the reservoir of the human historical experience. The poem is a space of encounter, a mode of conversation. Many of his poems also engender what we may call an *Atemwende*—an event both somatic and artistic, which may bring about new thinking and, perhaps, a change of direction, particularly in the realms of ethics and politics.

Pagis's *Atemwende* takes the form of a "multilayered communication between author and audience, one that involves the engagement of the audience's intellect, psyche, emotions, and values."[59] A number of his poems, particularly those written in the late 1970s and published in *Milim nirdafot* (Synonyms), employ dialogue to explore the rhetoric of Israel's public discourse after the 1967 Six-Day War. The war resulted in the occupation of the West Bank of the Jordan River and the subjugation of millions of Palestinians, many of them refugees of the 1948 Arab-Israeli War, the violent collision that secured the young Jewish state and brought devastating exile to hundreds of thousands of Palestinians. In the mid-1970s, Israel began establishing settlements in the territories it captured in 1967. Pagis wrote that although Israeli political rhetoric professes a desire for peace, the occupation of the West Bank is an act of colonization, and the cycle of violence between Israelis and Palestinians is bound to continue.

The opening poem cycle of *Milim nirdafot*, "Ivrit shimushit" (Practical Hebrew), juxtaposes Israeli political rhetoric with this reality. Pagis turns, with sharp irony, to the language used in Israeli grammar books of that time. "Ivrit shimushit" begins with the poem "Targilim be-Ivrit shimushit" (Exercises in practical Hebrew) and with an epigraph that quotes verbatim two interrogatory sentences printed on

the cover of grammar exercise books: "Are you at peace? Did you murder and take possession?"[60] The multivalent Hebrew expression "Are you at peace?" (*Ha-shalom lecha?*) plays on the conflation of the casual (albeit anachronistically phrased) gesture of inquiring about the state of a person (as in "How are you?") with the decidedly more existential "Do you live in peace?" The question remains unanswered. The person asking the question is not interested in knowing if the addressee is at peace. As the second question hints, both the addresser and the addressee live and are bound to continue to live in a condition of perpetual war: "Did you murder and take possession?" is a direct reference to 1 Kings 21:19, where the prophet Elijah admonishes King Ahab of Israel for having plotted to kill one of his subjects, Naboth, because he wanted Naboth's vineyard. How can there be peace—the poem as a whole seems to ask—if the metaphorical king, the State of Israel, uses wars like the Six-Day War to take possession of Palestinian land?

Pagis's irony-laced political examination of Israeli public discourse persists throughout the poem.[61] The first verse reads:

> Shalom, shalom. In Hebrew there is only past and future,
> but there is no present, only participle.
> Now, let us transition to the sentence.[62]

Once again, we find *Atemwende*: the long poem begins with a set of staccato sounds and elliptical sentences. We register the meaning here, in part, via the breath. Supposedly conveying grammatical information in a highly condensed manner, the abruptness and concision mimic a standardized, militarized public discourse. Taken together, they expose the hollowness of Israeli public discourse after 1967, specifically in regard to the possibility for *shalom*, "peace." In the first part of the opening verse, Pagis plays with the fact that saying "shalom" in Hebrew is rarely meant in the pregnant sense of "bringing peace" but is most commonly used as a casual greeting. Through use of repetition that consists of a single sentence ("Shalom, shalom"), the poem both strengthens the offhand tone (the casual air implied by the repetition is more evident to speakers of Hebrew) and draws the reader's attention to the word's original, elevated sense: peace. The poem thus creates a

condensed commentary on the facile platitudes that constitute much of Israel's official rhetoric, which, while extolling peace in the abstract, will not push for the concrete steps needed to realize it.

Alluding to a peculiarity of Hebrew grammar—the relative weakness of the present tense (הווה)—the poem then ironically employs the multivalence of the adjective בינוני, which means both "the present tense" and "mediocre." Read rhetorically (in Phelan's sense) as a "communication between author and audience," it invites readers to consider that the Hebrew of public Israeli rhetoric has become pedestrian. The third verse further emphasizes Pagis's *Gegenwort*. The Hebrew noun משפט means both "sentence," in the sense of syntax, and "trial," "judgment." Thus, the verse עכשיו נעבור למשפט means literally "now, let us transition [in this grammatical introduction] to the study of the sentence/syntax; to the trial/judgment." As the long poem transitions to its second part, the next section (2) presents the judgment:

> A land that devours its inhabitants.
> Its lovers devour its lovers.
> Turn all sentences into future mode.[63]

The section employs an allusion. In Numbers 13:32, the spies that Moses sent into the Promised Land to find out about its inhabitants and conditions return with "an evil report": "The land, through which we have gone to search it, is a land that eateth up the inhabitants thereof." Describing the Promised Land, Pagis's speaker inverts the biblical narrative, in which a natural entity is the ethical culprit. Now it is the land's lovers, people of flesh and blood, who devour each other. The ethical responsibility for the death of its inhabitants is not external but lies with them. The tragedy implied in these scant words is that all inhabitants, both Israeli Jews and Palestinians, equally love the land; and it may very well be that this love brings them, time and again, to destroy each other.

The imperative "Turn all sentences into future mode" is another remarkable moment of *Atemwende*. A literal reading of this line suggests a deterministic view: a past marked by constant, reciprocal mutilation of lovers of the land is bound to repeat itself ad infinitum. Metaphorically, it suggests that the State of Israel is on a path to making the very condition the poem describes irreversible, irresolvable. Yet a more attentive

reading includes the possibility that this section engenders what Richard Rorty (referring to Shelley) describes when he writes that "the poet does not fit past events together in order to provide lessons for the future, but rather shocks us into turning our back on the past and incites hope that our future will be wonderfully different."[64] The line can evoke a shudder, that visceral sensation Celan called *Atemwende*. It thus affords readers the opportunity to reflect on the consequences of resigning themselves to present-day reality. The poem prompts its readers to think through what it might mean for their future if they were to allow their language, their public discourse, and their ethics and politics to be driven by the folly of a love that only consumes the lovers.

Pagis, like Celan, answers the question "What counts?" by reminding us of the capacity of poiesis in general and poetry specifically—as an experience—to provide us with opportunities to stop, reflect, judge, debate with others, and possibly alter our customary forms of thought, judgment, and action. Their work suggests that poetry, with this potential power, may protect us from the kind of thoughtlessness that has led in the modern era to such exceptional evil as the Holocaust and such madness as the gruesome, protracted conflict between Israelis and Palestinians. By confronting us with unique lyrical expressions, poetry may shock us, cause us to pause for a moment, and help us think about both otherness in general and the particular otherness of people who seem to differ from us. It may thus also impact—however minimally—the realms of ethics and politics.

Pagis's and Celan's work is hardly a critique in the tradition of thought that emerged with the Scientific Revolution, which searches for what is right and aspires to find Truth. Evoking the biblical myth of humankind as created in the image of God, for example, the poetry of both poets instead seeks to pursue a new ethics for our day. One way to do this, the poems suggest, is to consider what it would take to fulfill the core idea of the biblical creation myth: to secure the "God-like-ness" of humans, the inviolability of human life and dignity. Pagis and Celan are not invested in returning to some glorious past in which the almighty Abrahamic God had placed his human creation on a pedestal above nature and all other creatures. Nor do they plead for a "posthuman" future of complete domination over the planet and all forms of life.

Rather, they express the sense that humankind is *yet* to create itself in the image of God, *yet* to secure, universally, the inviolability of human life and dignity. Invoking the verses of Genesis, their words do not describe what *is*—for example, that people *were* or *are* made in the shape of a divine image. They instead poetically consider what follows now, when no one kneads us *again*, when in the course of the human-made catastrophes of the modern era God and all other metaphysical anchors such as Good and Justice have turned into a gaping nil. Their poetry suggests that one may answer the question "What counts?" by ensuring that plurality—the dissimilarity of all those whom we encounter and with whom we negotiate our histories, beliefs, and needs—does not lead to the kind of brutality that both Celan and Pagis experienced firsthand.

Their poetry thus gives rise to a narrative, a way of seeing the world that I understand as a poetic version of pragmatist ethics. This story does not involve an overbearing God or a dominant metaphysical moral system that rules over a humanity that is first sinful and then remorseful. It tells of creation as the emergence of a human community comprising distinct individuals, people who are capable of feeling and inflicting pain and thus seek to establish modes of cohabitation—including sharing a land, such as the Holy Land, that some may believe belongs only to them. As the messy, diverse, plural "nothing" of this creation, *we* are, we remain, nevertheless, a rose, even if only no one's rose.

Thinking Paintings

On Gerhard Richter

ATEMWENDE IN PAINTING

How do paintings think? When painters approach the empty canvas and turn it into a piece of art, how do they express both the urge to create and their thoughts, concerns, and ideas? How does a painter's work, and the thoughts it engenders in the beholder, engage with the experience of modern tyranny? And how does that relationship between artist and audience partake in charting an ethics for our time? In other words, how does the notion of poetic thinking change when we consider it beyond the confines of the writer and the reader—when the artwork's place is the public sphere? These questions were on my mind when I traveled to Dresden, Germany, in the fall of 2015 to visit the Galerie Neue Meister (New Masters Gallery) in the Albertinum Museum. I went to Dresden during the time I was writing about poetry for this essay to explore the notion of poetic thinking in painting—a medium I have never studied as a discipline yet have loved since my youth. From what I read about the works I was about to see, I sensed that while they (unlike poetry) cannot rely on words to present or engender ideas, they foster thinking on their own terms. I was curious to place my intuition to the test: to explore how the paintings

I intended to see (like the poems I was writing about) think poetically, capture thoughts without submitting themselves to system or logic; and, more specifically, how they contribute to our understanding of ethics in our time. Set in a museum, this "understanding," it was clear to me, is not least a public occurrence. Although it involves the aesthetic experience of the individual, as it does with poetry, it also includes the exchange an individual may have with other exhibition visitors, the conversation a visiting school class may have, and the media discussion about the works' various meanings.

Gerhard Richter, *Birkenau*

I entered the main hall in the Galerie Neue Meister, a large space with a high, imposing ceiling, dedicated to contemporary masters. On a single wall were displayed the four large and thundery paintings I had traveled to see: Gerhard Richter's *Abstrakte Bilder* (*Abstract Paintings*), soon to be officially titled *Birkenau*.[1] They exude immense drama. They are all the same shape and size: 260 × 200 centimeters. They seemed like portentous giants united by the same color palette: a rich display of layered white, red, black, gray, and green paint and countless shades in between.

Gerhard Richter, *Birkenau*

One can view the cycle as a pictorial movement from either left to right or right to left. Either way, there is an irresolvable tension between the organic and more calming green of the two paintings on the right and the intensity and concentration of the two on the left. This pull is also immanent in each individual part of the series: each displays a polyphony of light and shadow, boundless energy and stillness. The clash of colors and shapes correlates with the enormous dynamism that Richter brought to bear on the canvases. I could easily trace the spirited movement of his squeegee and brush and detect the

Gerhard Richter, *Birkenau*

lines with which he combined and mixed different color fields. I could sense the scratching of paint and the motion of the artist's hand in the geometric crisscross shapes that evoke fabrics, networks, windows, or fences. I could also discern the enormous creative attention involved in bringing the different colors and shapes within each canvas into conversation with the other three to create a congruent and forceful visual landscape. It was clear that here is a painter wrestling with enormous powers, struggling to restrain them, to give his emotions and thoughts a lasting form.

Gerhard Richter, Birkenau

As I was searching for words to describe what I saw, two further things caught my attention. On the opposite wall Richter had placed digital copies of the paintings, as if to create a mirror image of the originals. However, each of the digital copies had been divided symmetrically into four. On a bench at the center of the gallery the museum staff had placed copies of newspaper clippings that gave a sense of the origin of these artworks and of their focus on the number 4. The clippings reported a press conference Richter had given on the occasion of the first public display of *Birkenau*, where he explained that the paintings are his artistic meditation on four photographs taken by members of the *Sonderkommando*, concentration camp prisoners who were forced to assist with the disposal of the remains of those murdered in the gas chambers. In August 1944 a few prisoners in the Auschwitz-Birkenau camp collaborated in taking those four photographs under severe danger to their lives to bear witness to the extermination process and the Nazi attempt to conceal the physical evidence of the mass murder.[2] Pressing the shutter button four times, the photographer—Alex, a Greek Jew whose last name remains unknown—and all involved in smuggling these images out of the concentration camp bluntly displayed to the world the unspeakable realities of the Nazi tyranny: corpses in a fire pit outside the crematorium, a group of naked women who would shortly be forced into the gas chamber. I read the newspaper clippings, looked again at the paintings and the digital reproductions, and my breath turned.

The four large canvases in the Galerie Neue Meister, the four reproductions, and the history recorded in the newspaper clippings elicited from me *Atemwende*. They evinced a "somatic quality" similar to the one I described when reading Paul Celan's "Psalm" or Dan Pagis's "Testimony."[3] *Atemwende* stands in Celan's thought for a change in one of our most basic and instinctive human activities: breathing. Literally and metaphorically turning our breath, such poems as Celan's and Pagis's deliver a jolt to our customary being and bring the flow of time to a brief yet noticeable halt. *Atemwende*, I have suggested, is not only a bodily sensation. Emerging from the artist's creative sensitivities and choices, it also captures the artist's thoughts and may engender thinking in the reader.

Continuing this discussion, I now focus on Richter's *Birkenau* as it embodies the thinking that led to the work, which I believe thinks poetically as it captures the artist's evolving ideas about the Holocaust and how he might address that event in his visual language. Richter's paintings, like Celan's and Pagis's poetry, give rise to much thought on ethics and politics in our time. To be sure, *Birkenau* remembers Nazism's victims and presents a visual meditation on the tension between amnesia and memory surrounding what transpired in the German concentration camps, as some critics have suggested.[4] Yet *Birkenau* also goes significantly beyond the challenge of remembrance, the demand to acknowledge the Nazi crimes that was central for post–Second World War literature and the arts. Invoking the crimes of the regime, *Birkenau* poetically thinks about the implications of the appearance on the world stage of the new class of modern human beings that Pagis's "Testimony" so acutely describes.[5] Drawing our attention to the fate and the actions of the *Sonderkommando* in Auschwitz-Birkenau, Richter's work, like Pagis's "Another Testimony," invites us to acknowledge those people of the modern era who were first stripped by a tyrannical political system of all their rights and then of all human attributes, leaving them, in the words of the poet, with nothing that "would die," leaving them as mere shades or "smoke" lacking even an "image" or a "likeness." Richter's *Birkenau*, however, gives form, visible for all to acknowledge, to those who were brutally deprived of an image and even a grave. *Birkenau* also moves from the historical and the figurative to the abstract and thus invites us to consider the fate and choices of the *Sonderkommando* as they relate to the destiny of others, in our own time—those many men and women and children who similarly fall victim to tyrants, who are deprived of all rights, who are left with nothing in them that would die.

Birkenau, like Celan's and Pagis's poetry, avoids any conclusive argument or lesson. Suspicious of all metaphysical philosophical structures, especially ideology, it engenders a multilayered encounter between painter and audience, "one that involves the engagement of the audience's intellect, psyche, emotions, and values."[6] Facing the abyss of modern civilization for which the name "Birkenau" stands, it expresses Gerhard Richter's lifelong focus on the notion of hope, his ongoing

interest in the human role in shaping history's course. *Birkenau* is thus also a meditation, I believe, on the human ability to confront despotism and to resist it, even in moments when meaningful action seems impossible.

"BEYOND THIS SENSELESS EXISTENCE"

To fully grasp poetic thinking in *Birkenau*, we must first turn to Richter's artistic beginnings, especially to those works that touch on Nazism and its aftermath. Since the early 1960s, when he became transfixed by pop art, Richter has sought to transform various photographs into paintings. Inspired by Andy Warhol, Richter's early photo paintings turned our attention to familiar artifacts: a table, a chair, a piano. Along with the mundane objects of consumerist culture and its celebrities, however, these photo paintings also paid close attention to historical subjects: from jet fighters and bombers to family members whose lives were decisively touched by recent German history.[7] This is hardly a coincidence. Richter was born in Dresden in 1932, so his early life was shaped under Nazism and marked by the Second World War, the destruction of Dresden, and the oppressive regime of the so-called German Democratic Republic, whose grip he escaped when he fled to the West in 1961.[8] In 1965 Richter painted three works that have become canonic in regard to his interest in this history: *Onkel Rudi* (*Uncle Rudi*; CR 85), *Tante Marianne* (*Aunt Marianne*; CR 87), and *Herr Heyde* (*Mr. Heyde*; CR 100).[9] All three paintings avoid presenting history through the distancing lens so typical of "history painting" as a genre. The traditional task of history painting was to represent an event or historical actors in the context of their time with the aim of preserving the past and, occasionally, lifting historical figures to the status of idols. But in Richter's paintings, we don't have heroes, kings, or armies in the throes of immense power clashes, resulting in works that, like Francisco Goya's *The Second of May 1808*, intentionally or not, elevate the pain of war to the level of a moral tale. We instead encounter history in these works as the gray, leaden matter of everyday life, as it touches and ravages the lives of individuals, even of one's own family members.

The painting *Uncle Rudi* was created from a photograph taken just before Richter's maternal uncle Rudolf Schönfelder (nicknamed "Rudi") died while fighting for Hitler's Wehrmacht.[10] The family was left with an image of the smiling man, who cannot know what is about to come. Blurring the specificities of Rudi's face, uniform, and insignia, the painting invokes the factual uncle. *Uncle Rudi* is Richter's artistic *reaction* to the original artifact rather than a representation of his uncle: it renders the person almost faceless. Emphasizing *reaction*, I follow Florian Klinger, who encourages us to focus less on the capacity of Richter's paintings to represent an individual than on the artist's imaginative *response* to the material he is working with; in this case, we should pay close attention to the act of blurring.[11] Reaction also captures how we encounter the painting: the range of our somatic and mental responses to what we see—our visceral sensations, emotions, associations, and thoughts. Richter is consistent in his belief in art's capacity "to help us think something that goes beyond this senseless existence."[12] His creative procedure in paintings such as *Uncle Rudi* counts on our ability to both recognize what we see (e.g., the haunting quality of the almost faceless Rudi and his ominous surrounding) and, crucially, to go beyond to reflect, ponder, debate with others something only we may create: insight, recognition, judgment, decision, and perhaps even some form of action.

Asked why his paintings look like blurred photographs, Richter replied, "I've never found anything to be lacking in a blurry canvas. Quite the contrary: you can see many more things in it than in a sharply focused image. A landscape painted with exactness forces you to see a determined number of clearly differentiated trees, while in a blurry canvas you can perceive as many trees as you want. The painting is more open."[13] In its openness, *Uncle Rudi* invites us to discover how individuals and families are implicated in events we habitually assign to the realm of history: it displays the interdependencies of the private and the public. History is not a set of events that takes place on some grand historical stage (for example, history paintings such as the 1807 *Coronation of Napoleon* by Jacques-Louis David). It takes place everywhere, including in such intimate locations as a family. *Uncle Rudi* also allows us to see in the concrete figure many more things—for example, the countless German soldiers evoked in Pagis's "Testimony," those who "definitely were / human beings: uniforms, boots." Like the poem, in which the poet considers the

perpetrators as a group of humans, *Uncle Rudi* reacts to the image of one German soldier by blurring the specific features, by exposing many others in the one. Yet Richter's hardly identifiable figure enables an even broader thinking regarding men and women of various times and places who opt to become faceless—who volunteer their bodies to the exercise of blind military might. Evading the concreteness of a discernible personality and an exact time and place, inherent in the original photograph, *Uncle Rudi* considers personal motivation as it intersects with ambition, ideology, and thoughtlessness: What kinds of choices do men and women face under historical duress? How do they make moral choices? What is the relationship between personal agency and collective belief in charting the course of their individual and communal lives? These and other thoughts emerge from the artwork itself. After all, in *Uncle Rudi* it is not only we who look. Staring at us, the figure of the carefree soldier questions us as well, asking where we actually stand and whether we will join him eventually. We must wonder what it means to be a human being in a world populated by Rudi and his ilk.

Gerhard Richter, Tante Marianne

Uncle Rudi, Aunt Marianne, and *Mr. Heyde* were all painted in 1965, and all embody their particular postwar moment: some twenty years after the end of the Second World War, such questions and, more generally, the relationship between evil and banality had taken center stage. The Eichmann trial in Jerusalem (1961–62) and the Frankfurt Auschwitz trials (1963–65) forced a global audience to reckon as never before with both the plight of Nazi Germany's victims and the extent to which countless "ordinary" Germans had participated in the crimes of the Nazi regime. In the mid-1960s it became obvious that most of these perpetrators had continued to live their lives without having to account for their crimes. In a 1970 interview, Richter explained his interest in the family photographs of his uncle and similar subjects: "I tried to find nothing too explicit, hence all the banal subjects; and then, again, I tried to avoid letting the banal turn into my issue and my trademark."[14]

In *Aunt Marianne* Richter wrestles with the "banal" (a laden term addressed later) by invoking his aunt Marianne Schönfelder. In a painting based on a 1932 photograph taken in the garden of his grandparents' home in Dresden, we see the fourteen-year-old aunt fondly holding a baby: Gerhard Richter himself.[15] Her hair is neatly combed, and Marianne's gaze is turned away from the camera as if in embarrassment or distraction. Richter's gray palette and the fine brushstrokes endow her face with a gentle, soft quality. A vivid light falls on both figures, making them appear like one glowing angelic being, yet they are surrounded by an ominous darkness. Marianne was twenty years old when she was diagnosed with schizophrenia. Under National Socialism, she was first sterilized and then placed in various institutions for the mentally disabled. Finally, in August 1943 she was sent to a psychiatric clinic in Großschweidnitz, Saxony,[16] where she became one of the many whom the regime regarded as *unwertes Leben,* "unworthy to live." The interned patients of Großschweidnitz were the target of the Aktion T 4—the euthanasia program aimed at "purifying" the Aryan race. They were starved and received overdoses of psychiatric medication with the aim to kill. Marianne Schönfelder died there on February 16, 1945. The reason given on her death certificate was "cardiac arrest." Earlier, the doctors had noted that she was weak and had lost a lot of weight, signs of systematic undernourishment. Dreamy and somewhat faint, Richter's

Aunt Marianne is also an act of remembrance. In an interview he gave in 2016, Richter remembers witnessing his grandmother and his mother sob and scream when they returned from visits to Großschweidnitz: "They saw the misery. I noticed, of course, even if I, as a child, would rather not take it in, would rather go outside."[17]

Painting *Mr. Heyde* later that year (1965), Richter further reflects on Marianne's fate by rendering a newspaper clipping as an artwork. The painting brings into focus two elements: a seemingly ordinary man in suit and hat as he is escorted by a policeman and a prosaic caption that reads "Werner Heyde in November 1959, as he gave himself up to the authorities."

Presented first in the photograph and then in the painting as an icon of a German dull bourgeois, Heyde was in fact a psychiatrist who had been involved in Aktion T 4. By making both him and the plain caption its subject matter, Richter's painting reacts (in Klinger's sense) to the source material—it highlights the vacuity of such phrases as "gave himself up to the authorities" and, more generally, of the German public discourse in the early 1960s when confronting the crimes of the Nazi

Werner Heyde im November 1959, als er sich den Behörden stellte.

Gerhard Richter, *Herr Hyde*

regime. What the caption elides is that for fourteen years after the war, Heyde was able to live a conventional bourgeois life as a neurologist in the West German city of Flensburg, where he was protected from prosecution by the local authorities.[18] Reacting to the source material, the painting also allows beholders to take another, closer look at a picture and a news item they may have encountered before; Hannah Arendt tells us that they are invited to stop, to think, to go beyond their previous, habitual existence. They may, in fact, discover that the painting highlights what the terse newspaper report of the arrest obscures: after the Second World War, Heyde and many others like him were able to proceed with their lives and avoid justice with the blessing of a political system that would rather look the other way and of a citizenry who wanted to forget their nation's crimes.

As Richter wrestled with the seeming ordinariness of Werner Heyde and his like, he was keenly aware of Arendt's now-famous suggestion in her book on the Eichmann trial that there is a unique and radical quality of evil in Eichmann's thoughtless willingness to serve as a cog in the Nazi killing machinery.[19] Referring to *Mr. Heyde* in conjunction with Arendt's notion of "the banality of evil," Richter highlights the "horrific" nature of what seems to be common and banal: "It is much scarier to paint people's faces as banal as I find them in photographs. That is what makes the banal more than just banal."[20] As mentioned previously, the customary charge of history painting as a genre was to invoke and preserve history, often elevating its actors to the status of idols, but Richter reacts to the historical actors: highlighting the banal, the everydayness of Heyde, the painting explores and exposes what the seemingly "decent" postwar German bourgeois existence painstakingly tried to avoid, to hide.

When *Mr. Heyde* was first displayed in West Germany in the 1960s, the younger citizens of that dynamic, rapidly recovering country were beginning to question whether their political institutions and their cultural discourse had done enough to investigate the crimes and pursue the perpetrators of the Nazi regime. Older citizens had often been part and parcel of the Nazi state. To a critically minded audience, *Mr. Heyde*'s portrayal of the banal offered a departure point for thought, debate, and possibly even action regarding what was thus far rarely

recognized and confronted: the Nazi era. Along with other works by Richter, *Mr. Heyde* was an appeal to finally make the Nazi perpetrators and, by extension, German society accountable for the past. Whereas history painting suggests the inevitability of what happened, Richter's photo paintings present events and actors of the past as objects of an ongoing examination: Why and how did a certain course of events transpire? Were the events inevitable? How did historical actors come to play their parts? What kinds of choices and alternatives did historical actors have under the conditions of a despotic regime such as Nazism? Reacting to family photographs by effacing the concrete facial features or by presenting the absurdity of allowing criminals such as Heyde to live a largely normal bourgeois life, Richter inserts himself into history's terrain. As he makes something such as a familiar family photograph unfamiliar, and as he endows the photograph with new perspectives, he also suggests how we may choose to move beyond the mere registering and chronicling of the past and how we, like him, may challenge the notion of history as an inescapable course of events or as a static reality.

TURNING TO THE SECRET BOOK

Gerhard Richter's interest in history became a hallmark of his work, demonstrated in iconic paintings of Mao Tse-tung, the 1972 cycle *48 Portraits*, and the 1988 fifteen-painting cycle *18. Oktober 1977* (*October 18, 1977*). From his artistic beginnings, however, the Holocaust remained one of the greatest challenges for his thinking poetically about the past. As he mentioned in many interviews, including our conversation in his studio in Cologne in the spring of 2016, Richter has been haunted by the Holocaust since, as a young student in the Dresden Academy of Fine Arts, he encountered photos of victims of concentration camps in two documentary books: "I'll never forget it. . . . Awful records. . . . It was like a secret book."[21] Richter's artistic reaction to this experience had begun in 1957 when he created a series of twelve ink drawings intended for an edition of *The Diary of Anne Frank*.[22] When in the early 1960s he started compiling his *Atlas*, a collection of photographs, sketches, and newspaper clippings for his artwork, he gathered photographs taken by English and American military photographers during the liberation of the Nazi concentration camps.[23]

Together with the German artist Konrad Fischer (alias Konrad Lueg), in the mid-1960s Richter planned an exhibition that would display, in the spirit of pop art, these and other Holocaust images in conjunction with pornographic materials.[24] Young and provocative, Richter and Lueg wanted to draw attention to the vulgarity in the consumerist circulation of such images: to the obscenity of displaying images of Holocaust victims in banal places like daily newspapers and commercial magazines, such as the sensationalist *Stern*, that one might find at the checkout counter of a grocery store. The exhibition was to reflect on the similarity

between the commercial marketing of sexuality in pornographic magazines and the exploitative use of the most horrific historical records. The project was to suggest that consumerist societies such as 1960s (West) Germany produce, market, sell, and consume images at a pace and in a fashion that leave no room or time to stop to think where a specific image comes from and what it actually means.[25]

For the exhibition, Richter envisioned adding crude colors, similar to those decorating his childhood fairy-tale books, to the archival Holocaust photographs. The projection of the gaudy colors onto the

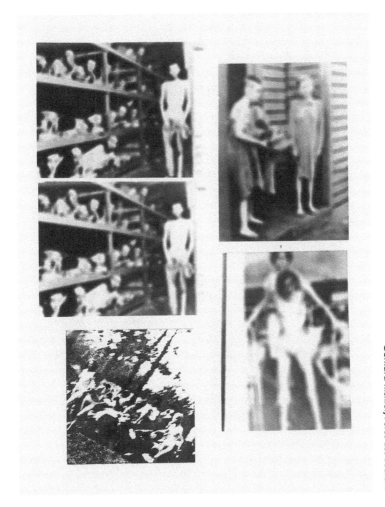

historical photographs would have suggested a resemblance between the inexplicably gruesome stories populating German fairy tales and the unfathomable realities of the German death camps.[26] But they would also have indicated an alternative to the passive consumption of images so typical of modern consumerist societies: adding the colors to the original records, Richter reacts to them and suggests that we might consider also actively engaging with the original photographs rather than merely taking them in. The more Richter and Lueg talked about this exhibit, however, the more they began to doubt the moral premises

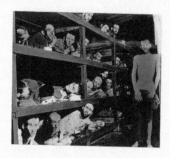

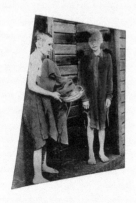

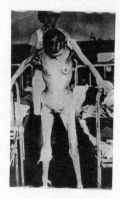

Gerhard Richter, *Fotos aus Büchern*

of their provocative idea. A few months later, they decided to abandon the plans for an exhibition.[27] Finally, Richter included the altered photographs in his *Atlas*, along with a record of his thought process in manipulating them.[28] *Atlas* sheets 16–23 testify to his wish to find ways of addressing the Holocaust and point to a crucial aspect of his entire oeuvre when it touches on the past: his interest in the human capacity to shape history.

The challenge of moving beyond passive spectatorship remained central for Richter when considering how to address the Holocaust in

his art. This challenge had a lot to do, I believe, with figuring out how to include hope—a concept Richter has referred to on numerous occasions. Acutely aware of modernism's nihilistic thrust and of the pitfalls of politically "engaged art," his work reflects a belief in art's "ethical and transcendental function," as the art critic Robert Storr lucidly pointed out.[29] With a hint of irony, Richter expressed this belief in a conversation with his friend, the art critic Benjamin Buchloh, by speaking of art's capacity to express longing "for lost qualities, for a better world—for the opposite of misery and hopelessness." Richter went on to speak of hope: "I might also call it [longing for] redemption [*Erlösung*]. Or hope—the hope that I can after all effect something through painting."[30] In an interview with curator Gregorio Magnani he specifically tied his abandoned exhibition with Konrad Lueg to hope: "The concentration camps were simply terrible, without any hope, and that is something I can't paint."[31]

Richter never stopped trying, though. In 1997 he returned to images of the Holocaust while considering how to design the main Western entry hall to the newly renovated German parliament building, the Reichstag. He collected hundreds of images, exploring the possibility of displaying some of them in the form of a mural.[32]

Presenting the images in an artistic constellation would have established the space of the Reichstag as mindful of recent German history, specifically of Germany's political path following the collapse of the Weimar Republic. Such a mural would have served as an artistic meditation on the consequences of a failed democracy. After further consideration, Richter decided to abandon this artistic path, too, noting that it seemed to him to be "wrong after all" (*doch falsch*).[33] "Perhaps it was shame or pity or piety that held me back," Richter told Jan Thorn-Prikker in an interview. "I never figured it out."[34] He ultimately decided that he wanted to design this space as "more optimistic and hopeful."[35] Instead of presenting images of victims of the Nazi regime, Richter opted for a work he called *Schwarz Rot Gold* (*Black Red Gold*; CR 856)—three rectangles of enameled glass in the colors of the German flag, colors that since the mid-nineteenth century have symbolized the political desire to modernize Germany as a democratic state. The work thus draws attention to this heritage and indicates the spirit in

Gerhard Richter, Reichstag

which today's German parliamentarians may choose to act. Richter's art installation in the Reichstag remains mindful of other dates in German history, of other moments leading to the day the renovated German parliament opened its doors.

POIESIS AS REFUTATION

Only in his 2014 painting cycle *Birkenau* did Richter finally find an appropriate means for addressing the question he had struggled with for some five decades: how to react to, not just bear witness to, the Holocaust in his art and how to do so without excluding the possibility of hope. The inspiration for the *Birkenau* paintings came in February 2008 in an article Richter encountered in the daily *Frankfurter Allgemeine Zeitung*: a review of the German translation of Georges Didi-Huberman's 2004 book *Images malgré tout* (*Images in Spite of All*). In this work, the French philosopher and art critic reflected on the history of the four *Sonderkommando* photographs and, more generally, on the ethical justification for the public display of Holocaust images.[36]

The review included one of the four photographs, an image showing a group of *Sonderkommando* burning corpses by Crematorium V in Auschwitz-Birkenau. Moved by the photograph and the review, Richter framed the image and hung it on the wall of his studio in Cologne.[37] When Corinna Belz interviewed Richter for her 2011 documentary *Gerhard Richter: Painting*, he showed her the framed photograph, noting the challenge of reacting to it in any meaningful manner: "This is an unbelievable [*irres*] photo. I find it fascinating how peaceful it looks, how normal. When you look closely, they're having a nice chat. . . . I can't tell you anything. It's insane [*irre*]."[38] In an interview with Nicholas Serota in the spring of 2011, Richter further expanded on his difficulties in coming up with "a suitable form of presenting it [the Holocaust] so that it's bearable and not just spectacular." He said that he couldn't "add anything" to the image as captured in the original photograph.[39]

The question of "a suitable form," a question that involves the ethical and the artistic equally, was the great challenge for Richter in his attempts to engage the Holocaust in his art. It remained acutely on

his mind when he invited Georges Didi-Huberman to visit his studio in December 2013, where the critic observed four empty canvases hanging on the studio wall as well as the framed *Sonderkommando* photo that had been printed in the *Frankfurter Allgemeine Zeitung*. In a letter to Richter after the visit, Didi-Huberman recounted their conversation about art; about Richter's sketches surrounding the photograph; and about the format, frame, and sequence of what might one day become an artwork that would address the original images. He also touched on the profound doubt that characterizes our age and that was, perhaps, among the reasons for Richter's hesitation in realizing such a work: "Today, God is dead, and so is the god of artists. Doubt inevitably reigns, but you [Richter] will no doubt create one, two, three, or four *pictures in spite of all.*" He linked Richter's statement in an interview that in the past he had solved artistic challenges simply by going on painting ("ich habe einfach weitergemalt") to the concepts of perseverance and hope. "Doubt," Didi-Huberman wrote to Richter, "is immense (*Skepsis*) and places everything in a state of high improbability, but desire (*Wunsch*) survives, and is indestructible." For him, Richter's emphasis on "visualizing the future" and on "hope" was closely related to the imperative to create and present images in spite of our ethically motivated hesitations—indeed, "in spite of all."[40]

In the months following Didi-Huberman's visit, Richter finally approached the four empty canvases to begin working on the cycle he would eventually call *Birkenau*. The work led him on a path of personal and artistic exploration that would take almost an entire year.[41] He drew on the experience he had gained during five decades of engaging history through photo painting, in full awareness of Theodor Adorno's much-recited doubt regarding art's ability to meaningfully address the Holocaust.[42] He was also familiar with Susan Sontag's observation about a world populated with countless photographs of horror, including those of the Holocaust: "Images transfix. Images anesthetize. An event known through photographs certainly becomes more real. . . . But after repeated exposure to images it becomes less real."[43] Richter was also conscious of what Buchloh has piercingly described as the inability of the post–Second World War avant-garde to offer "ethical authority" regarding fascism; that "the times of John Heartfield and Bertolt Brecht had come and gone."[44] Facing the canvases, Richter had no intention of engaging in the iconographic exploration of Nazi Germany and the Holocaust that Anselm Kiefer and others have pursued.[45] He did not want the canvases to be absorbed by the platitudes of the German *Erinnerungskultur* (remembrance culture), nor did he want them to further fuel the spectacle surrounding his work in the art market.[46] Richter's work yields enormous prices in the speculation-driven art market. He intended to paint the four rectangular canvases, but how?

The answer came gradually. While reading *Images in Spite of All*, Richter initially thought of the four *Sonderkommando* photographs as pictures (*Bilder*), so he could turn them—his doubts notwithstanding—into paintings.[47] In the previous months, he had studied the photographs carefully, arranging them in various forms.[48] Using the techniques he developed in works such as *Uncle Rudi, Aunt Marianne, Mr. Heyde*, and his iconic cycle *October 18, 1977*, he experimented in July 2014 first with projecting the original photographs onto the four canvases and with graphite sketches, only to realize that "it doesn't work."[49] One can only "describe the original images or write a musical score to them," Richter noted retrospectively, in an interview with the *Frankfurter Allgemeine Zeitung* and then in a conversation with me. Copying them ("Abmalen") onto the blank space, in whatever altered form, would mean creating bad paintings ("schlechte[n] Bilder[n]").[50]

Richter's recognition that his initial attempts would yield only bad paintings went hand in hand with the conviction he had had since he first encountered the photographs and their story in Didi-Huberman's book. If he were to create a work of art that originated in them, it would need to remain distinct from them. "These photographs are so good that I can only leave them as they are."[51] The German adjectives *schlecht* (bad) and *gut* (good) denote, as they do in other languages, both an aesthetic and an ethical quality. Why are the *Sonderkommando* photographs aesthetically good? Perhaps because there is nothing staged in them, nothing contrived or craftily done. They are four precise, frozen pictorial moments in time, four cadences created by pressing the shutter button—one, two, three, four—in which the utterly defenseless subjects of a vicious tyranny, the victims of a nearly unimaginable human circumstance, quickly record their experience before they are discovered. It is through this minimal yet momentous four-count rhythm that they bluntly confront us with what humans were, and are, capable of. It is in these four moments that they show us how the actions and inaction of countless people had led to what the photographs display: people stripped of their dignity before they are murdered, human bodies treated like mere waste. In a scant four seconds, the photographs exhibit in plain sight and capture the Holocaust as one of the most radical ruptures in the civilizational tradition that we encountered in Celan's and Pagis's poetry and that holds that all people are created "in the image of God"—the belief, across religion, culture, and time, in the inviolability of human life and dignity. Keeping their content and form in mind, one can hardly think of anything "better," anything more aesthetically poignant, anything more distressful to our sense perception, than these photographs. Long after we have seen them, we are haunted by the images that seem to pierce our eyes—by the pain and the humiliation of the victims or the monstrousness of the perpetrators we assume to be in their vicinity. What also haunts us is the knowledge that the images present only a few snippets of so much more suffering, of crimes we simply cannot fathom.

Yet the photographs are also ethically good. The Nazi intention in Birkenau and the other death camps was to extinguish European Jewry and eliminate any trace of the mass murder. Stopping to press the shutter button, the *Sonderkommando* captured a brief yet crucial moment in the rush toward annihilation and oblivion. Didi-Huberman thus calls

the photographs "snatched images"; he poignantly argues that they are "*refutations* . . . from a world that the Nazis wanted to obfuscate, to leave wordless and imageless."[52] As a brief, four-note score, they give back to those who were robbed of all their rights and dignity some (admittedly infinitesimally meager) amount of their lost respect. With all their limitations, these images nevertheless attest to what was done to the victims, claim in a fragmented though forceful manner their violated rights. The images could not undo the killing of those whose bodies we observe, nor could they stop the impending death of the naked women we see. In capturing their fate and in confronting us with the question of how to react to the images, the photographs, in spite of all, offer some form of intervention, some measure of action.

Intervention and action, indeed: pressing the shutter button four times and making sure that their images arrived in the outside world, the *Sonderkommando* were doing more than trying to ensure their own survival. In severe danger—they knew they would be immediately executed if caught—they were willing and able to resist one of the most radical tyrannies the world has ever seen and to interrupt, for four brief moments, the thrust of oblivion. In smuggling the camera into the area of the crematorium and taking the photographs, they not only created four lasting images—flimsy though they might be—of the unimaginable but also regained some "weight" (Pagis's image). Using Michael Rothberg's insightful notion of "the implicated subject," they implicated (they morally involved) the recipients of the photographs and all who view them in the circumstances they capture.[53] I do not wish to suggest here that the viewers are now as responsible as the Nazi perpetrators for the crimes committed in Birkenau and elsewhere. Rather, I believe that the photographs silently ask, now that you have seen us, "What will you do?" Implicit in the photographs is the hope—absurd though it might have been—that if the images were to reach the outside world, some caring portion of humanity would find them and somehow choose to act themselves, that more people would be found who were willing to insert themselves into the flow of current historical events, to intervene and possibly stop the madness of Birkenau. Poiesis, these photographs suggest, is not confined to the realm of aesthetic expression, experience, or pleasure. Poiesis may also indicate refutation: prevalent views

regarding the limitations of human action are often a mere excuse for fears or a simple reluctance to accompany ethical convictions with the appropriate actions. To be sure, the depicted dead in the photographs and those who are about to be killed could do nothing about their fates. The photographs also testify that even in such situations, even under exceptional duress such as the Nazi tyranny, there may be people who can choose and can act against all odds.

HISTORY AND HOPE: ON THE HUMAN CAPACITY TO ACT

Reacting to the photographs and through them to the experiences emblematically captured in the name "Birkenau," Richter's *Birkenau* is hardly an attempt to artistically *re*present the Holocaust, to paint a work that would offer a pictorial synecdoche to the horrendous realities of a political system that created the concentration camp. Viewing the cycle as an effort to capture Auschwitz "once and for all," as some of Richter's harshest critics have, is at best an astoundingly narrow reading of the work and its genealogy.[54] After initially trying to create photo paintings in July 2014, Richter decided to take a distinctively different path in August and began covering the surfaces with paint: brown, gray, and black. And a few days later, he added layers of red and green and finally more gray and black.[55]

Gerhard Richter, *Birkenau*

By rejecting one of his most characteristic modes of addressing history—the photo painting—Richter has indicated that in regard to the Holocaust he sees no possibility for himself to portray in any form events that defy *re*presentation, that no art can create a symbolic image that would give us the illusion of experiencing what had occurred in the camps. He thus abandoned the figurative form with which he experimented in the first stages of *Birkenau* and has suggested that for him the only path for an artistic reaction to the photographs is to offer a visual meditation in the abstract. *Birkenau* draws our attention through its title to the concrete realities of the concentration camps but also, crucially, takes on the formal and conceptual aspect of the *Sonderkommando* photographs, the cadence of the original photographic cycle— one, two, three, four. Richter's four paintings carry forward, with the same pictorial meter, the thought that emblematically arises from the photographs.[56]

Sounding the rhythm of the photographs, *Birkenau* considers and invites us to reflect on the human capacity to do something, anything at all, when confronted with circumstances that seem to suggest we can do nothing at all. *Birkenau* is a pictorial score, in the abstract, a rich and dynamic chromatic adaptation of one of the photographs' most unsettling messages: even as we face hell on earth, even as we think (as we often do) that there is no possibility for us to act, choice and action are still possible. Richter states that the photographs are "a

Gerhard Richter, *Birkenau*

testifying message in a bottle" (*eine Zeugnis ablegende Flaschenpost*), "already a form," and "*we will give it* [the photographs in their unique form] *other forms* in order to further mediate its content. It will not function otherwise."[57]

Having painted *Birkenau* in his own, chosen form, Richter modeled one of the primary purposes of art: its capacity to serve as a message, to mediate not only content but also our ability, in principle, to actively engage with any given human circumstance. By suggesting that Richter "models" to others, I don't mean that he presents

Gerhard Richter, *Birkenau*

himself or his work as an icon of what things may ultimately, perfectly look like "in a different world"—a notion of the concept of "model" that Richter forcefully rejects.[58] I see his decision to react to the photographs, and then his choice to complete the cycle, as an encouragement to others to consider their own ways of reacting. Facing *Birkenau*, sensing the energy and force with which Richter's hand moved on the canvases, beholders are presented with the task of carrying the message forward: How do we react to what we see and sense? What forms will our reactions take?

Gerhard Richter, *Birkenau*

Richter suggested that the *Sonderkommando* photographs are "a document and a memento" demonstrating that what drives us is "the desire to do something and to fight back against misery, against our cruelty and malice. We are not just evil."[59] Notice that in speaking of the photographs and their import, Richter shifts from the first-person singular to the first-person plural: considering this document, it is *we* who may reflect, may recognize that humans are not just evil but have the capacity to resist, to fight back. His decades-long thinking regarding the daunting question of how to approach the past and, more specifically, how to address the Holocaust in his work, and its result in the form of the *Birkenau* cycle, are thus closely akin, in my view, to Hannah Arendt's philosophical exploration of the human capacity to take meaningful political and ethical action. Having witnessed firsthand that so many Germans had chosen to believe that they had no ability to act at all, having seen how many people in other totalitarian regimes of her era had followed suit, Arendt conceives of humans as creatures of her concept of "natality": Every birth of a human being brings about a new beginning; it is the onset—regardless of its scope—of novelty in the world.

Visitors to Gerhard Richter, *Birkenau*

Our only way to survive and thrive in the world is to enter the realm of action in concert with others: "The miracle that saves the world, the realm of human affairs, from its normal, 'natural' ruin is ultimately the fact of natality, in which the faculty of action is ontologically rooted. It is, in other words, the birth of new men and the new beginning, the action they are capable of by virtue of being born. Only the full experience of this capacity can bestow upon human affairs faith and hope."[60] We can act in many ways. For Arendt, the most important actions are political and take place in the public sphere of the polis. Yet acting under circumstances that seem to undo the very idea of natality and action, for example, in a Nazi concentration camp, can also be pressing the shutter of a camera to record unspeakable crimes. This one-two-three-four reenacts, Richter's *Birkenau* invites us to acknowledge, the wonder of the new beginning inherent in our birth and, more explicitly, our capacity to act.[61]

Arendt's hope is a close relative of Richter's notion of hope. Richter told Gregorio Magnani in 1989 that he could not paint the loss of hope that existed in the concentration camps. Completed some fifteen years after this interview, *Birkenau* acknowledges the ruin (in Arendt's sense) that our civilization often resembles, but it also points to the miracle she suggests: those individuals who smuggled a camera into the camp and took the four images. Arendt would have agreed with Richter's comment regarding his *Birkenau* that "we are not just evil" since she consistently emphasized the faculty of action as something that characterizes the human condition and as precisely what allows us to speak of hope. Nothing changes the fact that "the unexpected can be expected" of humans. We can never release ourselves from our ability to act or "to perform what is infinitely improbable."[62] The photographs are exactly this: an expression of the startling human capacity to do the infinitely improbable.

From this perspective, it seems clear what had been missing in Richter's earlier, abandoned attempts to deal with the Holocaust in his art. The images he considered on both occasions—the exhibition with Konrad Lueg and the design of the Reichstag's entrance hall—were taken by English and American military photographers while liberating the concentration camps at Bergen-Belsen, Buchenwald, and Theresienstadt. They were thus, overwhelmingly, a document of

the crimes.[63] While we need such images to remember the victims and demand accountability for what has been done, there is very little hope to be discerned in them. The *Sonderkommando* photographs are decisively different in this regard. Taken by the victims and testifying to what can still be done under the most unimaginable circumstances, they allow us to discover, even in one of history's darkest moments, a distant, flickering glimmer of hope.

Reflecting on the place of hope in our time, Richard Rorty reminds us that it was the Romantics and their inheritors who transformed the discipline of historiography from merely chronicling events into a genre: the historical narrative. In the course of the nineteenth century, writing history became the domain in which we turn the endless jumble of historical events into a story of transformation through human action and thus into "the source of human hope."[64] Engaging the past in his paintings and in various statements and interviews, Richter similarly explores history as a source of hope. Art is "the highest form of hope," he writes in the catalogue for *documenta 7* (1982), because it is there that we glimpse "that which has never been seen before and is not visible."[65] Recent history often fills us with terror, Richter notes elsewhere. Reacting to it by creating figurative or abstract art means also wrestling hope from history:

> Crime fills the world, so absolutely that we could go insane out of sheer despair. . . . Our horror, which we feel every time we succumb or are forced to succumb to the perception of atrocity . . . [,] feeds not only on the fear that it might affect ourselves but on the certainty that the same murderous cruelty operates and lies ready to act within every one of us. I just wanted to put it on record that I perceive our only hope—or our one great hope—as residing in art. We must be resolute enough in promoting it.—I was interrupted just as I was detecting something like hope in the very realization that this cruelty is present in everyone—as if this very fact could be the starting-point of betterment, a key to the possibility of doing something.[66]

Hope resides in history and then in art because both display the role people play in shaping the realities they inhabit. For example, *Uncle Rudi*, *Aunt Marianne*, and *Mr. Heyde* all intimate in their dark

chromatics that all is not as it seems. By blurring the faces of Rudi and Heyde, Richter presents us with the possibility that "murderous cruelty" is much more widespread than is evident in clear cases such as Nazi prison-camp guards. He encourages us to look beneath the surface. By blurring the subjects' faces, these artworks show us their true faces. In such ways, art prompts us to think, debate, and possibly to mitigate despair, horror, and cruelty by taking other kinds of action.

Our recognition of cruelty when we are presented with its realities in an artwork may lead us to take the first step toward what Richter aptly calls "betterment." Making cruelty "accessible," confronting us with its reality, is linked to "doing something," to trying to ensure that the possible reasons for cruelty and then cruelty itself become matters of the past. In a 1986 conversation with Buchloh, Richter ties art to this very possibility. When the critic asks him to consider art's capacity to liquidate "a false bourgeois cultural inheritance," Richter replies that "liquidation" alone hardly describes what an artwork may achieve: "Above all, art does more than destroy. It produces something, a different image,"[67] a rather vague way to describe the kinds of alternatives art may suggest or hint at. Highly suspicious of any sort of ideology, Richter remains deliberately vague. But what remains crucial in this and many similar statements is his belief—expressed in his artworks themselves—in what Arendt calls "natality": the possibility of beginning something new, of moving beyond the despair, horror, and cruelty of the past by doing something, which certainly describes the act of taking photographs and sharing them with an ignorant and indifferent world, as did the *Sonderkommando* in Birkenau. It may also mean writing books such as Didi-Huberman's or drawing the attention of many more through the creation of four abstract paintings. It is in this sense that I share Paul Rabinow's succinct characterization of the "Kairos" of Richter's work as "the relationship of modernism to modernity as they became historical."[68] Faced by *modern* human-made catastrophes such as the murder of European Jewry, *modernism* as the ideology of radical untamed art may very well remain attuned to human pain, may very well offer hope, by the sheer fact that it is a mode of doing. Richter is and remains "unconsoled," as Rabinow suggests, since nothing art does would undo any of the devastation implied in the name "Birkenau." But

being unconsoled doesn't necessarily mean nihilistic, and, ultimately, narcissistic hopelessness.[69] Creating art that testifies to Richter's unwillingness to be consoled is a form of resistance to the modern political forces that made Birkenau possible and thus is an expression of hope.

EXPANDING THE MUSICAL SCORE

Richter's search for a "suitable form" for reacting to the *Sonderkommando* photographs yielded the four canvases of *Birkenau*, as we have seen. He was finally able to express in color and movement what he could not express in words. Once the work was completed, questions remained: How might these paintings take their message in a bottle to those who had never heard of the photographs? How might the paintings elicit the kinds of thoughts I had during and after visiting the exhibition in the beholder who has no access to the range of references mentioned here? The answer lies first in Richter's decision to create the digital versions of the original paintings (designated 937 B in the *Catalogue Raisonné* [CR]). It also lies in his choice to display the paintings in various European museums and in the Reichstag before deciding where they would ultimately hang as part of a museum's permanent collection. Furthermore, starting with the 2016 exhibition *Gerhard Richter: Birkenau* in the Frieder Burda Museum in Baden-Baden, *Birkenau* went on display accompanied by auxiliary materials that were not part of the initial Dresden exhibition that presented the origin of the work.[70] If *Birkenau* was the original pictorial score, then the digital reproductions and, later, the display of *Birkenau* with those materials to which we now turn expanded it substantially so that we can further reflect on its multiple meanings.

The first step in expanding the "musical score" was creation of the four digital reproductions of the oil paintings and splitting each into four symmetrical sections. This continued the dialogue between the four original photographs and the four paintings and incorporated the score's rhythm, as each of the digital reproductions is implicitly divided into the same rhythm—one, two, three, four. The meanings of the photographs and the paintings, and now the photographs of the paintings, Richter seems to be telling us, can and should be the subject of an ever-expanding rhythm, of an ongoing process of remembrance

and contemplation. Richter himself emphasized this line of thought by further expanding the score with his 2015 book, *Birkenau*. This work presents ninety-three digital images that are detail fragments of the four paintings. Highlighting countless elements of the original work that are bound to go unnoticed when one sees the paintings for the first time, the book encourages us to look, and look again, and then to stop and take more time to fully absorb the possible meanings of the paintings and the events they invoke.

With the book version of *Birkenau*, Richter continues a distinct creative feature of his recent work in which an artwork becomes a departure point for more thinking and, possibly, consideration of political and ethical issues. In his 2006 book, *War Cut*, for example, he brought together 216 close-up photographs of elements from his

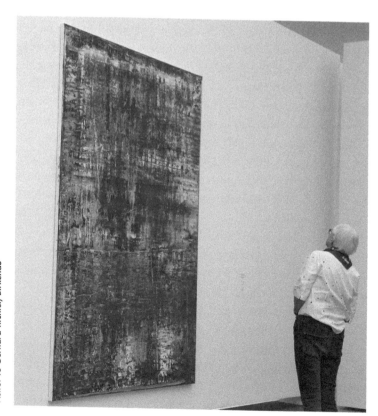

Visitor to Gerhard Richter, Birkenau

Abstraktes Bild (*Abstract Painting*; CR 648-2) with 155 texts taken from the *Frankfurter Allgemeine Zeitung* of March 20 and 21, 2003, that reported on the beginning of the Iraq War. The fragments of the paintings, combined with the newspaper reports from a highly contentious war, turned the book into what I called earlier a space of and for reflection—in this case, on the causes, course, and wider implications of war.

In the spring 2016 exhibition at the Frieder Burda Museum, Richter brought the process contained in the book version of *Birkenau* and in *War Cut* to the museum walls. He presented in the central exhibition hall the painting cycle *Birkenau*, the digital reproductions, enlargements of the four *Sonderkommando* photographs, and the ninety-three fragments presented in the book *Birkenau*. In the adjacent hall, he displayed all his previous, abandoned attempts to address the Holocaust in his art (e.g., the 1967 *Atlas* sheets 16–21). Tellingly, he also displayed panels from *War Cut*. Walking the exhibition halls in Baden-Baden, I could see how carefully designed museum halls enable open-ended thought, how poetic thinking emerges in the public sphere. If the four paintings of the *Birkenau* cycle and the split-in-four digital reproductions urged us to look carefully, to take notice, to both remember and reflect—alone or with others—on the

Visitor to Gerhard Richter, *Birkenau*

meanings captured in the historical photographs, then the ninety-three fragments and the auxiliary materials urge us to slow down and spend even more time reflecting on the phenomenon the paintings so richly invoke.

Birkenau's expanding score continued in the Baden-Baden exhibition in another, highly revealing form. During a 2014 exhibition in the Fondation Beyeler, Switzerland, Gerhard Richter encountered Ivan Lefkovits, a Czech Holocaust survivor who immigrated to Switzerland after the war. Over the previous decade, Lefkovits had met with other Holocaust survivors living in Switzerland; the participants recounted their traumatic stories of persecution and survival and shared with those who went through similar experiences how they eventually rebuilt their lives after the war. These gatherings yielded a series of fifteen small booklets, each written by a survivor and each recounting their torments during the Holocaust, their endurance, and their experience of living with the traumas of the past. After a short conversation with Lefkovits, Richter offered to create a design for the fifteen booklets, including the use of elements from the four *Birkenau* paintings for their covers.[71] The booklets were published together in 2016 in one box, titled *"Mit meiner Vergangenheit lebe ich"—Memoiren von Holocaust-Überlebenden* ("I live with my memories"—Testimonies of Holocaust survivors), and were

Visitors to Gerhard Richter, *Birkenau*

presented at the opening of the Baden-Baden exhibition in February 2016. The box and the brochures were exhibited in the same hall as the four *Sonderkommando* photographs, the original *Birkenau* paintings, and the four digital reproductions of the canvases.

With their abundance of color and display of Richter's artistic dynamism (one can clearly observe the movement of his squeegee and brush), the images on the booklet covers unfold the imposing richness of *Birkenau*. While many reviews of the *Birkenau* cycle noted the extensive use of somber colors in the paintings, the booklets' covers bring out the works' actual, enormously rich chromatic range.[72] The paintings are filled with every shade of black and gray, but the covers show how these colors interact with and at times morph into delicate shades of pink, violet, green, yellow, and brown, which provide energy. The snippets from *Birkenau*—and the colored ribbons Richter chose as bookmarks for the booklets—reflect the fullness of the life stories contained in the booklets themselves.

The Nazi ideology had lumped together all Jews as identical specimens of a subhuman race and thus the targets of extermination. As the photographs chillingly show, the Nazis wished to turn their victims into a faceless mass—into, literally, a pile of bodies—and wipe any trace of their individuality from the face of the earth. But in the fifteen succinct

General view of Gerhard Richter, Birkenau

Memoiren von Holocaust-Überlebenden

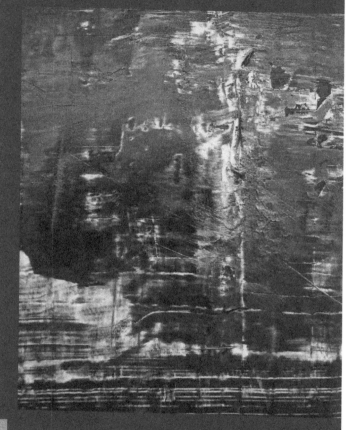

«MIT MEINER VERGANGENHEIT LEBE ICH»

Herausgegeben von Ivan Lefkovits
Mit 15 Bildern von Gerhard Richter

Jüdischer Verlag im Suhrkamp Verlag

accounts in the booklets we find brief, distinctly nuanced accounts of individuality, of the many shapes the will and the capacity to resist can take, and of the ways different individuals can hold on to life under unimaginable circumstances. We also discover how the Holocaust survivors found within themselves the will and ability to return to life, establish families, pursue professions, and finally give an account of their experiences.

Richter's booklet design reacts to the diversity of the life stories and their inversion of the Nazi ideology. Although some elements on the covers are similar, they are all distinct, unique. Names such as "Holocaust," "Shoah," "Auschwitz," and "Birkenau" often obscure the individuality of people and their fates, the distinctiveness of a single life. But instead of the facelessness and sameness that so often mute the complexity of the Holocaust, the booklets and their covers bring out the inimitability of each person.

THINKING AND EVIL

There is nothing naïve in Gerhard Richter's poetic exploration of hope in regard to history, nothing gullible in his creative adaptation of the four notes struck by the *Sonderkommando* photographs in *Birkenau* or in his decision to present this work with auxiliary materials such as the original photographs and the booklets. Hope, we have seen, is not blind confidence in a future promised to us. It has nothing to do with the desire for Utopia—a notion Richter has always been suspicious of. Hope instead emerges in Richter's work and writing as the fragile feeling we may sense when we consider history not only as an account of our disastrous past but also as the vast array of narratives and images through which we understand our capacity—at times nothing more than a scant series of notes: one, two, three, four—to shape our individual and communal circumstances. In their 2004 interview, Buchloh asks Richter, with a good dose of provocative irony, "What role does art play with respect to evil?" He then asks, with a certain sarcasm, as if he is unsure of the answer, "[Is art] a governess for our improvement?" Richter replies to the provocation simply: "That too, naturally, and for our enlightenment, and much more."[73]

Hope also emerges in Richter's work, I suggest, when we consider art's capacity to engender uninhibited thinking. By suggesting that art is linked to thinking in Richter's work, I do not mean that painting in general and Richter's work in particular are the visual presentation of ideas, concepts, or convictions.[74] As previously mentioned, he tells Robert Storr in 2001: "Art can help us to think something that goes beyond this senseless existence. That's something art can do."[75] By capturing the artist's thoughts in an image that invites our reaction, the artwork prompts thought. We have seen how thinking informed various facets of the creative process that finally led to *Birkenau*. We have also observed the considerations involved in Richter's curatorial decisions once the painting cycle itself was completed and then in subsequent, related works (the digital reproductions, the book *Birkenau*). I conclude by expanding on the ways a work such as *Birkenau* affords thinking performed by the beholder and in what sense thinking is related to the realm of ethics and, specifically, to the confrontation of evil.

To consider Richter's thinking that led to *Birkenau*, and its relationship to evil, I return to Hannah Arendt. She became interested in the concept of evil, particularly what she saw as its embodiment in the German concentration camp Auschwitz-Birkenau, while attending the Eichmann and Frankfurt Auschwitz trials.[76] Her observation of the trials had left her wondering how such an apparently ordinary individual as Eichmann could commit unspeakable crimes, such as facilitating the murder of numerous Jews. We have seen that Arendt proposes in her last, unfinished book, *The Life of the Mind*, that not stupidity but *thoughtlessness* led Eichmann to become a bureaucratic monster. She suggested that thinking, our capacity to halt life's gushing flow and contemplate what we experience—without a set telos and without focusing on utility—may be "among the conditions that make men abstain from evil-doing" and that this ability to stop and think may, in fact, condition us against evil.[77]

Thinking for Arendt is not confined to the establishment of epistemological data. It instead allows us to go "beyond the limitations of knowledge, to do more with this ability than use it as an instrument for knowing and doing."[78] Recalling Richard Rorty's ironic questioning of "knowingness" presented in the Prologue, Arendt views thinking

as our ability to go beyond the limitations of established, disciplinary knowledge by imaginatively creating connections between elements of our experience that had never been related to each other before. For Arendt as for Rorty, the key vehicle of thinking as the inventive creation of such connections is the metaphor.[79] Thinking draws on the visible to get to—through newly created metaphors—invisible, or undiscovered, concepts. Metaphors allow us to name what we cannot see; thus, thinking as Arendt conceives of it is metaphorical.[80] Metaphor and, by extension, figurative language give us access to what we call truth, which doesn't mark any supposed correspondence between our verbal utterances and the realities of the world. Truth describes the active relationship we have with our changing, contingent circumstances—a relationship shaped by our capacity to create metaphors, narratives, images, and the like. We first establish this relationship through metaphors, through *dichten*, "poeticizing."[81] Metaphor is "the greatest gift language could bestow on thinking and hence on philosophy"; it is the verbal creation that bridges "the abyss between inward and invisible mental activities and the world of appearances." The origin of the metaphor itself "is poetic rather than philosophical."[82] But, like philosophy, its effect is the establishment of truth, the disclosure of what *is* in relation to *us*. Quoting the art historian Ernest Fenollosa, Arendt states: "Metaphor is . . . the very substance of poetry"; without it, "there would have been no bridge whereby to cross from the minor truth of the seen to the major truth of the unseen."[83]

The metaphor is essential for understanding the power of Richter's poetic thinking. Gerhard Richter's *Uncle Rudi, Aunt Marianne, Mr. Heyde,* and *Birkenau* are, among many other things, pictorial metaphors. Observing the blurred facial features of the young man in *Uncle Rudi*, we wonder, make associations and connections, and consider contexts; we think. What we *can* see in the image hanging on the wall prompts us to think about what we *can't* see. At least some of us will see this image and our thinking will expand outward from the "minor truth" of this one particular soldier, the known family member of the painter Gerhard Richter, to the "major truth" of the many young men who, like Richter's uncle, became part of Nazi Germany's killing machinery. Taking on the rhythm of the *Sonderkommando* photographs,

Richter's *Birkenau* is metaphoric in a different sense. Unlike the figurative *Uncle Rudi, Aunt Marianne*, and *Mr. Heyde*, this work engenders thought as an abstract painting. "Abstract," we have seen, denotes the tension between the concrete and the conceptual—what allows us to consider not only the particular of the concentration camp but also a broader array of cases in which a tyrannical polity turns people into shades and the way the victims and those surrounding them react to this program. While the title *Birkenau* conditions our mental activity to remember the concentration camp Auschwitz-Birkenau, the abstract paintings suggest that we should not stop there but think with the paintings in more general terms.

Whether figurative or abstract, Richter's pictorial metaphors are wide open in their scope and meanings. None of his works suggest a clear and singular meaning or offer some kind of clearly packaged "teaching," not even when they touch, as does *War Cut*, on the topic of war.[84] As we have seen throughout this discussion, what Richter's work offers when it alludes to history is a space for and of "thinking without a banister." Reflecting on his favorite John Cage quotation, from "Lecture on Nothing"—"I have nothing to say and I am saying it"—Richter notes that "we can't know or say very much at all, in a very classical philosophical sense: 'I know that I don't know anything.'"[85]

Affording us space and time for free reflection, Richter's unconstrained pictorial metaphors offer orientation without striving to constrain our reality, to direct us with demarcated concepts, or to push us toward a finite goal. According to Arendt, "All philosophical terms are metaphors, frozen analogies, as it were, whose true meaning discloses itself when we dissolve the term into the original context, which must have been vividly in the mind of the first philosopher to use it."[86] She suggests that Martin Heidegger was right when he called poetry and thinking close neighbors: "Analogies, metaphors, and emblems are the threads by which the mind holds on to the world even when, absentmindedly, it has lost direct contact with it, and they guarantee the unity of human experience. Moreover, in the thinking process itself they serve as models to give us our bearings lest we stagger blindly among experiences that our bodily senses with their relative certainty of knowledge cannot guide us through."[87] Gerhard Richter's work similarly offers such

analogies and threads through which we gain access to and reflect on the human experience, but without limiting our thoughts, prescribing judgments, or following any kind of metaphysical ethics. In his review of recent books about Richter's *Birkenau*, in which he also considers the cycle itself, art critic Hanno Rauterberg notes that the abstract cycle in its indistinct openness allows "anyone to see what he wants."[88] Since the paintings are abstract and open to interpretation, Birkenau in its grim reality "becomes what it should never be: a myth." Understandable as the worry may be, Rauterberg misses the core effect of Richter's decision to use the abstract form. A figurative work tends to limit the scope of our thoughts to whatever it displays. In this case it would be the important yet confined realm of remembering the Holocaust. A figurative work would have illustrated, illuminated, informed us about events that are captured in what we see, arrested in time. Invoked as an abstract work of art in dialogue with the *Sonderkommando* photographs, the historical Auschwitz-Birkenau presents itself as an event that escapes a clear image. Precisely because the paintings that bear the name *Birkenau* are abstract, they call on us to go beyond recognizing historical details, to develop our own reaction, for example, to think, and then think again, about the meaning of what the *Sonderkommando* did when they took those four photographs. One crucial meaning, I believe, is that even under the unthinkable conditions of Auschwitz-Birkenau, some form of action was still possible. That realization may lead us to admit that our capacity to act is much broader than we often tend to believe. Hanging four reproductions of *Birkenau* on the north wall of the Reichstag's entrance hall opposite Richter's panels *Black Red Gold*, Richter invites us to remember: "Anyone wishing to enter this site of German democracy, must pass this way—between Birkenau and the national flag," said Norbert Lammert, president of the German parliament when *Birkenau* was first presented there in September 2017.[89] This work also invites us to reflect on our abilities as political actors, reminding us, in the abstract, of what the Birkenau inmates were capable of doing. Parliamentarians entering the Reichstag, but also everyone else, face the questions, "What are you willing to do?" "How would you act?"

Arendt's concept of thinking is also informative in this regard. When we think, we are (metaphorically speaking) stepping outside

the physical and temporal spheres we usually inhabit. Thinking is the very activity by which we question the information gathered by our senses and our established, inherited worldview. If Gerhard Richter's work is "philosophical," as Robert Storr and Georges Didi-Huberman, among others, suggest, then it is so in Arendt's sense.[90] Rather than offer a thesis or an argument, it is philosophical in its effect. Richter puts it succinctly: "Painting is a different mode of thinking" (*Malen ist ja eine andere Form des Denkens*).[91] Embodying his thoughts in the form of paintings, his art encourages in its viewers the unconstrained activity Arendt calls thinking. As we observed in the creative process that yielded *Birkenau*, Richter proceeds as a poetic thinker: reading, reflecting, discussing, experimenting with and abandoning several attempts, he finds his own way to address the Holocaust in his art. In its completed form and various iterations, *Birkenau* offers, both spatially (in paintings and digital reproductions) and temporally (for the duration of our stay in the gallery and once we leave the exhibition behind), an opportunity for further thought. Facing *Birkenau*, or Richter's design for the booklet covers, we are indeed in the spatiotemporal domain of thinking. Works such as *Birkenau* afford us the opportunity of stepping outside the realm of our daily, mundane beliefs and going beyond our ready-made judgments to dwell for a while in the domain of thought. And as we move from one painting to the next, we have the opportunity to look and then look again, to doubt our traditional concepts and ideas, and to form our own opinions without resorting to the ideas of others. Both in its figurative and abstract form, Richter's work, when it touches history, reacts and signals resistance to tyranny both in thought and in political practice. It offers us multiple opportunities for what Arendt calls "the silent intercourse (in which we examine what we say and what we do)." When we observe and reflect on his pictorial metaphors, when we visit the visual spaces Richter has created through curatorial choices, we know that thinking is not confined by rigor and system or to the production of knowledge but is the cultivation of "the ability to tell right from wrong, beautiful from ugly" and that it thus "may prevent catastrophes . . . when the chips are down."[92]

Thinking Sculptures

On Dani Karavan

A DIFFERENT GATE

How do sculptures think? How do artists capture their thoughts in their materials of choice? How do sculptures, once they are present in a landscape or a cityscape, participate in what I have called, with Michael Oakeshott, the conversation of humankind? And, as they do so, how do they touch on politics and ethics? I thought about these questions when I traveled in the fall of 2015 to Tel Aviv, and later to multiple locations in Germany, to explore the work of Dani Karavan and to meet him. My decision to turn to Dani Karavan was not accidental. For decades, I had admired the modernist minimalism of his work and was fascinated, and at times puzzled, by his sculptures' evocative titles. As with the works of Celan, Pagis, and Richter, I was drawn to Karavan's oeuvre because of its keen attention to history, memory, politics, and ethics. My interest in his works concerned their ability to shape the public realm. In *The Human Condition* and elsewhere, Hannah Arendt observed that the modern age, which gave birth to totalitarianism, is characterized by "the loss of the world," by the curtailing and, at times, elimination of the public realm ("the space of appearance"), those spaces where we may "come together in

the manner of speech and action."[1] She tied this decline of the public realm to people's increasing tendency to retreat into the private world of introspection or consumption and to the prevalent and blind pursuit of economic advantage. I suspected that Karavan's work, which he calls "environmental sculpture," reflects and is meant to counter this very concern.

Karavan's poetic consideration of these themes is the result of a life marked by momentous historical events. Born in 1930 in Tel Aviv in Mandatory Palestine, he grew up at a time when mainstream Zionism still strove to combine the aspiration for Jewish self-determination with secular, universalist, and humanistic values. Karavan was a child when, between 1936 and 1939, the vision of peaceful Palestinian-Jewish cohabitation suffered one of its most severe setbacks as a result of the Arab Revolt. In 1939, when the uprising finally subsided and Palestinian Arabs and Jews mourned their dead, the Second World War erupted. Many members of Karavan's extended family perished during the Holocaust.

The son of Tel Aviv's municipal landscape architect, Avraham Karavan (1902–68), Dani Karavan inherited his father's wish to design public spaces marked equally by purpose and natural beauty. Both also shared the desire to make natural elements, such as native trees, an integral part of the modern city to counter the tendency for its inhabitants to feel alienated. Raised in the Zionist-Socialist youth movement, Hashomer Ha-tzair, Dani Karavan has remained committed to the idea of a human community based on social justice and has demonstrated an almost messianic longing for peace.

Karavan's art echoes the modernism of Celan, Pagis, and Richter. He was twenty years old when he enthusiastically watched Martha Graham dance on a stage designed by Isamu Noguchi at the Habima Theater in Tel Aviv.[2] Later, while studying art in Florence (1956–57) with the painter Giovanni Colacicchi, he discovered the Renaissance frescoes of Piero della Francesca and others. Art, he realized, should not be confined to the private palaces of the rich and mighty or to highbrow museums. Art can and should be public and accessible for all. After his return from Italy, Karavan befriended Noguchi, who also designed the Israel Museum's Billy Rose Art Garden. Like no other modernist sculptor, Noguchi

embodied the pioneering thought of Constantin Brancusi, who believed that "architecture is inhabited sculpture." These words would succinctly capture Karavan's aesthetics in the decades to come.[3]

With Brancusi's words in mind, and with an interest in how Karavan's thoughts take shape in his creations, I decided to focus on some of his most celebrated art in Israel and Germany, art that grapples with memory, history, and notions of judgment and justice. Eager to understand the evolution of Karavan's poetic thinking, I turned first to one of his earliest works: the installations in the Court of Justice in Tel Aviv. Karavan won the commission for placing sculptures in this new building in 1961, when he was thirty-one years old and working mostly as a set designer. Although he had little experience in creating permanent public art at the time, more than fifty years later I found his early attempt to grapple with questions of moral conduct and judgment both beautiful and thought provoking.[4]

Karavan approached the challenge of creating captivating art in the bustling space of the urban courthouse by constructing a variety of interlinked objects in prominent locations throughout the building and its courtyard, beginning, right at the entrance, with *The City Gate*.

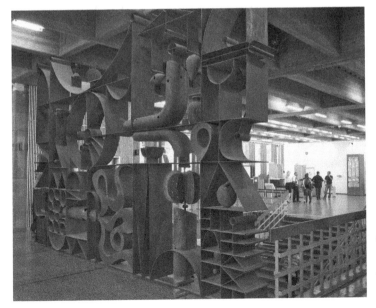

Dani Karavan, *The City Gate*

Airy and transparent, this dynamic structure is filled with playful and abstract forms that evoke symbols of fate and judgment: circles allude to the zodiac, the ever-spinning wheel of fortune; elements of scales remind us of the scales of justice; snakelike shapes bring to mind the biblical myth of Adam and Eve and their surrender to the temptation of moral transgression. These forms are stacked next to and on top of one another, separated by thin horizontal and vertical bands of metal, bringing to mind a series of moving boxes, their sides almost effaced, their contents portentous. They seem to explode with energy.

Walking around *The City Gate*, I was struck by its transparency, how it gives people on both sides the chance to see each other through seemingly familiar metaphors such as the scales of justice. Rather than simply encounter a familiar figure such as the scale or the snake, we are compelled to look through the symbols to the realities on the other side of the gate. By looking through these emblematic images, we are urged to reconsider our inherited ideas and convictions regarding good and evil, right and wrong, and to become aware of the people on the other side of these ideas. Justice emerges here from the ongoing process of taking notice of each other by seeing through myths and beliefs, a tricky endeavor, as our sight can be obscured by those very forms and ideas.

Standing before and looking through this piece of art, I grasped for the first time the sheer variety of ways in which poetic thinking can be expressed. A poem presents a poet's thoughts, of course, and as we have seen, it engenders further thinking through the medium of words on the page. A painting creates the possibility for a similar experience, via canvas and paint, thus prompting our engagement through image rather than word. If presented in a gallery or a museum, it extends its ability to induce poetic thinking to all those who visit those spaces. Karavan's work, in contrast, captures thought in at least three other ways: first, by use of a broad array of materials; second, by its site-specific placement; and third, by creation of a public space of and for reflection. While the printed page and the painted canvas are spaces, of a sort, a sculpture is an actual space, a three-dimensional expression of the artist's thought and the embodiment of the artwork's capacity to allow us as individuals

and as a community to stop, step out of our habitual modes of existence, and gain a different perspective on our own place in the world.

The City Gate offers this embodied possibility for poetic thinking both in its physical structure and in its historical reference. In the biblical tradition, judges and prophets stood at the city gate, adjudicating civil and communal cases, reprimanding the citizens and the rulers of the day for their transgressions, and also giving their listeners an opportunity to publicly reflect, debate, and exercise judgment: "Judges and officers shalt thou make thee in all thy gates, which the Lord thy God giveth thee, throughout thy tribes: and they shall judge the people with just judgment" (Deuteronomy 16:18). In that liminal space between the polis and an indeterminate periphery, between the inside and the outside, the judges and the prophets presented their verdicts regarding past offenses and offered their moral injunctions for the future. Located at the very entrance to the Court of Justice, *The City Gate* captures what is lasting and worth preserving in this image of biblical authority at the city's edge: the idea that legal arbitration and the individual and communal consideration of moral issues should not be a matter for a distant, bureaucratic system; rather, they should be the centerpieces of public life.

"JUSTICE JUSTICE"

As I stood in front of *The City Gate*, I was reminded of Franz Kafka's *The Trial*, where Kafka prophetically captured the reality of modern tyrannies in which legal deliberation is exercised by a sweeping, domineering authority. He presented the fate of K.—a modern everyman, a clerk in a world of clerks. Unspecified allegations are raised against K., and although he seeks to clarify them, he never discovers what wrongs he has allegedly committed. The legal authorities who pursue the charges against him and the political order to which they belong remain elusive throughout *The Trial*, yet the faceless sovereign of Kafka's nightmarish tale has power over K.'s life and death. Seeking to clear his name, K. cannot approach the judges and officers "in all thy gates," cannot rely on any of the traditional institutions that have shaped Western civilization since the introduction of biblical law. The lawyers and their courts, the detectives and executioners, seem to

belong to an unintelligible order. Upon hearing the parable "Before the Law," K. realizes that he lives in a world where the law is beyond reach, nothing but a maddening desire.

The Trial ends when two executioners bring K. to a desolate stone quarry at the outskirts of the city. The setting is telling: K.'s end will come in that liminal space between the polis—the realm of politics—and the lawless wilderness that lies beyond. Just before the executioners carry out K.'s death sentence, the narrator tells us that K.'s gaze falls on the top story of the last city house adjoining the quarry:

> Like a light flicking on, the casement of the window flew open, a human figure, faint and insubstantial at that distance and height, leaned far out abruptly, and stretched both arms out. . . . Who was it? A friend? A good person? Someone who cared? Someone who wanted to help? Was it just one person? Was it everyone? Was there still help? . . . Where was the judge he'd never seen? Where was the high court he'd never reached?[5]

No one reacts to K.'s hopes. He is executed, Kafka's narrator tells us, "like a dog!" The novel thus ends by juxtaposing the victim of an inexorable legal and political system and those who witness, from the comfort of their homes, a killing that occurs right outside their window—yet seemingly beyond reach. Written in 1915, *The Trial* emerged at the cusp of a new modern political order in which countless humans would be stripped by a tyrannical political system of all the rights of citizenship, becoming shades, as Dan Pagis puts it in "Testimony." The novel portrays a trajectory that has become a reality in the totalitarian regimes of our era. Dani Karavan's *The City Gate* presents a diametrically opposed image to the dystopian scenario of *The Trial*: one cannot enter the Tel Aviv courthouse without looking through the various symbols of judgment and justice at those who are on the other side of this work. *The City Gate* stands as a literal yet poetic point of entrance, offering Karavan's sense of the law's ideal aim: to defend the right of all people to a transparent legal procedure, a right located at the center of civic life.

Walking past the wide sculpture, we encounter Karavan's thirty-five reliefs, distributed throughout the building, which spell out in more tangible terms the principles with which our legal order should be

infused—the guidelines that will prevent a tyrannical order from depriving individuals of their rights or, even worse, from creating an entire class of people who are beyond the pale of humanity. Inspired by the art of Mesopotamia—its use of symbolic figures and writing in public art—as well as by the frescoes of Piero, these artworks mesh potent symbols of action, such as the hand, with the square angles of the Hebrew letters and the straight lines of the modernist exposed cement walls.[6]

Radiating quiet beauty with their clear, unvarnished aesthetics, the reliefs of varied sizes seek to draw our attention to the ideas that should guide not only the lawyers and the judges serving in this courthouse but all the rest of us who come to argue our cases before the law. Each relief presents a full or partial quotation of crucial elements of the Hebrew Law (משפט עברי) or notions of justice from the biblical prophecy books, especially that of Isaiah. These reliefs, such as the one quoting Isaiah 11:6—"The wolf will live with the lamb, the leopard will lie down with the goat"—are all at eye level or just above it. They are purposely rendered unavoidable. Walking the corridors of the building, one may be lost in thought, but the reliefs offer a momentary chance for broader thinking, a brief yet perhaps meaningful opportunity to see one's concerns in relation to some of humanity's most lasting ideas of justice, even in relation to messianic visions of the human future.

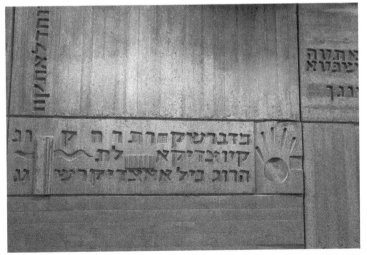

Dani Karavan, concrete relief, Tel Aviv Court of Justice

Like the poetry of Celan and Pagis and the paintings of Richter, Karavan's sculptures offer no prescriptions for how we should achieve justice. Rather, they engage with their sources interpretively, suggesting that the law is not given by a divine sovereign but is the outcome of human ingenuity. One concrete relief, for example, presents a truncated quotation from Deuteronomy 16:20. The biblical passage reads in full: "Follow justice and justice alone, so that you may live and possess the land the Lord your God is giving you." Tellingly, Karavan writes only "Justice justice" (צדק צדק).

By eliding the biblical quotation, Karavan indicates that the law is a matter of interpretation; as we strive for justice, we should no longer rely on the metaphysical idea of a divinity that is directly involved in legal and moral adjudication or on any other set of eternally valid directives. This is the goal of what I earlier called nonmetaphysical ethics when discussing Celan and Pagis—ethics as a relational, evolving, and at times conflicting set of principles. Faced by ethical challenges, the abbreviated quotation suggests that we should not orient ourselves in relation to metaphysical frameworks—for example, the notion implied in Deuteronomy 16:20 of an all-knowing God who instructs all human subjects, granting them life and possessions. Justice instead emerges when we strive to give this abstract concept our own contingent meanings.

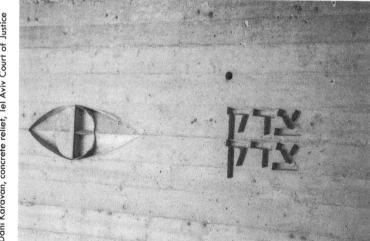

Dani Karavan, concrete relief, Tel Aviv Court of Justice

Karavan's hermeneutic procedure—his decision to present the word "justice" alone, leaving its meaning open for each viewer to determine—accords with art critic Pierre Rastany's characterization of Karavan's work as expressing a philosophical pragmatism in the vein of William James.[7] It is also a potent expression of Richard Rorty's philosophical rejection of metaphysical morality, the belief that we could ever establish an ultimate Justice, with a capital "J," or what Rorty ironically calls a "strictly moral point of view."[8] Karavan did not read James's or Rorty's work, nor did he seek to give their philosophically argued ideas the shape of an artwork. But their philosophical vocabulary allows us to unfold what Karavan's courthouse reliefs embody—to unpack his own, poetic thinking.

I thought of Rorty's doubts with regard to an uppercase Justice when I stepped into the courtyard to see the final element of Karavan's installation: the captivating white concrete shapes of his *Justice the Measuring Line and Righteousness the Plumb Line*. Set in an intimate, twenty-five-by twenty-five-meter public square at the center of the building among some trees and low vegetation, the work comprises various elegant geometric white cement figures: a long bench set on half-moons and triangles, some cubes, a ball, a pillar, and a scroll-like structure onto which Karavan etched a biblical text. As visitors to the Court of Justice enter

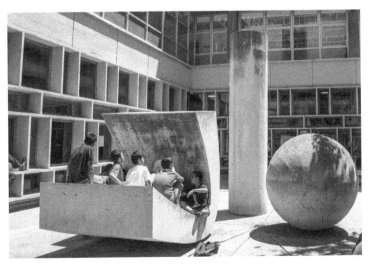

Dani Karavan, *Justice the Measuring Line and Righteousness the Plum Line*

this courtyard to relax, they can sit on the bench or enjoy the shade of the trees. This tranquil resting place also offers them an opportunity to talk, to reflect, or, indeed, as I could see myself while I spent some time there observing a visiting school class, to encounter the law as a human product—something we may touch, feel, and make our own.

The title of this part of the work (קו למשפט ומשקולת לצדקה) comes from Isaiah 28:17: "I will make justice the measuring line and righteousness the plumb line." But here, as we have seen earlier, a divine, distant God is no longer the source of authority concerning questions of justice; no supernatural source serves as the ultimate arbitrator. Once the "I will make" of the biblical verse disappears, the quest for justice becomes a challenge to whoever rests in the welcoming courtyard. The work invites us to consider how we may ensure that justice will be what measures us and that righteousness will be what keeps us straight.

The scroll-like sculpture, some ninety-one centimeters tall, presents excerpts from Exodus 21. This is the beginning of Parashat Mishpatim, the eighteenth portion in the weekly cycle of the Torah reading that is the systematic introduction of Judaic law in the Bible, the very foundation of the Judaic communal order. Karavan's work seems fully aware of Kafka's modernist nightmare of a law that cannot be discerned. Here, in the courthouse's enclosure, the law is instead the source of immediate encounter: it is what shelters us, as individuals and a community. We cannot know if the children taking shelter inside the structure or touching the engraving have any idea of their meaning. Nor can we know if anyone else resting for a while in this majestic little garden would, as I was, be reminded of Kafka's *The Trial*. Anyone who spends some time in this public place, however, will be gently persuaded to remember that the encounter with the law doesn't exclude the experience of refuge and relaxation, that striving for justice or arguing one's case before the court can and should be a human endeavor rather than the anonymous, alienating experience of Kafka's dark tale.

OPENING UP A WORLD

During his four-year work in the Tel Aviv Court of Justice (1963–67) Dani Karavan first created the artistic language with which he would continue to engage with questions of justice, politics, and ethics.

While this early work was set within the framework of a single edifice, many of Karavan's later works involve the creation of an entire *environment*. Beginning with his early masterpiece *Monument to the Negev Brigade* (1963–68), his *environments*, for this is indeed what he would now call his public art, form an artistic whole by bringing together a given topography (a hill, a garden, the banks of a river, or the shores of a lake); natural elements such as sand, trees, and water; modernist architecture and sculpture; and literary elements. Taken together, the constituents of Karavan's environments create a modern *makom* (place).[9] In biblical times, this richly connotative Hebrew noun referred to God himself as well as a sanctified place. In the wake of secularism and modernist art, the notion of *makom* implies an experiential site, a transformative, spiritual space where the artist and the beholder step outside the realm of the mundane, of custom and ordinariness, to gain an existential, political, or ethical perspective on their lives. Karavan's concept of public artwork as creating an environment with such transformative capacity displays a striking affinity with the phenomenological philosophical tradition, most especially with Martin Heidegger's notion of the artwork as a "passage."

For both Heidegger and Karavan, human edifices reshape our natural habitat, thereby offering us a pathway to transform ourselves. Reflecting on the nature of the artwork in "The Origin of the Work of Art," Heidegger turns to a spiritual structure—a Greek temple, which he notes, "portrays nothing," means nothing on its own. It stands in the middle of a rock-cleft valley and, metaphorically speaking, waits for us to make use of it, to make it our own. Upon its completion, the temple gives the space it now inhabits a new and specific shape: the temple "opens up a world." "Standing there [*dastehend*]," it "gives to things their look and to men their outlook on themselves." The artwork thus "set[s] up" a world and "holds open the Open of the world." Whoever designed and built the temple expanded the realm of human experience. Those who view it, enter it, and use it in various ways will also evolve in this process. In Heidegger's poetic words, "By the opening up of a world, all things gain their lingering and hasting, their remoteness and nearness, their scope and limits."[10]

Opening up a world, or giving things their look, the work of art is a transformative event: "In the midst of being as a whole an open place occurs. There is a clearing, a lighting." This clearing, in turn, gives those who choose to actively engage with the work of art the opportunity to make that event their own and to fashion themselves and their various circumstances anew. The artwork "grants and guarantees to us humans *a passage to those beings that we ourselves are not*, and access to the being that we ourselves are."[11]

Karavan's environments, whether embedded in a natural landscape, a building, or the heart of a city, open up a space in which we are at once within a known habitat—a street, a garden, a park—and stepping into a *makom*, an experiential space that affords us an opportunity to view ourselves and our circumstances differently and, thus, potentially to transform ourselves. In our modern era, with its ever-accelerating pace, we usually neglect to stop, reflect on, and meaningfully consider our circumstances. As Hannah Arendt puts it, this often results in what she calls "absence of thinking" and even unimaginable evil. In Karavan's *Environment Made of Natural Materials and Memories* (created for the 1977 *documenta 6* exhibition in Kassel, Germany), for example, the two walls separating the path from the staircase physically impose such a suspension of movement: it is impossible to continue to walk toward the stairs; one has to come to a halt. The work thus creates a spatial and a temporal

Dani Karavan, *Environment Made of Natural Materials and Memories*

gap, an opportunity to consider the work, other people and their use of the environment, the memories the work may invoke, and more.

Karavan's abstract walls and white concrete cubes arranged as a staircase—inserted among the trees and meadows of a city park—also serve as a focal point from which to experience the environment *anew*. Visitors were invited to climb the stairs, which were intentionally built without a banister, and then to sit atop them, think, converse, be. These stairs elevated visitors to a higher position from which they could observe the world and others who remain below them on the ground. A playful inversion of the monotheist tradition with its all-seeing, all-knowing God, in this miniature tower of Babel it is we humans, any one of us, who may take charge. We can decide for ourselves, for example, whether to ascend the stairs, how best to address the danger of falling, and so forth. Karavan told me in our conversation in 2015 that the Kassel authorities initially forbade anyone from using the stairs for safety reasons. Visitors to the *documenta*, however, quickly removed the police's "do not enter" banner and made the work their own.

Martin Heidegger's notion of the artwork as "a passage to those beings that we ourselves are not" is mostly restricted, in his own writing, to the domain of the individual's experience. Some of Karavan's most celebrated artworks, however, tie the idea of the transformative capacity of a sculpture to our communal sphere and thus to politics and ethics.

Dani Karavan, *Ma'alot*

In works such as *Maʾalot* (Cologne, 1980–86), Karavan also unfolds the link between art and our communal life through language, for example, by giving his works potent Hebrew titles. The Hebrew noun *maʾalot* can mean "stairs" or "degrees" (as a unit of measurement), as well as "merit," "value," and "virtue."[12]

Using a warm carpet of red bricks, *Maʾalot* gathers into one topographic frame, one spatial context, the thirteenth-century Gothic Kölner Dom (Cologne Cathedral); the Heinrich-Böll-Platz (Heinrich Böll Plaza, named after a famous post–Second World War German writer); the contemporary Ludwig Museum; the Rhine with its rich, troubled history; and the Cologne train station. The first meaning, "stairs," was evident when I first climbed the striking, serpentine steps that lead from the bank of the Rhine toward the Cologne Cathedral. The contrast between the warmth of the small red bricks of the stairway and the imposing grandeur of the cathedral builds a stimulating tension. In the middle of the path from the Rhine to the cathedral, Karavan placed a 10.8–meter-high stepped sculpture made of (alternating) granite and iron—a structure reminiscent of his artwork for the 1977 *documenta 6* yet on a much larger scale. He also created a circular granite sculpture on which passersby can sit and rest or children can play. *Maʾalot* as a whole also makes use of natural local elements, such as trees, bushes, iron, and the rainwater in the little ponds on the path to and from the river.

Dani Karavan, *Maʾalot*

Michel de Certeau and Marc Augé described transitional spaces such as the track from the Rhine to the cathedral as "non-places."[13] Non-places are a modern invention: train stations, airports, huge parking lots outside suburban malls. These are spaces we rush through mindlessly, with the single aim of getting from one point to another, where we remain anonymous individuals in an anonymous space. Visiting *Ma'alot* in 2015, I could see how the work turned what had once been such a non-place into a public *makom*. *Ma'alot* is a communal place that invites us to dwell for a while, observe the sculptures, reflect, and interact with others.

Dwelling is closely associated in *Ma'alot* with memory and history. Visually uniting the cathedral, the train station, and the Rhine, the work draws together the past, the present, the future. Cologne's Christian heritage, as inscribed in the cathedral, is just as contemporaneous here as the destruction of the city by the massive air raids during the Second World War or the deportation of the city's Jewish population through this very train station to Lodz and Theresienstadt and from there to the extermination camps in Poland. The straight lines running from the massive granite-and-iron sculpture toward the cathedral and down the spiral staircase toward a circular pond, for example, are made of old train rails similar to those along which Jews from Cologne and other cities were transported to their deaths.[14]

Karavan has rejected suggestions that the train rails and the six blocks composing the abstract, gigantic sculpture at the center of *Ma'alot* represent the six million Jewish victims of the Holocaust—that *Ma'alot* is an "illustration of history."[15] Yet it is impossible to avoid remembering the Second World War and the Holocaust here. *Ma'alot* is a multifaceted, polyphonic creation in which the artist's intentions are but one voice in a rich choir that includes collaborators in Cologne's city government, urban architects, visitors to the site, casual passersby, and others who create *Ma'alot* as an aesthetic experience.[16] Karavan tellingly emphasized that *Ma'alot* doesn't exist "without the people for whom it was made": it depends on the voices of others and what they bring to the work of art, with their multiple, at times conflicting memories, experiences, fantasies, thoughts, and reactions.[17]

Maalot connotes merit and virtue as well as stairs and degrees. Ethical and political dimensions are an important facet of Karavan's work in Cologne. Ascending the stairs from the Rhine and inhabiting this environment may indeed also involve stopping for a while to consider, even if only for a few moments, one's path: What do I regard as having merit? What is of value for me? What do I see as a virtue? At the same time, *Maalot* affords an opportunity to reflect on the public realm. The public and thus the political have been inscribed in this work from the beginning; since its inauguration, *Maalot* has served as a space of communal experience and interaction, including concerts, performances, commemorative events, group walks, and meditation.[18] When the art suffered physical erosion, a grassroots group of citizens demanded that the city ensure its preservation and integrity.[19] The *Maalot* as a public space demands that the people of Cologne pay attention and come together as the citizens of a polity to discuss their priorities. How do we shape and protect our public spaces, and to what do we attach value (*maala*)? How do we live together?

Dani Karavan, *Ma'alot*

PLURALITY AND ENCOUNTER

By suggesting that Karavan's art thinks poetically on politics and ethics, I do not mean that it has any overt political meaning. Rather, I wish to highlight an affinity between his public work and the philosophical dimension of the political as outlined by Hannah Arendt, for whom the human condition is predicated on natality: our "ontologically rooted" capacity, as creatures born into life, to insert ourselves with word and deed into the world, to undertake meaningful political actions.[20] The poetic thinking of Karavan's public environments brings to mind Arendt's notion of plurality and the affinities between Martin Buber's thought and Paul Celan's poetry. In Arendt's vocabulary, plurality denotes the idea that we are born into an already-existing communal sphere. She also views plurality as "the conditio per quam [condition for] . . . all political life."[21] Politics is thus the range of actions in which people engage as they gradually become a fully integrated part of the civic fabric they entered at birth.

We have seen that Karavan's environments give a new shape to public spaces in which people come together to argue their cases before a court, walk along the bank of the Rhine, or enjoy the sight of a sculpture. We almost always experience his sculpture in the company of others, which gives us a sensual grasp of our existence as a community, Arendt's plurality. Karavan's environments further embody plurality as they provide citizens and all visitors with venues for human encounter, public ceremonies, and even the staging of new artworks.[22] Finally, they explore and expand our grasp of plurality because Karavan has been able to realize them only in concert with others and after lengthy processes of planning, deliberation, decision making, and production.[23] Long after works such as *Ma'alot* are set in place, they continue to challenge city officials in various ways because they demand maintenance and care. They test our capacity to shape and reshape—for good or for bad—our physical and communal environments.

Karavan's *Mifgash* (*Encounter*, 2004–5) in the garden of Villa Lemm, a large estate on the banks of the Havel River in Berlin, captures in form and verbal content the very essence of plurality, as well as the challenge to our ability to come together in the public sphere when we face tyranny.[24]

The villa was designed and built between 1907 and 1913 by the famous Berlin architect Max Werner (1877–1933) for the manufacturer Otto Lemm. During its rich history, Villa Lemm has had several prominent owners, including the renowned Hungarian-Jewish physician János Plesh (1878–1957), who regularly hosted his good friend Albert Einstein. Karavan's sculpture consists of a flat circle of Carrara marble, approximately four and a half meters in diameter, atop which sit nine marble chairs. As its title suggests, the sculpture evokes a *mifgash*, the Hebrew word for an encounter, a gathering. On the back of the chairs, Karavan engraved the names of the nine men who gathered there in February 1927, at the behest of János Plesh, for an evening of personal and intellectual exchange: the composers Artur Schnabel (1882–1951) and Fritz Kreisler (1875–1962); painters Max Slevogt (1868–1932) and Emil Orlik (1870–1932); chemist Fritz Haber (1868–1934); legal scholar and politician Ulrich Graf Brockendorff-Rantzau (the first foreign minister of the Weimar Republic, 1869–1929); Josef Grünberg (a friend of Plesh's); and Albert Einstein.[25] The work thus points to a moment in history when Jewish and non-Jewish Germans could still engage as

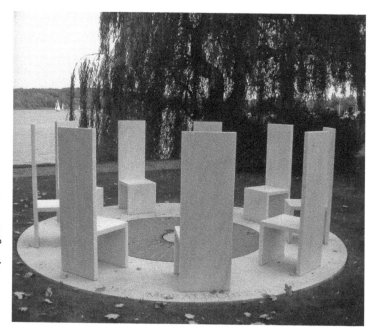

Dani Karavan, *Mifgash*

equals in conversations about culture, politics, and the natural sciences. It was a gathering that reflected the cultural and scientific renaissance of the interwar period at its best.

But *Mifgash* is not confined to a remembrance of things past. The ring of marble chairs is intended for use by visitors. The chairs set up a world, in Heidegger's sense, and afford visitors an outlook on themselves: as a physical arrangement, they make visible the human condition of plurality. Sitting on a chair, a visitor can see all the other chairs and thereby experience what it is to be a part of an already-existing human circle, never utterly alone. Plurality is further emphasized by the large marble disk underneath the chairs. The circle, a global symbol, denotes among many other things a benevolent celestial order.[26] Karavan's circle does not affirm a particular religious or metaphysical moral system, but symbolically it gives visitors an opportunity to encounter each other as equals: to sit on chairs of identical size and observe each other from the same distance. As they do so, they may ponder the artist's choice to inscribe into the circular marble foundation a quotation from Albert Einstein in both German and English: "Only morality in our actions can give beauty and dignity to life." If Arendt considered plurality a constitutive element of the human condition and the only state of being from which we can act meaningfully, Karavan's citation of Einstein's famous "Letter to a Minister" further suggests that ethically based action alone ensures dignified human cohabitation in the face of the diversity of religion, ethnicity, values, opinions, and ways of life:

> The most important human endeavor is the striving for morality in our actions. Our inner balance and even our very existence depend on it. Only morality in our actions can give beauty and dignity to life. To make this a living force and bring it to clear consciousness is perhaps the foremost task of education. The foundation of morality should not be made dependent on myth nor tied to any authority lest doubt about the myth or about the legitimacy of the authority imperil the foundation of sound judgment and action.[27]

An assemblage of physical, spatial, and textual components, *Mifgash* illustrates both Einstein's and, unintentionally, Arendt's words: peaceful plurality, embodied in this egalitarian, dignified human circle, can exist

only when ethics is not divorced from politics, when there is "morality in our actions." Essential for morality, however, is that we actively engage in the political domain. Karavan's chairs physically rest on this idea. Ensuring dignity requires an ethical stance and the will to act according to our moral convictions. The lack of political action against fascist totalitarianism, Karavan's empty chairs remind us, ended the world that made the gathering in 1927 possible in the first place. In the future, *Mifgash*, a gathering like the one at Villa Lemm, will be possible only if we couple our ethical convictions with action.

ON DIGNITY

I considered the circular shape of *Mifgash* and the quotation "Only morality in our actions can give beauty and dignity to life" in 2015 as I walked along the Reichstagufer, the promenade by one of the branches of the Spree River in Berlin. While Einstein's idea is compelling and effortlessly persuasive, it is hardly self-evident. How can it be realized in the tedious and highly contentious business of politics? Berlin itself stands as a lasting symbol for what occurs when Einstein's notion of meaningful action gives way to the human drive for self-preservation, at best, and complete domination, at worst. I was on my way to visit two of Karavan's works that address this particular conjunction: environments (in his sense) that offer a spatial meditation on what ensures the place of ethics in our politics and what occurs when tyrannies crush morality in the name of metaphysical ideas about a superior race.

The first work, *Grundgesetz 49* (*Basic Law 49*, 1997–2002), is located right by the Reichstagufer on a path that leads to the German parliament, the institution that in the 1930s failed to protect the ideas of the progressive Weimar constitution. Facing the Reichstagufer, *Basic Law 49* also evokes the Berlin Wall, which ran alongside what is today the promenade and was the very structure that the Communist German Democratic Republic erected to ensure the party's grip on power. I was heading toward another Karavan work just a few minutes away, across the street from the Reichstag building, *Denkmal für die im Nationalsozialismus ermordeten Sinti und Roma Europas* (*Memorial to the Sinti and Roma Victims of National Socialism*, 2000–2012). This piece offers

an opportunity to remember the consequences of the politicians' failure to act when Hitler assumed power in 1933 and to recognize the vital importance of active political and ethical engagement.

Like Karavan's installation in the Tel Aviv Court of Justice, *Basic Law 49* invites beholders to explore their individual and communal notions of value, judgment, and justice in the public sphere. Nineteen transparent glass plates, each about three meters high, present the articles of the German Basic Law, the equivalent of Germany's constitution (ratified in 1949, hence the work's title). The text was etched onto the glass with a laser. Even after seventy years, the wording of this document remains moving and thought provoking. As I was visiting the site, I overhead a mother discussing the first article with her children, which begins, "Human dignity shall be inviolable. To respect and protect it shall be the duty of all state authority."[28] As *The City Gate* also demonstrates, the law and system of justice that the installation presents are public, transparent, and at eye level. Easily accessible, it invites us to touch it, to contemplate, to converse and debate. What does "dignity" imply? How can a bureaucratic structure such as that of the modern state protect everyone's dignity? Should we protect only the dignity of the citizens of our polity or everyone's dignity? What occurs when citizens of the same polity have different, even conflicting notions of dignity?

Dani Karavan, *Grundgesetz 49*

Dani Karavan, *Grundgesetz 49* (above and below)

Those who walk the promenade and stop to look at this artwork can see, through the transparent glass and the letters of the law, the building behind it and, occasionally, those who work there. At the same time, they can be seen by the people inside that large structure, the Jakob-Kaiser-Haus. Named for Jakob Kaiser, a Christian member of the trade unions and an active member of the German anti-Hitler resistance, the building on the other side of *Basic Law 49* serves as office space for members of the German parliament. Karavan's work enjoins the law-makers to reflect on the German Basic Law as they engage in the daily business of politics. Passersby look into the offices of their representatives through the prism of the constitution and perhaps wonder whether the politicians are doing all that is needed to ensure, for example, that human dignity remains inviolable.

Walking toward the Reichstag, one encounters the *Memorial to the Sinti and Roma Victims of National Socialism*. Set at the edge of the lush and tranquil Tiergarten park, Karavan's environment invites us to remember what transpires when human dignity is not protected.

The memorial comprises different, interlinked elements. A rectangular iron gate is set in a wall of opaque glass plates that display a chronology of the genocide of the Sinti and Roma during the Nazi era. A roughly three-meter-wide area of white stone paving slabs circles a

Dani Karavan, *Memorial to the Sinti and Roma Victims of National Socialism*

large, dark pond. The larger stone slabs present the names of German concentration camps in which Sinti and Roma were murdered. The pool appears a sinister bottomless pit. A black triangular block inside the pond, protruding above the water, evokes the black or brown triangles of cloth that the Nazis forced the Sinti and Roma to wear. Karavan has chosen to accompany this symbol of persecution with a sign of renewal: a flower lies atop the black triangle. When the flower withers, it is replaced by a fresh one. At the edge of the pond visitors can read the words of the poem "Auschwitz" by the Roma poet Santino Spinelli: "Sunken in face / extinguished eyes / cold lips / silence / a torn heart / without breath / without words / no tears."[29]

This is a quiet space of remembrance and contemplation. As Karavan describes it, "Only tears, only water, surrounded by the survivors, by those who remember what happened, by those who know the horror as well as those who never experienced it. They are reflected, upside down, in the water of the deep black pit, covered by the sky—the water, the tears."[30]

As I was reading the names of the concentration camps inscribed on the stone slabs and, later, observing my own reflection and those of other visitors in the dark water of the circular pool, I was reminded again of the human circle, an idea advocated by Richard Rorty and Peter

Inauguration ceremony for Memorial to the Sinti

Singer and reflected in the poetry of Celan and Pagis and Karavan's *Mifgash*. Recall that "moral progress," as Rorty noted, quoting Singer, "consists in enlarging the range of those whose desires are taken into account. It is a matter of . . . 'enlarging the circle of the "we," enlarging the number of people whom we think of as 'one of us.' "[31] There it is, I thought, standing at the edge of the pond: we may prefer not to see anyone standing beside us, here by the water or anywhere else. But the reflections of others in the dark water manifest their presence regardless and compel us to ask, "What do we think of those standing, as we do, in this place? To what extent do we fully acknowledge their humanity, their histories, convictions, and needs? Do we regard all of them or merely some as equal to us in rights and duties?"

From various vantage points, the Reichstag is also reflected in the pond. The reflection of the bodies and faces of those who stand by the water are enmeshed with that of the German parliament. Through the prism of this image, politics is inseparable from the human circle. The surrounding stone slabs proclaim the places in which people who were judged as not belonging to humanity were murdered. This act of brutality was the consequence of choices made inside that very building, the Reichstag, and in its immediate vicinity. But it was also made possible by the reluctance of many outside that building to consider the Roma, Sinti, and others as having a place in the circle.

Visiting bustling Berlin, visitors may remain at the outer circumference of Karavan's memorial, quickly glance at the circular pool in the quiet garden, and then rush on to the next attraction. They may also choose to enter the memorial, read the writing on the glass plates and the stone slabs, peer into the pond, and think. The murder of the Sinti and Roma resulted from the political will and deeds of those in power, yet it was also made possible by the choices of many more to remain passive observers.

The very existence of this memorial, I thought as I walked away from the pond, is tied to the choice of stepping in, paying attention, taking an interest in the lives and fates of those who stand close to us yet may remain invisible. The inauguration of the memorial itself followed a lengthy, highly contentious process of communal deliberation, choice, and action. Only after heated debates around the need for such

a memorial, its location, its name, and even the use of sources and texts, did the German government decide to commission it in 1992. It took twenty more years to turn this decision into a reality: the memorial was finally inaugurated in 2012.[32] When it comes to the human circle, Karavan's memorial suggests, our capacity to deliberate, choose, and act in concert with others is avoidable only at the cost of unbearable pain to those who stand right by us, waiting to be seen as "one of us."

ETHICS AS ORIENTATION

Vocal in regard to his own political choices as an Israeli citizen, Karavan refrains in his art from committing to any single authoritative ethical school, any all-encompassing political ideology. Visiting his remarkable environment *Mizrach* (1997–2005) in Regensburg, Germany, it became clear to me that his work suggests we should come to moral and political judgments through cautious, communicative orientation. German filmmaker, writer, and thinker Alexander Kluge writes: "What people need in their lives is orientation. Like ships navigate." Kluge sees the "function" of his own art as assisting in a fundamental human endeavor: to compare different ideas, to determine what ideas we are attracted to, what ideas we are appalled by, and thus to chart our own path as individuals who are always already a part of the communal fabric. Using his stories to orient themselves, Kluge suggests, readers may investigate a range of questions: What can I count on? How can I protect myself? What do I need to fear?[33] If we understand ethics as Kluge does, as an ongoing consideration of specific challenges, a process by which we reflect on our subjective position and our idiosyncratic emotions, then our lives are a matter of constant navigation. Like a ship's navigator, we are continually calibrating our path through multiple means and devices, trying to avoid mistakes that would run us aground. Karavan's *Mizrach*, meaning "east" (*Orient*, in German), visually captures the idea of ethics as constant orientation.

Mizrach is an open public space that one can enter or leave in countless ways. How one decides to experience or use the work is similarly individual. As I could clearly see when visiting Regensburg, one may come here to rest, chat, eat, play, or reflect on one or all the questions

Alexander Kluge names. This openness to individual orientation is embodied, I believe, in the compelling, clear outline of the work. Made of rectangular white concrete blocks that encircle a sunken piazza, *Mizrach* gives us a variety of geometrical forms we can use in any way we choose. The graceful white concrete is as striking to look at as it is pleasant to touch. A single word, in Hebrew, is inscribed on one of the blocks at the circumference: מזרח (*mizrach*).

Located at the center of Neupfarrplatz, the buzzing Regensburg marketplace, *Mizrach* is surrounded by cafés, shops, and the Lutheran church Neupfarrkirche. Yet it marks a significant historical location, standing at the center of the large area that served as Regensburg's Jewish quarter from the arrival of Jews in the city in the tenth century to their expulsion in 1519. The sculpture is built at the exact location of the old Regensburg synagogue and thus commemorates the structure that was once the spiritual center of Regensburg's vibrant Jewish community until (following the death of Emperor Maximilian I in 1519) that community was deemed undesirable and forcibly expelled. It evokes a political act: the decree passed by Regensburg's city council on January 12, 1519, to expel all Jews from the city within two weeks. And the memory of that expulsion, in turn, evokes the destruction of Jewish culture in the city during "Kristallnacht" (November 9, 1938)

Dani Karavan, *Mizrach*

and the murder of Regensburg's Jewish population in the death camps of Belzec, Sobibor, and Auschwitz.

While the white concrete blocks trace the precise foundations of the old synagogue, the Hebrew inscription מזרח marks where the Torah ark would have been placed, at the eastern perimeter of the site, the point closest to Jerusalem. Indeed, this work's multivalent title is at once a nod to Jerusalem, the city where the Jewish temple stood until its destruction in 70 CE, to Regensburg's Jewish heritage, and to the obliteration of that past in the death camps to the east. But like Karavan's other works, *Mizrach* is not restricted to memorializing a traumatic past; as a public plaque at the site states, in three languages, it is conceived as an "Ort der Begegnung," a "Place of Encounter," where "people of all religions come together."

Mizrach both affords and promotes the possibility of personal and communal alignment under the condition of plurality. This is what Karavan himself said at the inauguration ceremony for *Mizrach* in 2005: "This place can serve as a stage where people perform, read poetry, play music, or present theater. It is a cultural space in the middle of the city. A part of everyday life and not a place that should bring to mind hate and the destruction."[34] Choosing to commemorate the synagogue and

Dani Karavan, *Mizrach*

Regensburg's troubled Jewish history with a functional work of art, Karavan created a place where people can come together to experience the human circle. The sense of a traumatic past emerges only as we use it to experience and orient ourselves in the world. Like Karavan when he first approached this site, we are invited to ask ourselves, "What meanings do we attach to this place? How shall we use it? Do we take time to stop our rushed movement from one 'non-place' to another and closely look at what is in front of us?" It is here that we may choose to think and think again; to ponder what we can count on, how we can protect ourselves and others, and what we need to fear.

THE RIGHT TO HAVE RIGHTS

The laws of any country, German Basic Law included, aim to allow a community to respond to fundamental questions of how best to protect themselves and what to protect themselves against. They make tangible the notion of orientation for the nation-state. Visiting one of Dani Karavan's most intriguing environments, *Die Straße der Menschenrechte* (*The Way of Human Rights*, 1989–93) in Nuremberg in 2015, I was struck by the artist's wish to think about these questions in their transnational dimension. Inaugurated in 1993, *The Way of Human Rights* is entered through an arched, white concrete gateway (sixteen meters long and eight meters high) that leads into the Kartäusergasse, a narrow alley at the heart of the city. On both sides of this slender street, Karavan erected twenty-seven circular columns of white concrete (each eight meters high), burying two of them in the ground so that we can see only their tops, and planting a single oak tree, for a total of thirty columns. Each column presents one paragraph of the thirty articles of the Universal Declaration of Human Rights in German and in a language spoken by various victims of human rights' abuses, such as Yiddish, Polish, Armenian, Zulu, Hopi, and Khmer.

Standing tall and proud, the columns gleam. Their unadorned modernist silhouettes invite us to touch them and to enjoy their smooth texture. Like the scroll-shaped form of *Justice the Measuring Line and Righteousness the Plumb Line* or the transparent walls of *Basic Law 49*, these silent, welcoming giants present legal guidelines for all to see and

feel. Framing our view of the street and structuring our path along its course, they also encourage us to ponder the unique document of modern history they so gracefully display. Adopted by the United Nations General Assembly in Paris on December 10, 1948, the Declaration of Human Rights echoed some of the most hopeful aspects of the Enlightenment in its attempt to secure the rights of all people as free citizens of a rational polity. Drafted following the Second World War, it emerged as a reaction to the politics of exclusion and persecution of modern tyrannies and expressed the hope of creating an international legal standard that would ensure that the horrors resulting from excluding Jews, Sinti, Roma, and many others from the human circle would never again occur.

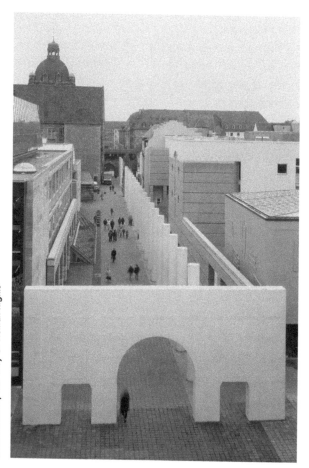

Dani Karavan, *The Way of Human Rights*

Drawing on a broad array of aesthetic and architectural ideas rang-
ing from those of ancient Egypt to those of post–Second World War
modernism, Karavan's *The Way of Human Rights* is the artist's response
to the Nuremberg government's wish to establish a visual, physical link
between the old and new wings of the Germanisches Nationalmuseum
(Germanic National Museum). The vision was to create a material and
metaphoric connection between the past—in which the adjective "Ger-
manic" served to emphasize the superiority of a race and a culture—and
the present of a busy city, with its yet-to-be-determined future.[35] Kara-
van chose to address this challenge through columns. Used in antiquity
to support the roofs or crests of large public structures such as palaces
and temples, columns evoked proudly erect human bodies. Made of
costly materials such as marble, they implied the ability of the ruler and,
by extension, the polity to carry a substantial weight, thus projecting
spiritual, religious, or political potency.[36] Often adorned with elaborate
capitals and other ornaments, they reflected the capacity of the mighty
to bring to fruition grand architectonic and political visions.

Karavan's columns echo this tradition, while their sober aesthetics
also leave its elitist legacy behind. His modernist interpretation of the
festive, spiritual dimension of ancient columns celebrates neither tyrant
nor military victory. Devoid of opulence, they present—through the
actual words of the declaration—the ideas we may draw on as we ori-
ent ourselves as individuals, as a nation, and as a global community.
They answer Paul Celan's question of what counts by translating the
biblical metaphor of humankind as created in the image of God into
the language of the declaration: "Everyone has the right to life, liberty
and security of person" (Article 3); "No one shall be held in slavery or
servitude" (Article 4); "No one shall be subjected to torture" (Article
5); "Everyone has the right to freedom of peaceful assembly and asso-
ciation" (Article 20).[37] Emerging from the wreckage of totalitarianism
and genocide, the declaration is the pragmatic attempt to develop a
global framework of rights to which all people are inherently entitled.
Its articles aim at laying the foundation for subsequent international
treaties, national constitutions, and other laws. Yet Karavan's work does
not suggest that the declaration has achieved its goals. Each column
presents, after all, but one paragraph. The remaining space seems to

call on those who visit the site to consider not only the validity of what they read but also what might be added.

Walking along *The Way of Human Rights* and stopping like other visitors to read the articles, I thought of Hannah Arendt, who argued a year after the declaration's adoption that the content of the legal framework was too abstract and unrealistic and was therefore bound to fail to protect countless people.[38] Given the fate of millions of people after 1948 in places such as Biafra, Cambodia, Rwanda, the former Yugoslavia, Sudan, and Syria, her critique proved correct. The fundamental problem, wrote Arendt, was that the declaration, which was intended as a powerful reaction to the "barbarous acts" committed by totalitarian regimes of the mid-twentieth century, based its principles on the abstract notion of a natural condition in which all people are presumably equal.[39] Yet only citizens of a polity have rights. The fate of Jews during

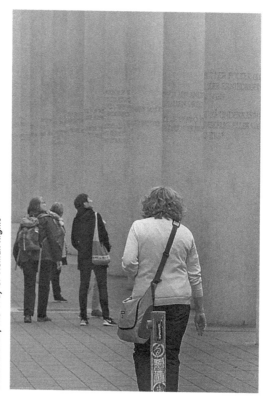

Dani Karavan, *The Way of Human Rights*

the Nazi era was directly linked to the political act of depriving them of their citizenship: "The conception of human rights broke down at the very moment when those who professed to believe in it were for the first time confronted with people who indeed had lost all other qualities and specific relationships, except that they were still human. The world found nothing sacred in the abstract nakedness of being human."[40]

The ongoing reality of genocide and mass murder in recent decades has proven these words to be prescient. The crucial weakness of such exalted ideas as universal human rights, Arendt rightly believed, is that they may divert our attention from the far less exalted but far more decisive realm of politics: from the tangible setting in which citizens, and citizens alone, struggle to create a legal realm protected by a sovereign state. It is there that citizens must try to collaborate, to shape their polity according to their ideas; and they must do so under the condition of plurality, while recognizing and working with their principal differences. We are "not born equal, we become equal as members of a group on the strength of our decision to guarantee ourselves mutually equal rights."[41] Deprived of their rights as citizens, Jews during the Holocaust and, more recently, countless Syrians who oppose Assad's tyranny, the Rohingya in Myanmar, and the Yazidi in land seized by ISIS, quickly became stateless—and thus defenseless. Tragically, people excluded from a polity (including Palestinians living in the Occupied Territories or in refugee camps across the Arab world) become a mere nuisance for those who live their lives behind closed doors, like the witness in the execution scene of Kafka's *The Trial* who looks on from a distance.

Though critical of the declaration, Arendt would have understood what Karavan's *The Way of Human Rights* embodies as a work of art: the importance of striving to establish a legal, binding framework throughout the world based on the notion of rights. By choosing to present columns that sustain no edifice, Karavan's work implies that the promise of the declaration is not yet realized. Arendt famously suggested that there is one right all people are still to be given—a right that such a future global legal system may very well protect: the "right to have rights." Without this right, "no other can materialize." Arendt hoped that the discussion of rights would ultimately bring about a new, transnational

legal structure—one that would have the capacity to enforce its laws and punish "crimes against humanity."[42]

Karavan doesn't discuss Arendt in his published writings or interviews. But *The Way of Human Rights* considers how to address doubts like those Arendt systematically articulated in the language of political theory and encourages us to do the same. One way in which it does so is via the arc of the tall gateway entrance, on which the Sixth Commandment is written: לא תרצח, "Thou shalt not kill."

This engraving stands in dialogue with the other inscriptions on the columns, suggesting that, in addition to the declaration—a document of modern thought and international politics—we have at our disposal multiple other codes of ethical conduct, including the Ten Commandments. It is only by consulting multiple sources, Karavan's artwork implies, that we may arrive at a better, more binding legal system. If the international community had adopted the biblical commandment alongside the declaration, perhaps it would have been more difficult for the tyrants of Cambodia, Serbia, Sudan, or Syria to blindly massacre scores of people. Thinking about human rights must continue. Fittingly, since the 1993 inauguration of *The Way of Human Rights*, Nuremberg has created a municipal Human Rights Office. The city now regularly awards the International Nuremberg Human Rights Prize, and since 1999, it has hosted the biennial

Dani Karavan, *The Way of Human Rights*

Nuremberg International Human Rights Film Festival. Alongside these municipal activities, an independent Human Rights Center has been established to support the defense of human rights throughout the world.[43]

Drawing on the biblical tradition of the Ten Commandments, *The Way of Human Rights* encourages us to continue the search for ideas that will help protect humanity from genocide or mass killing rather than to think that our work has already been completed through the declaration. In a speech delivered at the inauguration of *The Way of Human Rights*, Karavan reflected on this task by remembering his own family members who were barbarically murdered by the Nazis and by recalling Anne Frank: "I take you by the hand, little Anne Frank—at that time, I was younger than you—and we walk together on this very street to the third column and the third article of the Universal Declaration of Human Rights, and we read the Dutch inscription . . . 'Everyone has the right to life, liberty, and security of person.' And I see children, many children, whose right to life has not been observed."[44] By addressing Anne Frank in the present tense, Karavan relates her experience as a child victim of the Holocaust directly to present-day children whose rights are being ignored. The memory of the past and the experiences of the present finally lead him to shift the register of his short speech and turn to a theological-philosophical question: "Is there still a God, in spite of what has happened? Are we, humans, made in his image?"[45] Karavan's reference to Genesis 1:26–27 is remarkable: "Then God said, 'Let Us make man in Our image, according to Our likeness.' . . . So God created man in His own image; in the image of God He created him." As we know, he is a secular Jew; his invocation of the notion that humans are created in God's image is not an affirmation of a divine presence in human life. Rather, he alludes to the Bible to challenge those who listen to his words, indeed all of us. Only we may answer his rhetorical question. It is up to us, and us alone, to consider in what ways we may act to come closer to securing the life and dignity of all.

"IF THIS IS A MAN"

For the last fifty years, Dani Karavan has created countless public spaces that speak to ethical and political deliberation. In *The Way of Human Rights* and many other works that, for the sake of brevity, I do

not explore here, he asks, "Are we created in his image?" His body of work implicitly answers this question by suggesting that if we are to uphold the inviolability of human life and dignity, then we must, by means of our own words and deeds, engage with the political. Karavan expresses this stance in more than his art. As a board member of B'Tselem, the Israeli Information Center for Human Rights in the Occupied Territories, an organization whose name cites the biblical notion of humans as created "in the image," he strives to realize the idea of human life and dignity as fundamentally sacred.[46] He also tirelessly responds to oppressive politics through speeches, interviews, and newspaper articles.

A telling example of the link between art and political discourse is his highly publicized demand to withdraw one of his most famous works from public view. In 1966 he completed the large wall relief (seven by twenty-four meters) *Pray for the Peace of Jerusalem* that adorns the assembly hall of Israel's parliament, the Knesset, in Jerusalem. Given Israel's discriminatory policies against the Palestinians living in Israel and its brazen treatment of Palestinians who live under occupation in the West Bank and Gaza, Karavan has repeatedly asked that the wall be removed or covered until the Knesset's work finally reflects Israel's Declaration of Independence, the yet-unfulfilled promise of freedom, equality, and dignity for all citizens regardless of their religion, ethnicity, race, or gender.[47] In a 2006 article in the daily *Ha-aretz*, he invoked the lament of the prophet Habakkuk, "For the stone shall cry out of the wall," to question the ability of his wall in the Knesset to rattle Israeli politicians, for they have failed to end the repression of Palestinians and the occupation. Karavan asks, "Can a stone wall shake a heart of stone? . . . Ever since we turned into an occupying state in the course of the 1967 [Arab-Israeli] War, it is difficult for me to see and to hear what this wall [*Pray for the Peace of Jerusalem*] must endure . . . ; [how] one of the most cultured and humane people turns out to be one of the most merciless oppressors of Abraham's other descendants [the Arabs]. Innocent people are killed, homes are destroyed, landscapes are obliterated, and trees are razed. . . . The wall increasingly fills up with broken, burned olive trees."[48]

Almost ten years before he wrote this piece, Karavan gave poetic expression to this very lament. In 1997, the Israeli government began work

on the settlement Har Homa, in the area stretching between Jerusalem and Bethlehem also known by its Arabic name, Jabal Abu Ghneim. That same year, Karavan opened an exhibition at the Museum of Israeli Art in Ramat Gan that featured a work called *Har Homa*—an inverted hanging olive tree whose roots were fully exposed. The large hook that holds the straps that carry the tree evokes a butcher's hook or, worse, an execution.

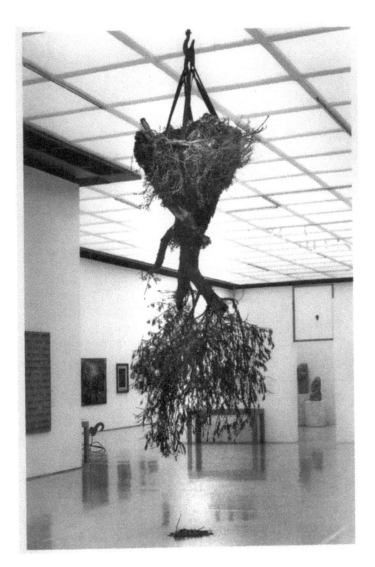

Dani Karavan, *Har Homa*

Facing what seems to be the senseless killing of a tree, visitors can choose to continue to stroll through the exhibition halls or, perhaps, to stop and think. If they choose to stop, they may reflect on the olive tree as a symbol of the return of peace and life after catastrophe. In the biblical story of the Flood, when Noah sends a dove to see if the waters have subsided, the bird returns with an olive branch. The State of Israel has used an olive branch in its official emblem to indicate its striving for peace. But the bare, torn roots of Karavan's tree question whether Israel has lived up to that promise.

The various reactions of visitors who view this tree are a crucial facet of the work itself. Their reactions (or lack thereof) complete it. Emphasizing reaction, I am once again following, as I did when discussing Gerhard Richter's paintings, Florian Klinger, who encourages us to focus less on an artist's capacity to represent the world and more on an artist's reaction to what she or he has witnessed or experienced. "Reaction" also captures, as Klinger reminds us, how we encounter the work, the range of our somatic and mental responses to what we see—our visceral sensations, emotions, associations, and thoughts. The uprooted olive tree is, in fact, Karavan's material and visual reaction to countless reports of Jewish settlers uprooting and burning Palestinian olive trees throughout the West Bank as acts of intimidation and economic sabotage.[49] The installation reacts to the actual acts of uprooting olive trees by making the tree the sign of an inverted world, of a twisted reality. *Har Homa* further reacts to the indifference of many Israelis to such actions, as well as, more broadly, to the occupation of the West Bank. "Here I am!" calls the inverted tree. "You may no longer think of me as existing only 'there,' in the Occupied Territories, and as belonging only to 'them'—the Palestinians. See me in my exposed, volatile existence in the midst of your leisurely life in mainland Israel." Karavan's *Har Homa* is a provocation, an expression of a belief he shares with Gerhard Richter in art's capacity "to help us think something that goes beyond this senseless existence."[50]

The olive tree itself was surely never in danger. Karavan specifically designed the installation to ensure that the roots of the tree remained wet so that the tree wouldn't wilt. But as we talked in his studio in 2015, he was still pained by the fact that some visitors to the exhibition expressed worry about the ethics of his piece. It was wrong, they said,

to extract the tree from the ground. The irony was, of course, that the same visitors did little or nothing to prevent the actual uprooting of trees in the West Bank by militant Jewish settlers—a recurrent reality since the emergence of the settlement movement in the 1970s. Those troubled visitors who worried about the tree's needs seemed less concerned with the Palestinians' right to have rights—including the right of citizenship in their own independent state.[51]

In the years following the display of *Har Homa*, Karavan expanded his disquieting poetic meditation around the symbol of the olive tree into a general consideration of politics. For the exhibitions *A Federico II* (*Homage to Frederick II*), at the Centro per l'Arte Contemporanea Luigi Pecci, in Prato, Italy (1999), and *Pardes* (*Orchard*), at IVAM (Institut Valencià d'Art Modern), in Valencia, Spain (2002), he presented two olive trees side by side: one uprooted and turned upside down and the other upright and planted in rich soil. As the backdrop for this allegorical installation, Karavan placed a reproduction of Ambrogio Lorenzetti's

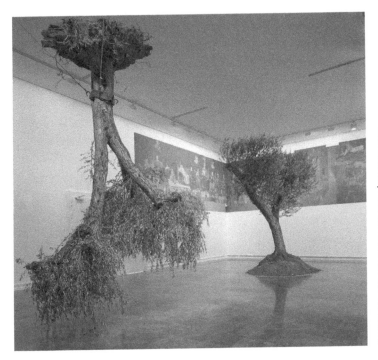

Dani Karavan, *Effects of Good and Bad Government*

masterful frescoes *Allegoria del buono e del cattivo governo* (*The Allegory of Good and Bad Government*, 1338–39). Echoing Lorenzetti, Karavan called his installation *Effects of Good and Bad Government*. Lorenzetti's frescoes were commissioned by Sienna's republican rulers, the so-called Council of Nine, for their boardroom in Siena's city hall. In these works, Lorenzetti juxtaposed two symbolic images: one of a world governed by "Justice," personified by a beautiful, serene female figure; the other governed by "Tyranny," a grimacing figure with horns and sharp teeth. Entering the hall where they would meet to discuss the city's fate through a door placed directly underneath the image of Justice, the rulers of Siena were called to remember to attend to their choices.

In its clarity and directness, *Effects of Good and Bad Government* takes Karavan back to his beginnings when he encountered the frescoes and the humanistic vision of the Renaissance as a young art student in Italy. It is also, of course, a meditation on the tension between justice and tyranny. Choosing between these poles is not only the duty of the fourteenth-century rulers of Siena. It is ours—the choice of citizens of Israel and Palestine and of all of us living under the sign of plurality.

Upon leaving Karavan's studio after our interview, I thought about *Effects of Good and Bad Government* and remembered Primo Levi's poem "Shema," which serves as an epigraph to his canonic *If This Is a Man*. Before Primo Levi tells the story of his enslavement in Auschwitz, he presents us with this poem, which suggests a setting reminiscent of the execution scene in Kafka's *The Trial*. In Kafka's novel we encounter a solitary human being deserted by a withdrawn humanity. "Shema" invokes the centerpiece of Jewish prayer, Shema Yisrael (Hear, [O] Israel). Yet it also addresses us, a passive, aloof humanity, in the form of the Hebrew imperative to "listen" or "hear":

> You who live safe
> In your warm houses,
> You who find, returning in the evening,
> Hot food and friendly faces:
>> Consider if this is a man
>> Who works in the mud,
>> Who does not know peace,
>> Who fights for a scrap of bread,

Who dies because of a yes or a no.
Consider if this is a woman,
Without hair and without name
With no more strength to remember,
Her eyes empty and her womb cold
Like a frog in winter
Meditate that this came about:
I commend these words to you.
Carve them in your hearts
At home, in the street,
Going to bed, rising;
Repeat them to your children.
 Or may your house fall apart,
 May illness impede you,
 May your children turn their faces from you.[52]

Both Kafka and Levi offer us a vision of the modern human condition in which the legal and political institutions responsible for the establishment of a just order falter while an indifferent civilization watches silently from the sidelines. Neither writer, moreover, is satisfied with blaming the monstrous political system that made the fate of the victims possible. Instead, they focus our attention on our role in allowing that system to operate as well as on our capacity to step outside our protected dwellings and into the realm of action. Karavan's works consider our capacity to insert ourselves into the realm of politics so as to protect justice and guard against tyranny. As Kafka does in *The Trial* and Levi does in "Shema," Karavan asks his Israeli audience to leave their position by the window, where many are content to merely observe from the comfort of home. He asks them not to be content with their passive stances but to fully absorb what is happening right outside their polity, in the gray zone of the Occupied Territories. Karavan's words and artworks call on them, and on all of us, to acknowledge the right of Palestinians and, by extension, the right of all humans to have rights lest, as Primo Levi warns, our house falls apart.

Coda

Our Poetic Age

TO UNDERSTAND EMOTIONALLY

"The world must be romanticized." With these words, written on the cusp of the nineteenth century, the German Romantic poet Novalis demanded that we give our world back "the meaning, magic, and mystery" it had lost during the forward march of reason in the wake of the Scientific Revolution and the Enlightenment.[1] In the two centuries since, Novalis's vision of Romanticism has led to an unprecedented flourishing of the arts and has played a crucial role in bringing about greater political freedoms; but as Isaiah Berlin bitingly observed, it has also bolstered irrationality, fueled antiliberal political movements, and had a significant role in the propagation of brutal mythologies regarding classless societies, chosen nations, and supreme races.[2]

More recently, the drive to Romanticize the world has contributed substantially to the birth of what I see as our poetic age. "Poetic" means here not only poetry but poiesis. Today we can find worldwide abundant manifestations of the Romantic desire to place free imagination and creativity at the center of human life. Never before have so many people spent so much time and energy on activities that, until very recently, were mostly the prerogative of artists: we write and publish

on various platforms in countless ways—from the 280 characters of a tweet to entire novels. We create and manipulate photographs and videos and effortlessly (if often thoughtlessly) share them with people near and far. We collect, curate, and design elaborate constellations of word and image. We instantly distribute our ideas and sensations while encountering those of the many other people we "follow." From the comfort of our homes and our workplaces or as we travel between them, we immerse ourselves in a 360-degree view of a gallery or museum on the other side of the world. We virtually attend a live concert, a theater production, or a dance performance on a distant continent. Using digital technology, we also cut, paste, and manipulate those moving images and sounds to create our own artworks.

To say that we live in a poetic age does not mean that I want to sing the praises of an existing, or a coming, digital utopia. Quite the opposite. The benefits of our poetic age are not available to all; the digital divide, in fact, may be growing or, at least, will remain substantial for decades if not centuries to come.[3] As we are now just beginning to realize, these new forms of poiesis are also deadly tools. The sweeping new creativity of our time has given birth to the epidemic of "fake news," feigned social media accounts, so-called trolls who harass the vulnerable, and an unprecedentedly loud popular culture that is arguably as inane as it is cacophonous.

As has become clear for the most prescient cultural observers, our poetic age empowers tyrannical politicians to surveil all our movements, to intervene in the legitimate political process of other states, and to spread havoc in political cultures throughout the world.[4] Yet recent technological advances may afford new avenues for poetic thinking. Just as Michel Serres argues in his 2012 essay "Petite Poucette," I am convinced that today's digital technologies pose unprecedented danger to our political freedom but, if employed thoughtfully, can help us, using Rorty's catchphrase, "take care of freedom." I believe technology can protect and even enhance our liberties in this historical moment that is perhaps better known for its new tyrannical tendencies—from actual, "old-school" despotism to our own self-inflicted subjugation to the allure of our devices, to the thoughtlessness that results in the cycle of production and consumption that drives our use of them.[5]

Technology changes our world every day, in more ways than I could ever address here. With this limitation in mind, we must grapple with the tension between the promises and dangers of our poetic age. One way is via the abundant complexities of art. Here I explore one emblematic example: a museum installation by Laura Poitras (b. 1964), an artist whose entire oeuvre touches on the question of freedom and tyranny today. I started this grappling in February 2016, as I was lying on a large platform, together with other exhibition visitors, in the middle of a small hall at the Whitney Museum of American Art in New York City. In this comfortable position, I was looking at time-lapse projected video images of a star-dotted night sky and listening to what sounded like the chatter of air traffic control. There was something both beautiful and eerie in the images and sounds: the sense of an endless open space and the disquieting feeling of being vulnerable, exposed.

The artwork I was experiencing was *Bed Down Location* (2016), part of Poitras's larger installation, *Astro Noise*, on display from February to May 2016. The interlinked artworks of *Astro Noise* were a multimedia meditation on our contemporary, technologically driven political and ethical circumstances.[6]

The title itself engages the question of technology. It borrows a military term that denotes the place where a person sleeps while drones, often weaponized, attempt to spy from above. The work projected recurring images of the night sky over Yemen, Somalia, and Pakistan on the ceiling above the cushioned platform on which I was lying. It also projected images of the sky over Creech Air Force Base in Nevada, where drones are steered remotely.[7] The sounds were made by the tiny drone engines and the chatter of their pilots, thousands of miles away. Further elements of the uncanny score came from recordings of radio noise heard at the edge of the universe, a reference to the title of the exhibition, *Astro Noise*.[8]

As I lay in the small exhibition hall, I sensed an *Atemwende*. Before visiting the exhibition, I knew that in recent decades drones have become a central means of espionage and warfare and are used to trace the movements of individuals and groups suspected of various crimes, including terrorism, and to collect vast amounts of data. I was also aware that in the hunt to kill such operatives, drones often inflict horrific

injuries and death on innocent civilians.[9] In the secure space of an exquisitely designed modern museum, I now gained some (admittedly infinitesimally slight) bodily sense of what drone warfare may feel like for countless people in the Middle East and elsewhere who are not involved in terrorism, of what they must experience as the objects of an all-embracing observation apparatus or, worse, as the potential "collateral damage" of state power.[10] From the perspective of the unmanned drone those innocent people are like the "I" in Dan Pagis's "Testimony": only "a shade" made by "a different creator." Equipped with the right technology and armed with the justification of fighting terrorism, the political and military apparatus behind those drones reminded me of the archangels in Pagis's "Another Testimony" who "Stand and admit / That you said / Let us make man, / And they said amen." In the logic of this warfare, the drone operators and commanders are, in Pagis's vicious irony, "created / in the image"—they are an expression of a self-assured, if radically derailed, divine order.

Poitras's work manifests poetic thinking in our time, precisely at the intersection of new technology, surveillance, and control. It does not present rigorous arguments against the despotic face of technological innovation. Her use of new media instead renders us sensitive to technological innovations and invites us to reflect on, and perhaps debate with others, what ethics and politics today should look like. Reflecting on the road that led her to create this artwork, Poitras noted: "By asking people to lie down and gaze upward in 'Bed Down Location,' I want them to enter an empathetic space and imagine drone warfare—not *simply to understand it* from news articles but to *ponder the sky and imagine* that there is a machine flying above you that could end your life at any moment. What does that feel like? . . . There's a lot of conceptual art that talks about violence or power *in an intellectual way*, but I want to expand people's *understanding emotionally*."[11]

Poitras juxtaposes what we may gain from media coverage focused on providing knowledge (and encourages what I identified in the Prologue as "knowingness") with the comprehension that emerges when we bring together imagination, experience, and thought—what I call poetic thinking. She believes, as I do, that, *as* poiesis, an artwork can make us think and then think again; and the resulting emotive comprehension

may give us a new perspective on who we are: for example, in our role as citizens of the polity that operates such drones. Poitras says, "I am interested in how to humanize the war on terror for everyone, so that we understand it. So that, hopefully, you could just imagine what it would be like if your town was occupied, or if there were drones flying overhead and killing people. I think that if you could imagine another country was flying drones over Texas and killing people, people would be angry. They would be upset. Somehow there is this hierarchy of viewing other people's lives in the world. . . . Trying to shift those hierarchies is how to make it more level. That human life, loss of human life is tragic. It is life."[12]

Bed Down Location raises political and ethical questions concerning the ever-more-widespread use of technology. Abandoning for a while our upright posture (often mistaken as the embodiment of our diligent, conscientious selves), we are invited to first feel and then, perhaps, to rethink what we take to be rational and moral.[13] Mainstream media and political debate often portray the use of drones in warfare as the cogent and thus morally justifiable implementation of a "measured mean" in an armed conflict. The argument seems sound: This type of military intervention is "the lesser evil," because the "surgical removal" of a suspected terrorist would save the lives of many who might be killed if the suspected person were not assassinated. But what about the lives of the many who are killed who have committed no harm? Placing visitors to the New York exhibition on the cushioned platform and allowing them to physically feel "this could be you," Poitras's *Bed Down Location* suggests, as an artwork, what critic and architect Eyal Weizman painstakingly argues: What we see as "the moderation of violence" (e.g., in the argument of the lesser evil or the surgical strike) in the pursuit of real or perceived terrorism "is part of the very logic of violence": "humanitarianism, human rights and international humanitarian law . . . , when abused by state, supra-state and military action, have become the crucial means by which the economy of violence is calculated and managed."[14]

Utilizing the same technology that allows drones to track the motions of others and potentially wreak havoc on the lives of those we have never met, Poitras's work brings their experiences somewhat closer

to us. It invites us to question the ways in which images from contemporary war zones, such as Yemen, Gaza, or South Waziristan, are presented by the mainstream media and how this presentation results in questionable political and moral judgment. The images of the devastation to life and property we see in such distant locations are often already framed as the inevitable outcome of a justified use of force in an armed conflict. Knowing that a certain suspected operative has been killed in a drone strike, we are less likely to grieve the innocent lives lost in the attack. Lying on the cushioned platform, however, we may ask ourselves, as Judith Butler does when she philosophically reflects on warfare since September 11, "Are certain lives less worthy of our grief? Are those lives that are lost in the pursuit of the real or perceived enemy less 'grievable'"?[15] Butler convincingly argues what Poitras's art physically displays through its cushioned platform and projected images and sounds: Politicians and journalists offer an authoritative version of reality, which often contains an implicit hierarchy in which some lives are worthier of grief than others—are more or less valuable. Some lives appear more human than others. Mainstream reporting and political discourse about, say, the lives lost in a terrorist attack or in a drone strike lead us to distinguish between "the cries we can hear from those we cannot, the sights we can see from those we cannot, and likewise at the level of touch and even smell."[16]

Earlier I suggested, pointing to Alexander Kluge and Dani Karavan, that an artwork can prompt political and ethical reflection as a means of ongoing orientation, as an aid to navigation in which we consider our subjective position and our idiosyncratic emotions. Poitras's *Astro Noise* reshapes our outlook on technology and freedom by doing just that: placing us inside a new frame. Near the exit of the exhibition, for example, I discovered the crucial, second part of *Bed Down Location*. A screen displayed how the padded platform I was just resting on looks from the drone's perspective. Sensors capture the body heat of the people lying on the platform and then display it on-screen. As we stared at the night sky, we too were being surveilled, rendered as yellow and red blobs of heat. A second screen nearby displayed the metadata generated by the mobile phones of those who visited *Bed Down Location*. While I and

others were thinking that we were observing an external reality—the night sky—we were both the momentary target of surveillance and the unconscious producers of usable data.

Using the new technologies of our poetic age, *Bed Down Location* thus prompts us to consider modern surveillance technology as a tool that does not distinguish between those who believe they are in control and those who are the target of scrutiny. We are all, to various degrees and in numerous ways, entangled in the surveillance machinery. Our devices are emitting, through GPS technology, vast amounts of data on our whereabouts. By participating in social media, we are also willingly dispersing incalculable amounts of information on almost all aspects of our lives for others to use for their own goals, which often include the manipulation of our beliefs and desires. Poitras's work allows us to emotionally understand this bleak reality, to both sense and think through what critic and legal scholar Bernard Harcourt boldly calls our "expository society": a public sphere that has become determined by data-sharing devices, as well as by our barely acknowledged willingness to freely expose our lives for others to see, use, and ultimately govern. Poitras's screens present us with the new tyrannical reality in which we are almost always both the consumer and the product, the stalked stalkers.[17]

Laura Poitras, *Bed Down Location*

EXPECTING THE UNEXPECTED

Poitras's work is an exemplary instance of poetic thinking in the wake of the digital revolution. It doesn't stop at the presentation of what threatens our freedom but also points to ways in which poiesis today may counter tyranny of various sorts and thus to what may give us a sense of hope. Reflecting on the creative path that led to *Astro Noise*, Poitras says, "I very much like the idea of creating a space that challenges the viewer as to whether to venture in or not. . . . We live life not knowing what will happen next. What do people do when they're confronted with choices and risks?"[18] Choice and risk are concepts Poitras confronts in both her life and work.[19] Following the occupation of Iraq in 2003, she began filming materials that would later become the documentary film *My Country, My Country* (2006). This film is a personal and critical contemplation on the consequences of a political choice: how the decision of American president George W. Bush and his administration to invade Iraq affected the lives of Iraqi physician Dr. Riyadh al-Adhadh and his family. Making a documentary that considered the Iraq War from this perspective had clear consequences: it made Poitras the subject of surveillance by the US government.[20]

After being trailed for six years, in 2012 Poitras produced *The Program*, a short documentary for the *New York Times*,[21] which focused on whistleblower William Binney. Binney was a former employee of the National Security Agency (NSA) who made a conscious choice: to expose a spying project that after the 9/11 attacks surveilled, without warrants, US citizens. An unsettling musical score accompanies Binney's quiet elaboration of the danger this program poses for the United States: "We may fall into something like a totalitarian state like East Germany."

While making *The Program*, Poitras could not have imagined that NSA contractor Edward Snowden would watch her film online. Nor could she imagine that Snowden was soon to make his own consequential choice: to expose the massive covert surveillance practices of the NSA. Familiar with Poitras's work, Snowden turned to her in January 2013, after an attempt to approach journalist Glenn Greenwald failed.[22] Together, Poitras, Greenwald, and the *Guardian*'s Ewen MacAskill chose to take a chance with a person they did not know and weren't sure they

could trust: They traveled to Hong Kong to speak with Snowden. The result was a momentous, international debate about the unimpeded reach of US espionage after 9/11 and its infringement of basic civil rights in the United States and norms of diplomacy abroad. Their choice to interview Snowden also yielded Poitras's acclaimed 2014 documentary *Citizenfour*—a film that details, among other things, Snowden's decisions and their consequences. Seen through this lens, the film is both a testimony to despotic tendencies in the United States and a meditation on the capacity of an individual to make significant choices and take meaningful action. Long before *Citizenfour* was completed, Poitras noted in her diary: "What is this film really about? It might be about the courage to resist power. That is the theme that runs throughout. It is also about a revolutionary historical moment when a new technology emerges that shifts the balance of power. But really it is about resistance. Surveillance is the organizing theme, or the prism, through which we observe resistance."[23]

We have seen in our discussion of Gerhard Richter's *Birkenau* how the painting cycle pays tribute to the capacity of the *Sonderkommando* to do, in Hannah Arendt's words, "the improbable." Richter's work highlights what Arendt sees as the fact that "the unexpected can be expected" of humans.[24] We can never release ourselves, Arendt prompts us to acknowledge, from our ability to act or "to perform what is infinitely improbable."[25] In *Citizenfour*, Poitras presents an individual of our own day who has chosen to do just this in the face of unprecedented invasive technologies: to perform the unexpected in an age in which almost every movement we make is exposed. Her documentary demonstrates that even under circumstances that seem to exclude the possibility of action, one may still act.

The title of the Whitney exhibition is a further evocation of that possibility for action against the odds. "Astro Noise" was the name Snowden gave the file of information on the NSA's activities that he shared with Poitras and Greenwald. Invoking Snowden and his actions, the exhibition *Astro Noise* thus asks if and how we are willing to see the installation as, using Richter's description of *Birkenau*, "a testifying message in a bottle" and, in turn, if and how we will give the images and sounds we experience, again quoting Richter, "other forms in order

to further mediate [their] content." *Astro Noise* asks us to reconsider our choices and perhaps even decide to act. The path Poitras follows and I describe here is diametrically opposed to the Romantic tradition of the artist as a secluded genius focused on expression, inspiration, and sublime aesthetics. Her path leads instead from the artwork to its audience, from the singular to the plural. Poitras notes, "The reification of the artist doesn't interest me. Instead I want to do something about practice and political realities that I hope will work on its own terms."[26]

As in Richter's case, Poitras's notion of doing something is closely linked to the concept of hope: "There's something inherently hopeful about doing any kind of art. . . . You're hopeful that it's going to reach somebody. . . . I feel confident that if we knew more about what the state was doing, our relationship to it would be different. . . . I want to do work that brings some of those realities to life so that we can reckon with them."[27] Poitras's desire to make us acknowledge the prevalence of surveillance and its tyrannical nature does not mean that she wants to prescribe or determine our conclusions. Rather, the elements of *Astro Noise* "are designed to provoke, to make points sideways rather than head-on."[28] "I guess some would say it is political. I don't really think of it that way. . . . I want it to be unsettling. What would it be like if the Chinese were flying drones over the U.S.? What would it be like if our citizens were being interrogated in this way?"[29]

In the Introduction, I willingly admitted the limits of art. As much as we might like to believe otherwise, a poem is just words, and a painting is just paint—artworks alone are not sufficient to combat tyranny. However, as we have seen time and again and as Poitras's work powerfully exemplifies, poetic thinking is a potent demonstration of our inherent capacity to protect and cultivate freedom in the face of despotism or authoritarian inclinations of any given form. There is a clear relation between our ability to imagine in words and images and our ability to act in the realm of politics and ethics. Poitras's work is just one powerful example of Richard Rorty's succinct avowal that "the imagination is the principal vehicle of human progress."[30] Rorty's words are but a different formulation of Arendt's question: "*Is there a way of thinking that is not tyrannical?*" The uninhibited and creative activity Arendt calls "thinking" is clearly at work in poems like those by Amichai and Celan and

Pagis, in paintings like those by Richter, in sculptures and constructed environments like those by Karavan, and in installations and films like those by Poitras. To ask or to think or to imagine (I see little difference), "What would it be like if the Chinese were flying drones over the U.S.?" implies already seeking to cultivate a more nuanced political discourse, a polity in which ethics is not just a lofty school subject.

Citizenfour is a good example: Following the stormy reactions to Snowden's revelations and the enthusiastic reception of Poitras's film (in February 2015 she received the Oscar for Best Documentary Film), in June 2015 the US Senate voted into law and President Obama signed the USA Freedom Act—a piece of legislation that, for the first time since 9/11, imposed limits on the extensive collection of data on US citizens by American intelligence agencies.[31] Since the exposure of the NSA documents and since *Citizenfour* received much praise for promoting a critical discussion of surveillance, we have found out much more regarding the convictions and complex motivations of Snowden and Poitras.[32] We experienced, for example, what Tamsin Shaw in her critical evaluation of Snowden's work has called Snowden's willingness to "become an unwitting pawn" of Vladimir Putin's repressive regime. We also encountered Snowden's and many of his allies' anarchist rejection of institutional politics as means to "achieving effective change."[33] One would surely expect the critics of tyrannical tendencies in American policies and of those concerned with the shortcomings of human rights in Western liberal democracies to be just as alert and critical when Putin's regime exercises its repressive, often deadly, powers. While there is ample reason for a cautious evaluation of Snowden and others who share his anarchist creeds, it is widely acknowledged that the new restrictions in the USA Freedom Act are a direct result of his choices, Poitras's film, and our ability to imagine what would happen in the future if governments continued to collect data as they did before Snowden and before *Citizenfour*.

THE POETIC ENDEAVOR

The hope inherent in Poitras's doing something is not restricted to her "kind of art," particularly not when that doing something touches on politics and ethics. That hope can also be found, I believe, in the place

where I have made my home for all of my adult life: the study and teaching of humanities. Let me be clear: I do not mean primarily to endorse what has been called "the Renaissance of student activism" on American campuses in recent years—a phenomenon that has brought about both renewed attention to politics and ethics but also, at times, the performance of action for action's sake rather than nuanced thinking or sensitive political and ethical engagement.[34] The kind of hope I mean is anchored in a pedagogy that embodies and follows from poetic thinking.

Writing this essay to address the unsettling feelings with which I began, I wanted to avoid the academy's obsession with philosophy only when it "dresses itself up with the nobility of the universal," as Theodor Adorno piercingly puts it.[35] I wanted to see how poetic thinking, particularly when it touches on questions of politics and ethics, could occur in that most ordinary heart of university life: the classroom. Over the last four years I have tried to answer this question by making my classroom more "poetic" and by experimenting with more "poetic" modes of teaching. I have tried to remove the typical banisters from my classroom—method, system, immediate telos—or at the very least, I have encouraged my students to rely on those banisters less. For example, in one course I both lectured about Franz Kafka's life and work, as I have always done, *and* in the discussion section tried to cultivate the kind of uninhibited thinking his aphorisms exemplify. Kafka's aphorism "The true path . . . seems more like a tripwire than a tightrope" became the guiding principle: I told my students that every time we feel as if we have reached something like "the true path," let us pause to consider that we may have merely encountered yet another tripwire. Let us consider then if we should not go back to our departure point and continue to search.

Experimenting with this Kafka-inspired version of the Socratic method, my students and I sought to examine Hilary Putnam's notion of "ethics" (which, as noted earlier, he deliberately sets in scare quotes) as "a system of interrelated concerns" that are both "mutually supporting" and "in partial tension" with each other.[36] Exploring ethics in Putnam's vein, we discussed poems such as Celan's "Zurich, at the Stork" in lively in-class conversations. At the same time, given what I see as the unique

affordances of innovative technologies, we also used a digital tool called Lacuna to try to emulate the *spaces of* and *for* reflection that Dani Karavan's environments offer. Built by Brian Johnsrud and Daniel Bush (then Stanford PhD candidates), academic technology specialist Michael Weidner, and me, Lacuna converts typical course materials into digital form and urges students to view their habitual marginalia—from highlights of a single word to an entire treatise—as poiesis, as an integral part of the process of creation, one that has been initiated by the writer or artist but continues in the work itself. When we annotate a text or an image, Lacuna suggests, we are not only passive learners of, say, Amichai's "The Place Where We Are Right," not just engaged in "knowingness." We are also imaginatively reacting to the poem through our own associations, insights, and thoughts. Annotation, Lacuna suggests, is not just a matter of memorizing, making sure we pay attention to details, accumulating data, and so forth, but a manifestation of our "poetic imagination" as it sets "the bounds for human thought."[37]

Inspired by Rorty's link between the imagination and progress, by Arendt's notions of plurality, and by the possibilities of new technology, specifically of social media, Lacuna asks students to consider sharing their annotations with their fellow students and their instructors. The shared annotations invite further reaction from course participants, so users of Lacuna often experience an entire online conversation around a single line, a paragraph, or an image. Since I often focus in my classes on political and ethical concerns, I could see how Lacuna exemplifies, within a digital annotation platform, Putnam's notion of ethics: When students react to any given source with their annotations, they reveal the moral position that drives them. Sharing their annotations with others, they discover similarities in their convictions but also their differences. Lacuna thus embodies at the same time possible points of conversion and the tensions underlying our communal debates. Peter Singer's idea of ethics as a pursuit of enlarging the circle of the "we," enlarging the number of people whom we think of as "one of us," is again useful here: Lacuna works as a circle of "we," as an annotating, sharing, and debating circle that prompts the students to consider who belongs in their circle and reflect on whether and how their circle could be enlarged.[38]

The result of our experiments with Lacuna has been moving and promising: a boundless array of writing—from poetry to mini-essay, from aphorism to short philosophical treatise. In one version of Lacuna, which we named "Poetic Thinking," we pushed the practice of annotation even further. We asked the students to react to a textual or visual artwork by creating their own work, whether verbal, pictorial, or sonic. The result was an abundant expression of what poetic thinking may look like for today's students: from one's own words and thoughts to a collage of images found online, from photography to video footage, and even a sound-driven walk through campus. Besides helping the students learn about—absorb, process, analyze—the poems, paintings, or movie scene we discussed, "Poetic Thinking" encouraged them to imaginatively make the works in question their own. Sharing their artistic assemblages with others, the students were no longer the mere recipients of an expert's knowledge or an artist's genius. They became active participants in what Michael Oakeshott has called "the conversation of humankind," contributors to a collaborative, creative pursuit.[39]

My experiment with Lacuna is not the final answer to Arendt's question with which we began; and technology is not the only or most important defense in the face of tyranny or tyrannical thinking. As we employ Lacuna, my colleagues and I are well aware that the vast majority of learners around the world do not enjoy the benefits of technology in education, that even in academic institutions in the United States, most students do not have access to the resources offered by Stanford, one of the wealthiest universities in the world. And we know that like any other digital tool, a platform like Lacuna may become a means, in the hands of manipulators, of quite different ends: a way to alter a textual source, forge annotations, or attempt to influence an unsuspecting user for the benefit of a political puppeteer. In recent years, we have seen multiple examples of how technological advances can be used for the most venomous manipulation of individuals and even entire populations in established democracies. But this experiment has convinced us of the value of such tools: The same technologies that can be used by sinister politicians and groups to sway our beliefs may also help us expose them for what they are; the same applications that seem to hold us captive in their despotic demand to share—the same

tools with which many for-profit venues today attempt to control and manipulate our needs—can also be used to help us imagine and engage politically and ethically.

As I watched my students creatively grapple with different sources and media by composing their own work, I saw them moving away from their traditional position as passive consumers of inherited knowledge, away from the comfortable position of the diagnostic critic who criticizes the artwork as a mere external artifact, a mere thing that demands scrutiny, like a chemical substance or a physical phenomenon. I saw these students becoming dynamic participants in the process of creation.

Expanding our capacity to think poetically does not mean that we should abandon current efforts to integrate scientific methods of all sorts into humanities scholarship and education. I have no desire to overthrow reason in favor of some flowery, self-absorbed Romanticist wandering in our imaginations. I wish to establish poetic thinking as an equal, *alongside* critical, methodical discussions. Recently, Bruno Latour, Rita Felski, and others have pleaded, as I wish to do here, that we must overcome the conceptual compartmentalizing of rationality and the imagination, of scholarship and poetry, that emerged with the Scientific Revolution and that has hallowed the image of the scientist as an independent and "critical" observer of external realities.[40] Latour has shown repeatedly that our false aggrandizing of science and critique has significantly limited our idea of the sciences. It has presented the scientist as capable of examining the world and its phenomena from a noncontingent, ahistorical point of view.[41] Latour deflates this myth: "With critique, you may debunk, reveal, unveil, but only as long as you establish, through this process of creative destruction, a privileged access to the world of reality behind the veils of appearances." With the "hammer" of "critique" in hand, Latour observes, "you can do a lot of things: break down walls, destroy idols, ridicule prejudices, but you cannot repair, take care, assemble, reassemble, stitch together."[42]

Poetic thinking gives up the hammer in favor of more generative pursuits. It places the emphasis on the artist, beholder, critic, student—positions that we can all occupy—and foregrounds our capacity to partake in such activities as taking care and stitching together. These are the pursuits that Latour calls "composition" and that I see as the poetic

endeavor. Pointing to the proximity between composition and poiesis, Latour traces the origin of his term to "composure," which denotes, according to the *Oxford English Dictionary*, the action or process of constructing, arranging, and forming. Composition, in short, is poetic in nature. As Latour explains, it "has clear roots in art, painting, music, theater, dance, and thus is associated with choreography and scenography; it is not too far from 'compromise' and 'compromising,' retaining a certain diplomatic and prudential flavor."[43] Paying attention to composition, to poiesis, we set our gaze on the artwork's affordances: according to Rita Felski, "what it unfurls, calls forth, makes possible."[44] Like Felski, I follow critic Yves Citton's argument that we must overcome our valorization of the "knowledge economy" and work harder to advance "cultures of interpretation." Our current imperative—the idea that we must equip students for the "information society"—is not sufficient in and of itself. It must be balanced with the far less definitive, but no less important, endeavor to think poetically.[45]

Poetic thinking, as an expression of our "cultures of interpretation," does not mean for Citton, Felski, or me merely "recovering original or final meanings" in the tradition of classical hermeneutics; rather, it refers to imaginative engagement with an artwork or, as Felski notes, placing the emphasis on mediating and translating, as texts, images, or sounds "are slotted into ever-changing frames."[46] Poetic thinking recasts interpretation as a part of a larger and undulating whole in which the critic, beholder, or student is a significant facet of the work in question.

Acknowledging the essential role of interpreters in the humanities, we recognize the capacity of our students—and all the rest of us—to serve as poetic mediators. Latour recently suggested that we see the humanist as capable of facilitating "diplomacy": encounters among discourses, disciplines, modes of creative production, and, as I suggest, between literature and politics, for example, or between the visual arts and ethics. For Latour (as for Rorty and Oakeshott before him) there is "no metalanguage" that can serve as a final arbiter among different modes of inquiry, "no language [that] can claim to lord it over all the others, or exclude them from assembling to progressively compose a common world."[47] Thus, the humanities are most powerful when they take on a facilitating role: suggesting connections, synergies, and manners of

thought and action that may be beneficial across different disciplines, such as the study of natural sciences, law, and religion.

One of the obvious, unintended consequences of technological innovation in recent decades has been that growing numbers of people possess the means to engage in the poetic endeavor and to share their creations—from the banal and mundane to the beautiful, if not sublime—with countless people around the world. Although the despotic zeal with which we expose ourselves and share our creations aids new technologically driven threats to our freedom, it has also resulted in a never-before-experienced poetic age. Our ubiquitous writing, photographing, curating, sharing, tweeting, and so forth can of course be done thoughtlessly and can mean very little. These activities can also become a means to steal an election, spur hatred, and engender violence. Or they can challenge our typical ways of thinking, perhaps even bridge the gaps between us. They can further our orientations and suggest new paths for our lives as individuals and communities. They may also, however, become another form of subjugation and enable new kinds of tyranny. The choice, I believe, is, as always, in our hands.

Acknowledgments

Arriving at the end of the journey this essay charts, I am filled with gratitude for those whose thoughts and care accompanied me while writing.

I thank Dani Karavan and Gerhard Richter for taking the time to talk with me about their work and for sharing their ideas about art as it touches on the human capacity to think and to act. I am also deeply grateful to Laura Poitras and her team for sharing images from *Astro Noise*.

Conversations I had with close colleagues and friends were crucial for the development of this essay. My initial thoughts emerged while attending a set of lectures on the notion of poetic thinking. Conversations with Michel Chaouli, Florian Klinger, Paul North, and Eyal Peretz during the 2012 German Studies Association's annual convention gave me the motivation to begin formulating my thoughts. Florian Klinger and Eyal Peretz later read the manuscript and shared their immensely valuable insights.

I am deeply indebted to Galili Shahar for his careful questions and nuanced thoughts. Ulrich Baer and Lital Levi read the manuscript in its entirety for Stanford University Press and offered astute suggestions for improving it. Insights from Paul Kottman and Emily-Jane Cohen during the final stages of writing and during the editorial process were extremely helpful in completing this work.

I am also greatly indebted to many other friends, colleagues, and students with whom I discussed this book: Lucy Alford, Vincent

Barletta, Lina Barouch, Nicolas Cote, Ella Elbaz, Amir Engel, Nir Evron, Abigail Gillman, Idan Gillo, Courtney Blair Hodrick, Nicholas Jenkins, Melissa Kagan, Renana Keydar, Friederike Knüpling, Joshua Landy, Michal Leibowitz, Akiba Lerner, Vivian Liska, Oded Naaman, Alexander Nemerov, Shoshana Olidort, Ilana Pardes, Paul Rabinow, Naama Rokem, Eric Santner, Vered Shemtov, Matthew Smith, Thomas Sparr, and Giddon Ticotsky. Impossible as it is to individually thank each person, I have vivid memories of the contributions of every conversation and written exchange.

Special thanks are due to my past and present colleagues at Stanford's Poetic Media Lab: Daniel Bush, Brian Johnsrud, and Michael Widner, who have built the Lacuna and Poetic Thinking platforms I mention in the Coda and whose energy, wisdom, and courage continue to inspire me.

I am greatly indebted to Pamela J. Bruton and David Lobenstine for meticulously reading, commenting, and editing various versions of the manuscript and for offering numerous ways to help me, a nonnative English speaker, better convey my ideas. Cynthia Lindlof methodically prepared the final version of the manuscript for Stanford University Press. I am grateful to her for all her efforts.

Over these last few years, I often discussed this essay with my family. From my wife, Martina, I learned how often poiesis is at work in places we rarely assume it: while tending to plants in the garden, while preparing food, and even, as it is the case with her professional life, while working in the technological marketplace. From my children, Jonathan and Naomi, I learned about the joys of poetic thinking where we may least expect it: in video games or in popular music. I also had numerous conversations with them about the regrettable absence of poetic thinking in today's American schools. It was with their frustration in mind regarding the senseless scientist and utilitarian drive of the educational system that I wrote much of this work.

While my conversations with friends, colleagues, and family were central to the evolution of this work, nothing was more important than the countless insights and ideas developed during discussions and debates with my students at Stanford, who have exemplified what Hannah Arendt meant by "thinking without a banister." Thinking along these

lines is not free of risks—one may end up celebrating narcissism or hubris. Yet the free and creative development of ideas I found while teaching the course "Poetic Thinking across Media" and while using Lacuna strikes me as worthy of taking risks. I often arrived and left the seminar room with a clear feeling that the moments of curiosity, engagement, and excitement in thinking together, without guardrail or barrier, are the best aspects of my work. It would be impossible to name here all the students to whom I owe thanks. Thus, I conclude by dedicating this book to them.

Notes

PROLOGUE

1. Richard Rorty, *Achieving Our Country: Leftist Thought in Twentieth-Century America* (Cambridge, MA: Harvard University Press, 1998), 126. Rorty goes on to describe the consequences of this thrust for philosophy departments in the English-speaking world as they adopted the rigorous-logical protocol as the hallmark of philosophical writing (126–31).

2. See, e.g., Eric Hayot, "The Humanities as We Know Them Are Doomed: Now What?," *Chronicle of Higher Education*, July 1, 2018, https://www.chronicle.com/article/The-Humanities-as-We-Know-Them/243769; and Benjamin M. Schmidt's detailed analysis of the general commitment to the humanities in undergraduate education during the last six decades, "Sapping Attention," July 2018, http://sappingattention.blogspot.com/2018/07/mea-culpa-there-is-crisis-in-humanities.html.

3. Franz Kafka, *The Zürau Aphorisms of Franz Kafka*, trans. Michael Hofmann (New York: Schocken Books, 2006), 3.

4. T. W. Adorno, "The Essay as Form," trans. Bob Hullot-Kentor and Frederic Will, *New German Critique* 32 (Spring–Summer 1984): 151, 158.

5. Adorno, "Essay as Form," 164, quoting Max Bense, "Über den Essay und seine Prosa," *Merkur* 1, no. 3 (1947): 418.

6. Following Geoffrey Galt Harpham and others, I focus here on literature and the arts as an exploration of "outsiderhood," that is, of other human beings in general but, more specifically, those who differ from us in their language, culture, beliefs, and values. Geoffrey Galt Harpham, *Shadows of Ethics: Criticism and the Just Society* (Durham, NC: Duke University Press, 1999), 7.

INTRODUCTION

1. Hannah Arendt, *Denktagebuch: 1950 bis 1973*, ed. Ursula Ludz and Ingeborg Nordmann, 2 vols. (Munich: Piper Verlag, 2002), 1:45.

2. Ibid.

3. See, e.g., Hannah Arendt, " 'What Remains? The Language Remains': A Conversation with Günter Gaus," in *Hannah Arendt: The Last Interview and Other Conversations*, by Hannah Arendt (Brooklyn, NY: Melville House, 2013), 18–19.

4. Hannah Arendt, "On Hannah Arendt," in *Hannah Arendt: The Recovery of the Public World*, ed. Melvyn A. Hill (New York: St. Martin's Press, 1979), 336.

5. Ibid., 337.

6. Friedrich Schlegel, *Philosophical Fragments*, trans. Peter Firchow (Minneapolis: University of Minnesota Press, 1991), 14. "Die ganze Geschichte der modernen Poesie ist ein fortlaufender Kommentar zu dem kurzen Text der Philosophie: Alle Kunst soll Wissenschaft, und alle Wissenschaft soll Kunst werden; Poesie und Philosophie sollen vereinigt sein." Friedrich Schlegel, *Kritische Schriften und Fragmente: Studienausgabe in sechs Bänden* (Paderborn: Schöningh, 1988), Kritische Fragmente, no. 115, 1:249.

7. Susan Sontag, *As Consciousness Is Harnessed to Flesh: Journals and Notebooks, 1964–1980* (New York: Farrar, Straus and Giroux, 2012), 103. Sontag was fully cognizant of her commitment to the tradition of German Romanticism and to the aphorism as a form. See ibid., 512; and Jan Zwicky, *Lyric Philosophy* (Toronto: University of Toronto Press, 1992), 192.

8. Antonia Peacocke, "What Poetry Teaches (and Philosophy Doesn't,)" unpublished manuscript, May 15, 2018, https://antoniapeacocke.com/re search-2/. While I approach the affinity of the arts and philosophy from the perspective of the (mostly) European post-Romantic tradition, Peacocke's systematic, and in my view brilliant, presentation follows the discussion in analytic philosophy while referencing a broad array of writers from Proust to J. M. Coetzee and others.

9. Thomas Sheehan, "Heidegger and the Nazis," *New York Review of Books*, June 16, 1988, https://www.nybooks.com/articles/1988/06/16/hei degger-and-the-nazis/. There is a massive and still-growing literature on Heidegger and National Socialism and, more specifically, Heidegger and anti-Semitism. On Heidegger's anti-Semitism, see Martin Heidegger, *Überlegungen VII–XI (Schwarze Hefte 1938/39)* (Frankfurt am Main: Vittorio Klostermann, 2014); and Peter E. Gordon, "Heidegger in Black," *New York Review of Books*, October 9, 2014, http://www.nybooks.com/articles/2014/10/09/heidegger-in -black/. My conviction that Heidegger's despicable politics should not mean dismissing everything he had ever written or said is akin to that of Elliot Wolfson, who cautions us: "Heidegger is thus neither defensible nor disposable; his

thinking—and this includes above all, his philosophical scapegoating of Jews under the rubric of das Judentum—demands reflective analysis and critical questioning. This injunction is not fulfilled by refutation." Elliot Wolfson, *The Duplicity of Philosophy's Shadow: Heidegger, Nazism, and the Jewish Other* (New York: Columbia University Press, 2018), 10.

10. Hannah Arendt, "Walter Benjamin: 1892–1940," in *Men in Dark Times*, by Hannah Arendt (New York: Harcourt, Brace and World, 1968), 156.

11. Ibid., 157.

12. Walter Benjamin, "On the Concept of History," in *Selected Writings*, vol. 4, *1938–1940*, ed. Howard Eiland and Michael W. Jennings (Cambridge, MA: Belknap Press, 2003), 392.

13. Arendt, "Walter Benjamin," 166. Interestingly, Arendt's broad understanding of the poetic seems to be widely shared in today's humanities disciplines. See, e.g., "The Poetic," special issue, *CounterText* 3, no. 2 (August 2017).

14. Arendt draws on Aristotle's classic distinction that "doing and making are generically different . . . since making [ποίησις, poiesis] aims at an end distinct from the act of making, whereas in doing the end cannot be other than the act itself." Aristotle, *Nicomachean Ethics*, trans. Roger Crisp (Cambridge: Cambridge University Press, 2000), 207. On the difference between praxis and poiesis in Aristotle, see Oded Balaban, "Praxis and Poiesis in Aristotle's Practical Philosophy," *Journal of Value Inquiry* 24 (1990): 185–98. The scholarly literature on the etymology and history of these two terms is vast. I refer here to only two sources: Hans Robert Jauss and Michael Shaw, "Poiesis," *Critical Inquiry* 8, no. 3 (1982): 591–608; and Étienne Balibar, Barbara Cassin, and Sandra Laugier, "Praxis," in *Dictionary of Untranslatables: A Philosophical Lexicon*, ed. Barbara Cassin, Steven Randall, and Emily S. Apter (Princeton, NJ: Princeton University Press, 2014), 820–32.

15. The notion "poetic thinking" has appeared recently in a variety of scholarly works and essays. The critic Marko Pajević, for example, employs it in the development of a new, dialogical philosophical anthropology. See Marko Pajević, *Poetisches Denken und die Frage nach dem Menschen: Grundzüge einer poetologischen Anthropologie* (Freiburg: Verlag Karl Alber, 2012). Referring to early German Romanticism and its emphasis on poetic imagination as holding a potential for human transformation, Pajević argues in favor of adopting poetic modes of thinking in the humanities as a way to avoid the limiting viewpoint of thinking when it is confined to logic. In *Lyric Philosophy*, the poet and philosopher Jan Zwicky has discussed the poetic nature of philosophical discourse, especially in the wake of Wittgenstein's later thought. Helen Vendler has traced in the work of four masters of modernist poetry "the way thinking goes on in the poet's mind during the process of creation, and how the evolution of that thinking can be deduced from the surface of the poem." See Helen Vendler, *Poets Thinking: Pope, Whitman, Dickinson, Yeats*

(Cambridge, MA: Harvard University Press, 2004), 6. Discussing the "styles of poetic thinking" in the work of Pope, Whitman, Dickinson, and Yeats, she explores "by what means" the poets "reproduce an individual and characteristic process of thinking" (8). In her discussion of Yeats, Vendler focuses on the poetic image "as both the product of thought and the bearer of thought," on how an image "becomes thought made visible" (9). Poets are "always thinking," "creat[ing] texts that embody elaborate and finely precise (and essentially unending) meditation" (9).

16. Robert Alter, ed., *The Poetry of Yehuda Amichai* (New York: Farrar, Straus and Giroux, 2015), 66.

17. I borrow the notion of images—and, later, artworks—as "rendering us sensitive" to "matters of concern" in our individual and communal lives from Bruno Latour. In a 2014 keynote address at MIT's Center for Art, Science, and Technology (CAST), Latour discusses a variety of artworks that "render us sensitive" to our "new climatic regime." Latour thus refers to what he considers the original meaning of the term "aesthetic": "So there is a range of things with which we try to render ourselves sensitive to. And I will use the aesthetic for that, aesthetic in this original sense of making oneself sensitive to." See Bruno Latour, "Keynote Address," filmed at "Seeing/Sounding/Sensing" symposium, MIT, Cambridge, MA, September 2014, video transcript, http://arts.mit.edu/wp-content/uploads/2014/12/Symposium2014_Video-3 .pdf. For his notion of "matters of concern," see Bruno Latour, "Why Has Critique Run Out of Steam? From Matters of Fact to Matters of Concern," *Critical Inquiry* 30, no. 2 (2004): 225–48.

18. Stathis Gourgouris, "Poiēsis," in *The Princeton Encyclopedia of Poetry and Poetics*, ed. Roland Greene, Stephen Cushman, Clare Cavanagh, Janah Ramazini, and Paul Rouzer (Princeton, NJ: Princeton University Press, 2012), 1071.

19. Plato, *Republic*, in *Complete Works*, ed. John M. Cooper (Indianapolis, IN: Hackett, 1997), 10.606d.

20. Gourgouris, "Poiēsis," 1071.

21. Giambattista Vico, *The New Science of Giambattista Vico*, trans. Thomas Goddard Bergin and Max Harold Fisch (1948; repr., Ithaca, NY: Cornell University Press, 1984), 367. For a detailed discussion of poiesis in Vico, see Gabrielle Collet, *Z(e)ro Spaces: Poïesis and the Art of Collaborative Creativity* (New York: Atropos, 2014), 68–75.

22. Immanuel Kant, *Kritik der Urteilskraft*, ed. Heiner Klemme (Hamburg: Felix Meiner, 2006); and Immanuel Kant, *Critique of the Power of Judgment*, trans. Paul Guyer and Eric Matthews (Cambridge: Cambridge University Press, 2000), § 49, 315. See also Michel Chaouli, *Thinking with Kant's "Critique of Judgment"* (Cambridge, MA: Harvard University Press, 2017), 183.

23. Kant, *Critique of the Power of Judgment*, § 49, 314–15. For Chaouli's commentary on this quotation, see *Thinking with Kant's "Critique of Judgment,"* 187.

24. Martin Heidegger, *What Is Called Thinking?*, trans. J. Glenn Gray (New York: Harper and Row, 1968), 135; and Martin Heidegger, *Was heißt Denken?*, in *Gesamtausgabe*, by Martin Heidegger (Frankfurt: Vittorio Klostermann, 1975), 8:140.

25. Ludwig Wittgenstein, *Culture and Value*, ed. Georg Henrik von Wright and Heikki Nyman, trans. Peter Winch (Chicago: University of Chicago Press, 1980), 24e (emphasis in original). The German quotation is taken from Ludwig Wittgenstein, "Vermischte Bemerkungen," in *Werkausgabe*, by Ludwig Wittgenstein (Frankfurt am Main: Suhrkamp Verlag, 1990), 8:483 (emphasis in original).

26. It's impossible to provide an overview of this work here, but see, e.g., Vincent B. Leitch, "Feminist Criticism—Critical Theory, Poetics, and Politics," in *American Literary Criticism from the Thirties to the Eighties*, by Vincent B. Leich (New York: Columbia University Press, 1988), 315–24.

27. James Baldwin, "A Letter to My Nephew," *The Progressive*, January 1, 1962, *https://progressive.org/magazine/letter-nephew/*.

28. Frantz Fanon, *The Wretched of the Earth* (New York: Grove Press, 1968), 36.

29. Adam Shatz, "A Poet's Palestine as a Metaphor," *New York Times*, December 22, 2001, https://www.nytimes.com/2001/12/22/books/a-poet-s-palestine-as-a-metaphor.html.

30. Judith Butler, *Frames of War: When Is Life Grievable?* (New York: Verso, 2009), 14.

31. Carlo Rovelli, *Reality Is Not What It Seems: The Journey to Quantum Gravity*, trans. Simon Carnell (New York: Riverhead Books, 2017), 15–40.

32. I follow John Dewey's conviction that the difference between poetic and scientific thinking is limited to where the artist and the scientist place the stress in their respective works: "The odd notion that an artist does not think and a scientific inquirer does nothing else is the result of converting a difference of tempo and emphasis into a difference in kind. The thinker has his esthetic moment when his ideas cease to be mere ideas and become the corporate meanings of objects. The artist has his problems and thinks as he works. But his thought is more immediately embodied in the object. Because of the comparative remoteness of his end, the scientific worker operates with symbols, words and mathematical signs. The artist does his thinking in the very qualitative media he works in, and the terms lie so close to the object that he is producing that they merge directly into it." *John Dewey, the Later Works, 1925–1953*, vol. 10, *1934*, ed. Jo Ann Boydston and Larry A. Hickman (Carbondale: Southern Illinois University Press, 1987), 21.

33. Michael Oakeshott, "The Voice of Poetry in the Conversation of Mankind," in *Rationalism in Politics and Other Essays*, by Michael Oakeshott (Indianapolis, IN: Liberty Press, 1991), 488.

34. Ibid., 509–10.

35. Richard Rorty, *Philosophy as Poetry* (Charlottesville: University of Virginia Press, 2016), 18.

36. Plato, *Republic*, 607b5–6.

37. Ibid., 20.

38. Ibid., 11; and Richard Rorty, "Response to James Conant," in *Rorty and His Critics*, ed. Robert Brandom (Malden, MA: Blackwell, 2000), 347. See also Richard Rorty, *Take Care of Freedom and Truth Will Take Care of Itself: Interviews with Richard Rorty*, ed. Eduardo Mendieta (Stanford, CA: Stanford University Press, 2006).

39. On Rorty's and the pragmatists' notion of truth, specifically in our age of "fake news," see Cheryl Misak, "To My Best Belief: Just What Is the Pragmatic Theory of Truth?," *Aeon*, August 7, 2018, https://aeon.co/ideas/to-my -best-belief-just-what-is-the-pragmatic-theory-of-truth.

40. Hilary Putnam, *Ethics without Ontology* (Cambridge, MA: Harvard University Press, 2004); and Richard Rorty, "Ethics without Principles," in *Philosophy and Social Hope*, by Richard Rorty (New York: Penguin Books, 1999), 72–90. Jonathan Dancy advances a similar approach (yet without resorting, as Rorty and Putnam do, to philosophical pragmatism) by promoting a "particularist" concept of ethics in which moral judgment emerges "without any appeal to principles": "Particularists think that morality is in perfectly good shape and functioning quite happily [without] the mistaken link between morality and principles." Jonathan Dancy, *Ethics without Principles* (Oxford: Clarendon Press, 2006), 1.

41. Putnam, *Ethics without Ontology*, 21–22.

42. To emphasize this notion, Putnam italicized it in the original (ibid., 21).

43. Hannah Arendt, *The Life of the Mind*, 2 vols. (New York: Harcourt Brace Jovanovich, 1978), 1:4 (emphasis in original).

44. Ibid., 5.

45. Ibid.

46. Ibid., 197.

47. Arendt, *Life of the Mind*, 1:201.

48. Ibid., 191.

49. Tal Niv, "So What If the Israeli Left Is Right?," *Ha-aretz*, July 29, 2014, https://www.haaretz.com/opinion/.premium-so-what-if-were-right-1 .5257179?=&ts=_1533573870722. Niv's article is just one example in which writers, thinkers, religious leaders, and others employ Amichai's image of "the place where we are right" to develop a peaceful line of thought regarding the

future of Palestine. For another example, see Giles Fraser, "Making Peace Means Leaving the Protected Place Where We Are Right," *The Guardian*, November 16, 2012, https://www.theguardian.com/commentisfree/belief/2012/nov /16/israel-palestine-making-peace-protected-right.

50. Arendt, *Life of the Mind*, 1:191.

51. Kant, *Kritik der Urteilskraft*, 144–46; and Hannah Arendt, *Lectures on Kant's Political Philosophy*, ed. and with an interpretive essay by Ronald Beiner (Chicago: University of Chicago Press, 1982), 70–77. Unfortunately, given the framework of this essay, I cannot explore the details of Kant's notion of individual judgment in its relation to the community. For an insightful consideration of Kant's "community" in regard to judgment, see Chaouli, *Thinking with Kant's "Critique of Judgment*," 43–75.

52. According to Arendt, "It is by virtue of this idea of mankind, present in every single man, that men are human, and they can be called civilized or humane to the extent that this idea becomes the principle not only of their judgments but of their actions. It is at this point that actor and spectator become united; the maxim of the actor and the maxim, the 'standard,' according to which the spectator judges the spectacle of the world become one." Arendt, *Lectures on Kant's Political Philosophy*, 75. On Arendt's notion of judgment in relation to Kant's doctrine of aesthetic judgment, see Seyla Behabib, *The Reluctant Modernism of Hannah Arendt* (London: Sage, 1996), 186–93.

53. Hannah Arendt, "Thinking and Moral Considerations: A Lecture," in "Fifty Years of Social Research: Continental and Anglo-American Perspectives," special issue, *Social Research* 51, no. 1/2 (1984): 36.

54. Ibid., 37.

55. Susan Stewart, *Poetry and the Fate of the Senses* (Chicago: University of Chicago Press, 2002), 330.

1. THINKING POEMS: PAUL CELAN AND DAN PAGIS

1. I consider this relationship in *Zeit der Zäsur: Jüdische Dichter im Angesicht der Shoah* (Heidelberg: C. Winter, 1999) and "Eternal Present: Poetic Figuration and Cultural Memory in the Poetry of Yehuda Amichai, Dan Pagis, and Tuvia Rübner," *Jewish Social Studies* 7, no. 1 (2000): 141–66. Recently, I have also offered a comprehensive discussion of ethical lines of thought in Pagis's work. See "Ha-koakh ha-shaket: Poetika ve-etika be-shirat Dan Pagis" [The quiet force: Poetics and ethics in the poetry of Dan Pagis], in *Dan Pagis: Mehkarim u-teudot* [Dan Pagis: Studies and documents], ed. Hannan Hever (Jerusalem: Mossad Biyalik, 2016), 60–79.

2. Vendler, *Poets Thinking*.

3. Jonathan Culler, *Theory of the Lyric* (Cambridge, MA: Harvard University Press, 2015), 109–31. With this idea Culler draws on Roland Greene's "concept of the ritualistic dimension of lyric" (122) and on the Greek

epideixis: "discourse conceived as an act, aiming to persuade, to move, to innovate" (130). On Greene's discussion of the ritualistic dimension of the lyric, see Roland Greene, *Post-Petrarchism: Origins and Innovations of the Western Lyric Sequence* (Princeton, NJ: Princeton University Press, 1991).

4. James K. Phelan, "Rhetorical Literary Ethics and Lyric Narrative: Robert Frost's 'Home Burial,'" *Poetics Today* 25, no. 4 (2004): 630.

5. On the dialectic of kinship and difference between thinking and poeticizing (*Dichten* and *Denken*), see Robert André, *Gespräche von Text zu Text: Celan, Heidegger, Hölderlin* (Hamburg: Meiner, 2001), 151–75; and Jennifer Anna Gosetti-Ferencei, *Heidegger, Hölderlin, and the Subject of Poetic Language: Toward a New Poetics of Dasein* (New York: Fordham University Press, 2004), 1–26.

6. James K. Lyon mentions the books found in Celan's library and their substantial marginalia as an important intertext to many of Celan's poems. He also mentions Christoph Schwerin's claim that Celan "was determined to school himself philosophically in order to explore the proximity of thought and poetry and, if possible, achieve a synthesis between the perfection of poetic language and the rigor of philosophical thinking." See James K. Lyon, *Paul Celan and Martin Heidegger: An Unresolved Conversation, 1951–1970* (Baltimore: Johns Hopkins University Press, 2006), 9; and Christoph Graf von Schwerin, "Bittere Brunnen des Herzens: Erinnerungen und Paul Celan," *Der Monat* 2 (1981): 76.

7. Martin Heidegger, "The Origin of the Work of Art," in *Poetry, Language, Thought*, trans. Albert Hofstadter (New York: Harper and Row, 2001), 49–54.

8. Paul Celan, *Selected Poems and Prose of Paul Celan*, trans. John Felstiner (New York: W. W. Norton, 2001), 140–41, 156–57.

9. Ibid., 141.

10. For a detailed discussion of the circumstances leading to the poem, see John Felstiner, *Paul Celan: Poet, Survivor, Jew* (New Haven, CT: Yale University Press, 1995), 156–60; and Thomas Sparr, "Das Gespräch im Gedicht," *Neue Zürcher Zeitung*, November 23, 1990, 39.

11. See Barbara Wiedemann, ed., *Paul Celan, Die Gedichte: Kommentierte Gesamtausgabe in einem Band* (Frankfurt am Main: Suhrkamp, 2003), 675; and Barbara Wiedemann, ed., *Paul Celan, Nelly Sachs: Briefwechsel* (Frankfurt am Main: Suhrkamp, 1993), 41.

12. See Elaine Martin, *Nelly Sachs: The Poetics of Silence and the Limits of Representation* (Berlin: De Gruyter, 2011). See also Werner Weber, "Laudatio," Peace Prize of the German Book Trade (Frankfurt am Main: Börsenverein des Deutschen Buchhandels, 1965), http://www.friedenspreis-des-deutschen -buchhandels.de/sixcms/media.php/1290/1965_sachs.pdf.

13. Culler, *Theory of the Lyric*, 287–88.

14. Celan, *Selected Poems and Prose*, 157.

15. Arendt, "On Hannah Arendt," 336.

16. See also Klaus Manger's commentary on "Psalm" in Jürgen Lehmann and Christine Ivanović, eds., *Kommentar zu Paul Celans "Die Niemandsrose"* (Heidelberg: C. Winter, 1997), 116.

17. While the Holocaust is not directly invoked in "Psalm" or "Zurich, at the Stork," both are part of a cycle of poems that starts with "Es War Erde in Ihnen" ("There Was Earth inside Them") and includes "Die Schleuse" ("The Lock")—works that unquestionably evoke the mass killings during those dreadful years.

18. Wiedemann, *Paul Celan, Die Gedichte*, 674.

19. See Ada Pagis, *Lev Pitomi* (Tel Aviv: Am Oved, 1995), 45.

20. Many critics have written extensively on this shift. See, e.g., Pagis, *Lev Pitomi*, 89; Shimon Sandbank, "Mipnei eimat harikh: Al krissat hamimesis be-shirei Pagis" [Because of the fear of emptiness: On the collapse of mimesis in Dan Pagis's poetry], in Hever, *Dan Pagis*, 14; Yohai Openhaimer, "'Limdod et hashetach hamet': Trauma ve-poetika be-shirato shel Dan Pagis" [To measure the dead terrain: trauma and poetics in the poetry of Dan Pagis], in Hever, *Dan Pagis*, 21, 27–30, 44–46; and Michael Gluzman, "Zikaron lelo subject: Al Dan Pagis ve-shirat Dor Hamedina" [Memory without a subject: On Dan Pagis and the poetry of Dor Hamedina], in Hever, *Dan Pagis*, 111–13, 115–17, 125–35.

21. Dan Pagis, *The Selected Poetry of Dan Pagis*, trans. Stephen Mitchell (Berkeley: University of California Press, 1996), 33.

22. My translation. Another translation is presented in Warren Bargad and Stanley F. Chyet, trans., *Israeli Poetry: A Contemporary Anthology* (Bloomington: Indiana University Press, 1986), 111.

You are the first and You remain the last,
if You are not able to judge between plea and plea
between blood and blood,
listen to my heart, hardened in judgment, see my plight:
Michael, Gabriel,
Your angel collaborators
stand and admit
that You said: Let us make Man,
and they said Amen.

23. Culler, *Theory of the Lyric*, 138.

24. This idea has evolved and transformed through Pseudepigrapha, Apocrypha, and the New Testament. In Judaic thought it was the subject of concentrated contemplations by Philo, Saadia Gaon, and Maimonides, to name only a few. Through the Latin *imago dei* this metaphor became of central importance to Augustine, Aquinas, Martin Luther, and John Calvin, among many others. On the rich discussion of the notion of "in the image of

God," see Yair Lorberbaum, *In God's Image: Myth, Theology, and Law in Classical Judaism* (New York: Cambridge University Press, 2015); Andreas Schüle, "Made in the 'Image of God': The Concepts of Divine Images in Gen 1–3," *Zeitschrift für die Alttestamentliche Wissenschaft* 117, no. 1 (2005): 1–20; Johannes Reinders, "Imago Dei as a Basic Concept in Christian Ethics," in *Holy Scriptures in Judaism, Christianity, and Islam*, ed. H. M. Vroom and Jerald D. Gort (Amsterdam: Rodopi, 1996), 187–204; and Johannes Reinders and Douglas John Hall, *Imaging God: Dominion as Stewardship* (Eugene, OR: Wipf and Stock, 2004).

25. See Mayer I. Gruber, "Angels," in *The Oxford Dictionary of the Jewish Religion*, ed. R. J. Zwi Werblowsky and Geoffrey Wigoder (New York: Oxford University Press, 1997), 48–50.

26. The critics Tamar Yacobi and Sidra DeKoven Ezrahi highlight the enigmatic character of Pagis's poetry as an expression of a coherent poetic position: an aesthetics of unintelligibility. See Tamar Yacobi, "Fiction and Silence as Testimony: The Rhetoric of Holocaust in Dan Pagis," *Poetics Today* 26, no. 2 (2005): 209–55; and Sidra DeKoven Ezrahi, "Ha-shir kebuat avir betoch ha-olam ve'kebavuato: Kriah mechudeshet b'Ruach mikivunim mishtanim' shel Dan Pagis letzad Kohelet" [The poem as an air bubble in the world and as its reflection: A renewed reading of the poem "Wind from different directions" by Dan Pagis alongside Ecclesiastes], in Hever, *Dan Pagis*, 136–55. Building on Theodor Adorno's suggestion in his *Aesthetic Theory* that the artistic enigma of modernist art shifts the attention from the artist to the reader or the beholder, DeKoven Ezrahi rightly emphasizes that Pagis's poems present us with "insoluble" riddles. See Ezrahi, "Ha-shir kebuat avir betoch ha-olam ve'kebavuato," 136–37.

27. John Dewey, *The Middle Works, 1899–1924*, vol. 14 [1922], *Human Nature and Conduct*, ed. Jo Ann Boydston (Carbondale: Southern Illinois University Press, 1983), 199, 208; and John Dewey, *The Middle Works, 1899–1924*, vol. 12 [1920], *Reconstruction in Philosophy*, ed. Jo Ann Boydston (Carbondale: Southern Illinois University Press, 1982).

28. Elizabeth Anderson, "Dewey's Moral Philosophy," in *The Stanford Encyclopedia of Philosophy*, Spring 2014 ed., ed. Edward N. Zalta, http://plato.stanford.edu/archives/spr2014/entries/dewey-moral/.

29. Rorty, "Ethics without Principles," 82, 72, 82–83.

30. Ibid., 80, 82.

31. Ibid., 83.

32. Ibid., 72, 81 (emphasis in original).

33. See Allison Kaplan Sommer, "Controversy Rages over Female Singers at Israeli Memorial Ceremonies," *Ha-aretz*, May 4, 2016, http://www.haaretz.com/israel-news/.premium-1.717651.

34. Richard Rorty, *An Ethics for Today: Finding Common Ground between Philosophy and Religion* (New York: Columbia University Press, 2011), 15.

35. Putnam, *Ethics without Ontology*, 22, 23.

36. Ibid., 28.

37. Richard Rorty, "Dewey and Posner on Pragmatism and Moral Progress," *University of Chicago Law Review* 74, no. 3 (2007): 923. In the last quotation, Rorty is quoting Percy Bysshe Shelley, "A Defence of Poetry," in *Shelley's Poetry and Prose*, 2nd ed., ed. Donald H. Reiman and Neil Fraistat (New York: W. W. Norton, 2002), 509–35.

38. Felstiner, *Paul Celan*, 158. The original quotation comes from Margarete Susman, *Das Buch Hiob und das Schicksal des jüdischen Volkes* (Zurich: Steinberg Verlag, 1948).

39. See Thomas Sparr's commentary on "Zürich, zum Storchen" in Lehmann and Ivanović, *Kommentar zu Paul Celans "Die Niemandsrose,"* 67.

40. See ibid., 68.

41. I quote from Susmann following Sparr, "Das Gespräch im Gedicht," 39 (my translation).

42. On Celan's engagement with Buber's thought, see James K. Lyon, "Paul Celan and Martin Buber: Poetry as Dialogue," *PMLA* 86, no. 1 (1971): 110–20; and Bernard Fassbind, *Poetik des Dialogs: Voraussetzungen dialogischer Poesie bei Paul Celan und Konzepte von Intersubjektivität bei Martin Buber, Martin Heidegger und Emmanuel Levinas* (Munich: Fink, 1995), 33–46.

43. Martin Buber, *I and Thou*, trans. Walter Arnold Kaufmann (New York: Charles Scribner's Sons, 1970), 53 (translation modified).

44. Hannah Arendt, *The Human Condition* (Chicago: University of Chicago Press, 1958), 7–8. Arendt repeats this almost verbatim in *Life of the Mind*: "Not Man but men inhabit the planet. Plurality is the law of the earth" (1:19).

45. Paul Celan, *The Meridian: Final Version—Drafts—Materials*, ed. Bernhard Böschenstein and Heino Schmull, trans. Pierre Joris (Stanford, CA: Stanford University Press, 2011), 106 (hereafter page numbers are cited parenthetically in the text). On Spinoza, see ibid., 180; Buber, *I and Thou*, 129.

46. On Celan's implicit rejection of Benn's poetics in "The Meridian," see Amir Eshel, "Paul Celan's Other: History, Poetics, and Ethics," *New German Critique* 91 (Winter 2004): 57–77.

47. The figure of "encounter" in Celan's lyric and poetics has been discussed often during the last decades. See, for example, the thorough discussion in Fassbind, *Poetik des Dialogs*.

48. Culler, *Theory of the Lyric*, 138.

49. Arendt, *Life of the Mind*, 1:4.

50. Ibid., 5.

51. Shelley, "A Defence of Poetry," 535.

52. On hermeticism in Celan's poetry, see Thomas Sparr, *Celans Poetik des hermetischen Gedichts* (Heidelberg: C. Winter, 1989).

53. Paul Celan, *Gesammelte Werke in fünf Bänden*, ed. Beda Allemann, Stefan Reichert, and Rolf Bücher (Frankfurt am Main: Suhrkamp, 1983), 1:249.

54. Ibid., 2:12–13.

55. Ibid., 1:284.

56. Ibid.

57. Ibid., 2:327.

58. Sparr, *Celans Poetik des hermetischen Gedichts*.

59. Phelan, "Rhetorical Literary Ethics and Lyric Narrative," 630. I discuss ethics in Pagis's poetry in detail in "Ha-koakh ha-shaket."

60. Dan Pagis, *Kol ha-shirim* [Collected poems: Hebrew] (Tel Aviv: Hakibbutz Hameuhad, 1991), 211. Pagis shares the origin of this programmatic poem in an interview: Yaira Genossar, "Dan Pagis—Likro be-shem, linkot emda" [Dan Pagis—Calling it by its name, taking a stand], *Iton 77*, no. 38 (1983): 32.

61. Pagis himself describes the poem as possessing a clear political dimension in Genossar, "Dan Pagis," 32.

62. Pagis, *Kol ha-shirim*, 211.

63. Ibid.

64. Richard Rorty, "Grandeur, Profundity, and Finitude," in *Philosophy as Cultural Politics: Philosophical Papers*, by Richard Rorty (Cambridge: Cambridge University Press, 2007), 4:84.

2. THINKING PAINTINGS: ON GERHARD RICHTER

1. In our conversation in his studio in May 2016 and an e-mail dating October 4, 2018, Richter explained that he wanted to avoid any sensation-driven reaction to the painting cycle *Birkenau* when he first introduced it in Dresden in 2015. However, the artistic origin of the paintings in the four historical photographs was made clear in his February 2015 press conference in Dresden at the opening of his exhibition *Gerhard Richter. Neue Bilder* (May 20–September 3, 2015).

2. See Dan Stone, "The Sonderkommando Photographs," *Jewish Social Studies* 7, no. 3 (2001): 132–48, esp. 132; and Franziska Reiniger, "Inside the Epicenter of the Horror—Photographs of the *Sonderkommando*," https://www.yadvashem.org/articles/general/epicenter-horror-photographs-sonderkommando.html (accessed October 27, 2016).

3. Culler, *Theory of the Lyric*, 138.

4. In his discussion of *Birkenau* Benjamin H. D. Buchloh proposes this dialectic as a perspective on Richter's entire oeuvre: "One could go as far as

to suggest that for an artist such as Richter, this dialectics of amnesia and anamnesis is actually the foundation of all his interventions." Benjamin H. D. Buchloh, *Gerhard Richter's Birkenau-Paintings: Amnesia and Anamnesis* (Cologne: Verlag der Buchhandlung Walther König, 2016), 34.

5. In recent years, there has been increased interest in the junction of Richter's painting and notions of thought or "intelligence." See, for example, Christian Lotz, *The Art of Gerhard Richter: Hermeneutics, Images, Meaning* (London: Bloomsbury Academic, 2015). Lotz discusses Richter's work through the conceptual framework of "formed intelligence" (17).

6. Phelan, "Rhetorical Literary Ethics and Lyric Narrative," 630. See the discussion of James Phelan in Section 1 and his description of poetry as engendering such an encounter.

7. On the difference between Richter's work and American pop art, see, e.g., Robert Storr and Gerhard Richter, *Gerhard Richter: Doubt and Belief in Painting* (New York: Museum of Modern Art, 2003), 57.

8. On Richter's unique approach to German history in the 1960s, see ibid., 58.

9. I present Richter's paintings by referring to the works' designation in Dietmar Elger, *Gerhard Richter: Catalogue Raisonné*, vols. 1–5 (Ostfildern, Germany: Hatje/Cantz, 2011), and on his website, https://www.gerhard-richter.com/en/ (accessed March 13, 2017).

10. Dietmar Elger, *Gerhard Richter: A Life in Painting*, trans. Elizabeth M. Solaro (Chicago: University of Chicago Press, 2002), 140.

11. Florian Klinger, *Theorie der Form: Gerhard Richter und die Kunst des pragmatischen Zeitalters* (Munich: Carl Hanser Verlag, 2013), 9, 21–22, 62, 133–35, 136.

12. Robert Storr, "Interview with Gerhard Richter," in Storr and Richter, *Gerhard Richter*, 183.

13. "Interview with Irmelinde Lebeer, 1973," in *Gerhard Richter—Text: Writings, Interviews and Letters, 1961–2007*, ed. Dietmar Elger and Hans-Ulrich Obrist (London: Thames and Hudson, 2009), 81.

14. "Interview with Rolf-Gunter Dienst, 1970," in Elger and Obrist, *Gerhard Richter—Text*, 54.

15. Elger, *Gerhard Richter: A Life in Painting*, 133.

16. Stefan Locke, "Als die Klinik zur Sterbeanstalt wurde," *Frankfurter Allgemeine Zeitung*, August 28, 2017, 7.

17. Ibid.

18. On the historical and familial circumstances of *Aunt Marianne* and *Mr. Heyde*, see Elger, *Gerhard Richter: A Life in Painting*, 129–32.

19. Hannah Arendt, *Eichmann in Jerusalem: A Report on the Banality of Evil* (New York: Penguin Books, 1994). On the affinity between Richter's photo painting and Hannah Arendt's thought, specifically her notion

regarding the banality of evil (e.g., on Richter's *Uncle Rudi* as an incarnation of this very idea: Nazi wickedness hiding behind a smile and the seeming innocence of a family snapshot), see John J. Curley, *A Conspiracy of Images: Andy Warhol, Gerhard Richter, and the Art of the Cold War* (New Haven, CT: Yale University Press, 2013), 199; and Hubertus Butin, "Gerhard Richter and the Reflection on Images," in *Gerhard Richter: Editionen/Editions, 1965–2004; Catalogue Raisonné*, ed. Stefan Gronert and Hubertus Butin (Ostfildern, Germany: Hatje/Cantz, 2004), 59.

20. Storr and Richter, *Gerhard Richter*, 167–68. Hal Foster similarly suggests that by focusing on the banal, Richter subverts what appears to be the benign nature of the mundane. See Hal Foster, "Schein im Sinne Gerhard Richters," in *Gerhard Richter: Fotografie und Malerei—Malerei als Fotografie Acht Texte zu Gerhard Richters Medienstrategie*, ed. Dietmar Elger and Kerstin Küster (Cologne: Verlag der Buchhandlung Walther König, 2011), 91.

21. "Interview with Jan Thorn-Prikker, 2004," in Elger and Obrist, *Gerhard Richter—Text*, 469. For a discussion of Richter's first encounter with images from concentration camps and their relation to *Birkenau*, see also his interview with Julia Voss and Peter Geimer, "Man kann Auschwitz nicht abmalen," *Frankfurter Allgemeine Zeitung*, February 25, 2016, 9, http://www.faz.net/aktuell/feuilleton/kunst/gerhard-richter-im-interview-ueber-gemael-dezyklus-birkenau-14088410.html.

22. Elger, *Gerhard Richter: A Life in Painting*, 20. For a detailed description of this project, see Kathrin Hoffmann-Curtius, Sigrid Philipps, and Anthony Mathews, *Judenmord: Art and the Holocaust in Post-war Germany* (London: Reaktion Books, 2018), 182–85.

23. Helmut Friedel and Gerhard Richter, *Atlas* (Cologne: Verlag der Buchhandlung Walther König, 2006), sheets 16–20. On the genealogy of Richter's collection of Holocaust images, see also Buchloh, *Gerhard Richter's Birkenau-Paintings*, 6–12.

24. Friedel and Richter, *Atlas*, sheets 21–23; and the discussion in Buchloh, *Gerhard Richter's Birkenau-Paintings*, 6–7.

25. Plans for this exhibition were eventually abandoned. See Richter's interview with Voss and Geimer, "Man kann Auschwitz nicht abmalen," 9. Kathrin Hoffmann-Curtius locates the actual source of the photographs Richter used in Gerhard Schoenberner, *Der Gelbe Stern: Die Judenverfolgung in Europa 1933 bis 1945* (Hamburg: Rütten and Loening, 1960) See, also Hoffmann-Curtius, Philipps, and Mathews, *Judenmord*, 309.

26. Hoffmann-Curtius, Philipps, and Mathews, *Judenmord*, 307–9. I agree with curator Mark Godfrey and with Paul Rabinow, who suggested in their consideration of Richter's abandoned exhibition plans that Richter's drive was to avoid turning the original photographs into "a monumentalist form." See Mark Godfrey's lecture "A Curtain of Trees," filmed November

2011 at Tate Modern, London, video, https://www.gerhard-richter.com/en
/videos/talks/a-curtain-of-trees-50.

27. See Buchloh, *Gerhard Richter's Birkenau-Paintings*, 6n2.

28. Helmut Friedel, "Gerhard Richter: Aufgehoben im Bild—zum *Birke-
nau-Bild*," in *Gerhard Richter: Birkenau*, ed. Helmut Friedel (Cologne: Verlag
der Buchhandlung Walther König, 2016), 8, 20n6.

29. Storr and Richter, *Gerhard Richter*, 147. On the ethical dimension
of Richter's work, see also Elger, *Gerhard Richter: A Life in Painting*, 333; and
Alex Danchev, "Der Künstler und der Terrorist oder Das Malbare und das
Unmalbare: Gerhard Richter und die Baader-Meinhof-Gruppe," in Elger and
Küster, *Gerhard Richter: Fotografie und Malerei*, 60. Danchev states clearly,
"For Richter, painting is a moral act" (60).

30. "Interview with Benjamin H. D. Buchloh, 1986," in Elger and Obrist,
Gerhard Richter—Text, 180–81.

31. "Interview with Gregorio Magnani, 1989," in Elger and Obrist, *Ger-
hard Richter—Text*, 222–23.

32. Friedel and Richter, *Atlas*, sheets 635–49. On Richter's selection of
photographs for this project, see Hoffmann-Curtius, Philipps, and Mathews,
Judenmord, 182–85, 311–13.

33. Voss and Geimer, "Man kann Auschwitz nicht abmalen," 9. See also
Buchloh, *Gerhard Richter's Birkenau-Paintings*, 7–8.

34. Gerhard Richter, Hans Ulrich Obrist, and David Britt, "Conversation
with Jan Thorn-Prikker," in *The Daily Practice of Painting: Writings and Inter-
views, 1962–1993*, by Gerhard Richter (Cambridge, MA: MIT Press, 1995),
206. See also Elger, *Gerhard Richter: A Life in Painting*, 333.

35. Voss and Geimer, "Man kann Auschwitz nicht abmalen," 9.

36. The book appeared originally as *Images malgré tout* (Paris: Minuit,
2004). The German translation appeared as *Bilder trotz allem* (Munich: Fink
Verlag, 2007). Richter had read the book review by the German literary
scholar Helmut Lethen. See Helmut Lethen, "Dein Herz sei Stein, dein Auge
ein Apparat," *Frankfurter Allgemeine Zeitung*, February 11, 2008.

37. Richter was familiar with one of the four photographs before reading
the review of Didi-Huberman's book. He included it in sheet 19 of his *Atlas*.
See the image on the bottom left, in Friedel and Richter, *Atlas*, sheet 19 ("Pho-
tos from Books," 1967).

38. Corinna Belz, dir., *Gerhard Richter: Painting* (Berlin: Zero One Film,
2011), film, 97 minutes. Pointing to the photograph, he highlighted that one of
the men is balancing his body, and he spoke about his first encounter with im-
ages of the Holocaust at the Dresden Academy of Fine Arts: "Since then it has
captivated me [*seitdem beschäftigt mich das*]: images, reports of these atrocities."

39. Gerhard Richter and Nicholas Serota, "I Have Nothing to Say and
I'm Saying It: Conversation between Gerhard Richter and Nicholas Serota,"

in *Gerhard Richter: Panorama*, by Gerhard Richter, Mark Godfrey, Nicholas Serota, Dorothée Brill, Camille Morineau, and Achim Borchardt-Hume (London: Tate Publishing, 2011), 25.

40. Georges Didi-Huberman, "Out of Plan, Out of Plane," in *Gerhard Richter: Pictures/Series*, by Hans Ulrich Obrist, Georges Didi-Huberman, Dieter Schwarz, and Gerhard Richter (Riehen, Basel, Switzerland: Fondation Beyeler, 2014), 165.

41. After completing the work, Richter's wrestling with his subject and the title did not end. The paintings were first presented in the Galerie Neue Meister in 2015 as *Abstrakte Bilder (Abstract Paintings)* (CR 937-1 to 937-4) together with four digital reproductions (CR 937 B). The exhibition *Gerhard Richter, Birkenau* at the Frieder Burda Museum in Baden-Baden in 2016 presented these two works as *Birkenau*. In 2015, Richter also published a separate book titled *Birkenau* (Cologne: Verlag der Buchhandlung Walther König) that displays ninety-three elements from the *Birkenau* painting cycle as digital photographs.

42. Asked by Benjamin H. D. Buchloh about Adorno's famous statement "After Auschwitz, lyric poetry is no longer possible," Richter replies that Adorno's position doesn't hold for him: "No. There is lyric poetry after Auschwitz," and, by extension, there is art after the Holocaust. See "Interview with Benjamin H. D. Buchloh, 1986," 175.

43. Susan Sontag, *On Photography* (London: Penguin Books, 1979), 20.

44. Buchloh, *Gerhard Richter's Birkenau-Paintings*, 13–14.

45. Ibid., 15.

46. Ibid., 29.

47. Voss and Geimer, "Man kann Auschwitz nicht abmalen," 9.

48. Friedel, "Gerhard Richter: Aufgehoben im Bild," 14; and Buchloh, *Gerhard Richter's Birkenau-Paintings*, 25.

49. Voss and Geimer, "Man kann Auschwitz nicht abmalen," 9.

50. Ibid.

51. "Diese vier Photos sind so gut, dass ich sie nur so belassen kann" (ibid.).

52. Georges Didi-Huberman, *Images in Spite of All*, trans. Shane B. Lillis (Chicago: University of Chicago Press, 2008), 20 (emphasis in original).

53. Michael Rothberg, *The Implicated Subject: Beyond Victims and Perpetrators* (Stanford, CA: Stanford University Press, 2019).

54. See, for example, art historian Wolfgang Brauneis and curator Hans-Jürgen Hafner's review of *Birkenau*, in which they claim that Richter's work is an attempt to present a finite artistic representation of the Holocaust, to present it as a "*closed job*" (emphasis and English in original). See Wolfgang Brauneis and Hans-Jürgen Hafner, "Das Richtersche Rakel-Treatment," *Perlentaucher*, July 7, 2016, https://www.perlentaucher.de/essay

/gerhard-richter-birkenau-problematik-eines-werkzyklus.html. Cynical and polemical, Brauneis and Hafner judge *Birkenau* to be an unquestionable artistic "failure" at addressing what the title of the work promises. They also sharply question critics such as Didi-Huberman who dare to view Richter's attempt to treat the Holocaust in his art a "success." For Brauneis and Hafner, the different elements of the Baden-Baden exhibition (the presentation of the *Sonderkommando* photographs, the digital reproductions CR 937 B) and the book project *"Mit meiner Vergangenheit lebe ich"—Memoiren von Holocaust-Überlebenden* (discussed later) are nothing less than a smart marketing maneuver to deliver a "'*Birkenau*'-package [das 'Birkenau'-Paket]" to the bourgeois audience. Art historian Stefan Krankenhagen argues similarly that *Birkenau* and its "staging" by art historian Helmut Friedel as a lifelong pursuit (*Lebensaufgabe*) are "pathetic" and "kitschy." Going even further than Brauneis and Hafner, Krankenhagen imagines what amounts to a conspiratorial attempt by art critics and the *Frankfurter Allgemeine Zeitung* to create a drama in which Richter's *Birkenau* serves as the telos for modernist art in general and for art as it grapples with the Holocaust in particular. Common to Brauneis, Hafner, and Krankenhagen is the notion that Richter's work is an attempt to answer the open question regarding the representability of Auschwitz-Birkenau by creating an artwork that tries to *re*present the event. Yet Richter's work, in my view, does not aim to *re*present the concentration camp Auschwitz-Birkenau or the Holocaust in any way. Rather, it is a poetic *reaction* to these experiences, specifically as they are invoked in the four photographs. Nothing in the paintings themselves, in the exhibitions in Dresden and Baden-Baden, and in Richter's statements in interviews supports those critics' idea that *Birkenau* reflects an attempt to settle the question regarding the possibility of *re*presenting the Holocaust "once and for all." Rather, Richter's cycle, curatorial decisions around its presentation, and cautious, personal interview statements indicate time and again the need to continue to think and rethink, to further react in various ways to the ethical and political challenges that fascism, modern genocide, and, specifically, the Holocaust present to us. What is also unsettling in these critics' writing is what I discuss later in respect to Wolfgang Ullrich: the moralistic rhetoric that has characterized debates around questions of remembrance in the German public sphere since the early 1980s. See Wolfgang Ullrich, "Debatte um Gerhard Richter: Finde Bedeutung!," *Art: Das Kunstmagazin*, May 4, 2015, https://ideenfreiheit.files.wordpress.com/2015/04/debatte-um-gerhard -richter-finde-bedeutung-art.pdf.

55. Friedel, "Gerhard Richter: Aufgehoben im Bild," 12; and Buchloh, *Gerhard Richter's Birkenau-Paintings*, 30.

56. By suggesting that *Birkenau* be considered as a pictorial score, I am also thinking of Richter's ongoing fascination with music as an immediate, visceral aesthetic experience. As a series of paintings, *Birkenau* thus continues

a musical thread running through Richter's work, including such works as *Bach* (1992; CR 785–88) and *Cage* (2006; CR 897). On seriality in Richter's work, see Hans Ulrich Obrist, introduction to Obrist et al., *Gerhard Richter: Pictures/Series*, 14–17.

57. Voss and Geimer, "Man kann Auschwitz nicht abmalen," 9 (emphasis added).

58. See, for example, his reaction to Robert Storr in their 2001 interview: "I have to distance myself from the concept of the *model*." Storr and Richter, *Gerhard Richter*, 183.

59. Voss and Geimer, "Man kann Auschwitz nicht abmalen," 9 (emphasis added).

60. Arendt, *Human Condition*, 247.

61. Ibid., 9.

62. Ibid., 178.

63. Buchloh, *Gerhard Richter's Birkenau-Paintings*, 6.

64. Richard Rorty, *Philosophy and Social Hope* (New York: Penguin Books, 1999), 265.

65. Gerhard Richter, "Text for Catalogue of *documenta 7*, Kassel, 1982," in Elger and Obrist, *Gerhard Richter—Text*, 121.

66. Gerhard Richter, "Notes, 1986," in Elger and Obrist, *Gerhard Richter—Text*, 159–60.

67. "Gerhard Richter and Benjamin H. D. Buchloh, 1986," in Elger and Obrist, *Gerhard Richter—Text*, 176–77. In a conversation with journalist Christiane Vielhaber, he similarly states, "Some people do this and others do that, and all these abilities belong to the richness of our humanity. It's a hopeful thing, to possess this ability, and a good, humanistic thing. It stands in opposition to all the unpleasant things, such as aggression and malice, war and crime." She asks, "In defining the function of art, then, would art be for you an ingredient of hope?" And he replies, "It's absolutely an ingredient of hope! To me it means this other side, which engenders hope, because we have this side in us: beauty, love, truth!!" "Interview with Christiane Vielhaber, 1986," in Elger and Obrist, *Gerhard Richter—Text*, 190–91. When, in a conversation with him a year later, the Dutch art critic Anna Tilroe wonders about the prevalence of the word "hope" in his diary, he responds, "I think that hope is one of our most important qualities. It is also a very simple quality; just a side-effect of consciousness. We are the only living beings that have a consciousness. Consciousness means knowing that I am here now and that I was here yesterday; on that basis I hope and believe that I shall be here tomorrow. It is a simple mechanism. But it is often misused and perverted." "Interview with Anna Tilroe, 1987," in Elger and Obrist, *Gerhard Richter—Text*, 197. In a diary note from June 1992, Richter continues this line of thought: "Consciousness is the capacity to know that we and others are and were and

will be. It is therefore the capacity to visualize, and therefore the belief that keeps us alive. Without visualizing the future, and our own goals and tasks, we should vegetate and—since we lack the instinct that the animals have—we should perish. Belief (view, opinion, conviction, hope, plan, etc.) is thus our most important quality and capacity. And in the form of faith it can dominate us with such power and conviction that we transform it into destructive superstition. That is why we must always confront belief with scepticism and analysis." Gerhard Richter, "Notes, 1992," in Elger and Obrist, *Gerhard Richter—Text*, 276–77. And when the journalist Birgit Grimm wonders in a conversation with Richter in 2000, "Is there a message inherent in the beauty of your paintings?," he answers, "Not a message, but the hope that life *can be* beautiful." "Interview with Birgit Grimm, 2000," in Elger and Obrist, *Gerhard Richter—Text*, 354 (emphasis added).

68. Paul Rabinow, *Unconsolable Contemporary: Observing Gerhard Richter* (Durham, NC: Duke University Press 2017), 8.

69. On the notion of the "unconsoled" in the context of Richter's work, see ibid.,125–36.

70. Richter's *Birkenau* was displayed November 2016–February 2017 at the Jewish Museum and Tolerance Center in Moscow and as part of the Richter retrospective at Prague's National Gallery, April–September 2017.

71. See Ivan Lefkovits, "Holocaust vollendet—unvollendet," in *"Mit meiner Vergangenheit lebe ich"—Memoiren von Holocaust-Überlebenden*, ed. Ivan Lefkovits, 16 vols. (Berlin: Jüdischer Verlag im Suhrkamp Verlag, 2016), 16:8.

72. See, e.g., Ingeborg Ruthe, "Auschwitz, Feuer, Ascheregen," *Frankfurter Rundschau*, March 4, 2015, https://www.fr.de/kultur/kunst/auschwitz-feuer-ascheregen-11645953.html.

73. "Interview with Benjamin H. D. Buchloh, 2004," in Elger and Obrist, *Gerhard Richter—Text*, 492.

74. "Painting," he notes in 1962, "has nothing to do with thinking, because in painting thinking is painting. Thinking is language—record-keeping—and has to take place before and after." Gerhard Richter, "Notes, 1962," in Elger and Obrist, *Gerhard Richter—Text*, 15.

75. Storr and Richter, *Gerhard Richter*, 183.

76. Hannah Arendt, "Introduction," in *Auschwitz: A Report on the Proceedings against Robert Karl Ludwig Mulka and Others before the Court at Frankfurt*, by Bernd Naumann, trans. Jean Steinberg (London: Pall Mall, 1966), xi–xxx. On the Auschwitz trial more generally, see Devin O. Pendas, *The Frankfurt Auschwitz Trial, 1963–1965: Genocide, History, and the Limits of the Law* (Cambridge: Cambridge University Press, 2006); and Rebecca Wittmann, *Beyond Justice: The Auschwitz Trial* (Cambridge, MA: Harvard University Press, 2005), 20.

77. Arendt, *Life of the Mind*, 1:5.

78. Ibid., 11–12.

79. On the affinity between Arendt's and Rorty's concept of metaphor, see Amir Eshel, *Futurity: Contemporary Literature and the Quest for the Past* (Chicago: University of Chicago Press, 2013), 7–9.

80. See Arendt, *Denktagebuch, 1950 bis 1973*, 2:728.

81. Ibid., 1:46.

82. Arendt, *Life of the Mind*, 1:105, 106.

83. Ibid., 105–6. See also Ernest Fenollosa, "The Chinese Written Character as a Medium for Poetry," in *Instigations*, by Ezra Pound (Freeport, NY: Books for Libraries Press, 1967), 25.

84. See, e.g., his nuanced exchange with Jan Thorn-Prikker on *War Cut* and the Iraq War. When Thorn-Prikker asks Richter, "Do you think your book [*War Cut*] involves a sense of mourning?," Richter replies, "Yes, and rage, too. Mainly rage because war is upsetting, because it demonstrates our impotence, because obviously we can't prevent it, because we cannot assess it anywhere near adequately. That becomes apparent in the many different judgments, prejudices and simplifications we hear and read. That is also why I absolutely avoided expressing an opinion, which is completely useless here and obstructs the attempt to come somewhat closer to the truth. In addition, my opinion is certainly just as wrong as that of my friends who almost all greatly simplify matters, condemning the war and grumbling about Bush in a way that is close to kitsch. That is not my way. I certainly don't think the war is unnecessary. Otherwise it wouldn't happen. And we are certainly far from being able to do without wars." "Interview with Jan Thorn-Prikker, 2004," 462.

85. See Storr and Richter, *Gerhard Richter*, 174; and "Interview with Jan Thorn-Prikker, 2004," 478.

86. Arendt, *Life of the Mind*, 1:104.

87. Ibid., 108–9.

88. See Hanno Rauterberg, "'*Birkenau*': Schlussgemalt," *Zeit Online*, February 11, 2016, http://www.zeit.de/2016/05/birkenau-gerhard-richter -schoah-drei-buecher. In his polemical review of *Birkenau* ("Debatte um Gerhard Richter"), art historian Wolfgang Ullrich goes even further to suggest that the paintings "need the abstraction as a 'protective jacket' [*Schutzmantel*] so they can avoid the scandal of their enormous monetary worth." Ullrich even suggests, with a rhetorical question, that Richter may have wanted to use *Birkenau* to increase his reputation at the cost of the victims. Ullrich's insinuation has little basis given Richter's clear position that *Birkenau* will not be made available for sale on the art market (see, e.g., Voss and Geimer, "Man kann Auschwitz nicht abmalen"). While Ullrich's position is hardly informative for our understanding of *Birkenau*, it is highly indicative of the moralist rhetoric of the debates surrounding National Socialism in general and the

Holocaust in particular that have characterized the German public sphere since the early 1980s. See Eshel, *Futurity*, 27–73.

89. Quoted in Hoffmann-Curtius, Philipps, and Mathews, *Judenmord*, 317.

90. Georges Didi-Huberman, "Die Malerei in ihrem aporetischen Moment," in Friedel, *Gerhard Richter*, 31–32. Robert Storr puts it similarly when he writes: "A broadly philosophical painter, more than a strictly conceptual one, a radical thinker and often traditional maker . . . Richter is an image-struck-poet of alertness and restraint, of doubt and daring." Storr and Richter, *Gerhard Richter*, 149.

91. Belz, *Gerhard Richter: Painting.* The quotes are from the film's transcript (selections), http://www.hoehnepresse-media.de/medien/gerhard_richter _painting/download/RPK_Ausschnitte_GERHARD_RICHTER_PAINTING .pdf (accessed August 3, 2018).

92. Hannah Arendt, "Thinking and Moral Considerations," 37.

3. THINKING SCULPTURES: ON DANI KARAVAN

1. Arendt, *Human Condition*, 198–99.

2. Pierre Rastany, *Dani Karavan*, trans. Jean Marie Clarke and Caroline Beamish (Munich: Prestel-Verlag, 1992), 24; and Marc Scheps, "An Axis for the Future," in *Dani Ḳarayan ḥoref 97 Ramat Gan* Yiśraʾel, by Dani Karavan, Meir Ahronson, and Smadar Schindler (Ramat Gan: Muzeʾon le-omanut Yiśreʾelit, 1997), 109. Graham's intense dramatic sense and Noguchi's dynamic forms have been a lasting source of inspiration for Karavan. In the 1960s he designed the sets for many of Graham's performances. In those early works, one could already observe the emergence of Karavan's unique visual language.

3. Scheps, "An Axis for the Future," 110 (translation modified).

4. Many critics have commented on the ethical dimension of Karavan's work. Marc Scheps, for example, has suggested that Karavan's systematic approach to the location and material elements of his work represents more than an artistic method and offers "an ethical position." Marc Scheps, preface to *Dani Karavan*, by Pierre Rastany (Tel Aviv: Sifriat-Poalim and Tel Aviv Museum of Art, 1990), 8. I am using both the German and the Hebrew versions of this book in this section because there are some variations in the text. In her general discussion of the ethical and political dimension of Karavan's work, Idith Zertal views his aesthetics in light of the Judaic notion of *tikkun olam*, "mending the world." Idith Zertal, " 'Tikkun Olam'—die Welt heilen: Über Kunst und Politik im Werk Dani Karavans," in *Dani Karavan: Retrospektive*, by Dani Karavan, Fritz Jacobi, Mordechai Omer, Jule Reuter, and Noa Karavan Cohen (Berlin: Wasmuth, 2008), 356–61.

5. Franz Kafka, *The Trial*, trans. Breon Mitchell (New York: Schocken Books, 1999), 230–31.

6. In my interview with Karavan on June 10, 2015, he elaborated at length on his inspirations for this work, which included Assyrian and Sumerian art.

7. Rastany, *Dani Karavan*, trans. Clarke and Beamish, 14.

8. See Rorty, "Ethics without Principles," 80.

9. Later in his career, Karavan used *Makom* as the title of exhibitions in Tel Aviv and Baden-Baden. See the catalogue of the Tel Aviv exhibition: Dani Karavan, Marc Scheps, Pierre Restany, and Manfred Schneckenburger, *Makom* (Tel Aviv: Muze'on Tel Aviv, 1982). The Hebrew word מקום is occasionally spelled *maqom*. On Karavan's notion of his artwork as *makom*, see Mordechai Omer, "Die Verbindung von Gegenwart und Vergangenheit—zum Oeuvre Dani Karavans," in Karavan et al., *Dani Karavan: Retrospektive*, 13. See also Rastany, *Dani Karavan*, trans. Clarke and Beamish, 76–80. On the notion of *makom* in Judaic thought and Jewish literature, see Amir Eshel, "Between Cosmos and *Makom*: Inhabiting the World and Searching for the Sacred Space in Jewish Literature," *Jewish Social Studies* 9, no. 3 (2003): 121–38.

10. Heidegger, "The Origin of the Work of Art," 40, 41, 42, 44.

11. Ibid., 51 (emphasis added).

12. See Dani Karavan, *"Ma'alot,"* in *Dani Karavan: "Ma'alot," Museumsplatz Köln, 1979–86*, by Christoph Brockhaus (Cologne: Museen der Stadt Köln, 1986), 36.

13. Marc Augé, *Non-places: Introduction to an Anthropology of Supermodernity*, trans. John Howe (London: Verso, 1995). See also Peter Osborne, "Non-places and the Spaces of Art," *Journal of Architecture* 6 (Summer 2001): 183–94.

14. Karavan also uses train tracks in his later work: for example, in his 1993–94 *Homage to the Prisoners*, Gurs, France, and in his 1989 *Ohne Titel* (*Untitled*) for his Düsseldorf exhibition. See Dani Karavan, Fritz Jacobi, Mordechai Omer, Jule Reuter, and Noa Karavan Cohen, *Dani Karavan: Retrospektive* (Berlin: Wasmuth, 2008), 210.

15. Karavan, *"Ma'alot,"* 32. The multivalence of the number 6 in conjunction with the noun *ma'alot* is reflected, for example, in the description of King Solomon's grandeur and wisdom in 1 Kings 1:18–19. There we read that King Solomon made a great throne: "The throne had six steps [*ma'alot*], and the top of the throne was round behind: and there were stays on either side on the place of the seat, and two lions stood beside the stays."

16. Ibid., 31.

17. Ibid., 34.

18. See *"Ma'alot: Ein Environment von Dani Karavan,"* http://maalot25.de /wordpress/maalot-das-kunstwerk-als-kolner-raum-fur-kulturelle-gestaltung/ (accessed February 1, 2017).

19. See "*Ma'alaot: Ein Environment von Dani Karavan*," http://maalot25.de/wordpress/titelseite/beispiel-seite/ (accessed October 14, 2015).

20. Arendt, *Human Condition*, 247.

21. Ibid., 7.

22. In 2009 the liberal Jewish community Gescher LaMassoret e.v. used *Ma'alot* as the site for reading the names of the seven thousand Jewish citizens of Cologne who were murdered during the Holocaust. *Ma'alot* was also used by the Karavan Ensemble (led by Dani Karavan's daughter, Yael Karavan) in 2001 to stage a performance based on elements of *Ma'alot*. See The Karavan Ensemble, *Ma'alot*, http://karavanensemble.com/shows/maalot/ (accessed January 13, 2017).

23. See Zertal, "'Tikkun Olam'—die Welt heilen." As Karavan told me in our interview, the completion of the Berlin memorial for the Roma and Sinti (discussed later) was accompanied by a series of sometimes stormy debates with a various German politicians and institutions. Plurality also means debating and arguing your case. On the conflicts surrounding the Berlin memorial, see Ofer Aderet, "The Roma Holocaust Memorial That Wasn't Built in a Day," *Ha-aretz*, September 14, 2012, http://www.haaretz.com/israel-news/the-roma-holocaust-memorial-that-wasn-t-built-in-a-day-1.464974.

24. This work is also referred to occasionally as *Mifgash—Herrenabend* (*Encounter—A Gentlemen's Evening*). I use the title presented on Karavan's official website, http://www.danikaravan.com/portfolio-item/germany-mifgash/ (accessed January 19, 2017).

25. Fritz Jacobi, "Das *Grundgesetz 49* und *Mifgash—Herrenabend*—Zwei Berliner Werke von Dani Karavan," in Karavan et al., *Dani Karavan: Retrospektive*, 345.

26. See Jean Chevalier, "Circle," in *The Penguin Dictionary of Symbols*, by Jean Chevalier and Alain Gheerbrant, trans. John Buchanan-Brown (London: Penguin, 1994), 195–200.

27. Albert Einstein, *The Human Side*, ed. Helen Dukas and Banesh Hoffman (Princeton, NJ: Princeton University Press, 1981), 95.

28. "Die Würde des Menschen ist unantastbar. Sie zu achten und zu schützen ist Verpflichtung aller staatlichen Gewalt." I use the official translation on the German Federal Ministry of Justice and Consumer Protection website, "Basic Law for the Federal Republic of Germany," https://www.gesetze-im-internet.de/englisch_gg/englisch_gg.html#p0021 (accessed July 5, 2017).

29. See Foundation Memorial to the Murdered Jews of Europe, "A Poem by Santino Spinelli," http://www.stiftung-denkmal.de/en/memorials/sinti-and-roma-memorial/poem-by-santino-spinelli.html (accessed February 1, 2017).

30. Stefanie Endlich, "Homage to the Sinti and Roma," *Kunststadt Stadtkunst* 60 (2013): 24–25, https://www.bbk-kulturwerk.de/con/kulturwerk/upload/kioer/kssk/skks_60_web.pdf.

31. Rorty, *Ethics for Today*, 15.

32. On the intricate circumstances surrounding the establishment of the memorial, see Aderet, "The Roma Holocaust Memorial."

33. Alexander Kluge, *Chronik der Gefühle*, 2 vols. (Frankfurt am Main: Suhrkamp, 2000), 1:7.

34. Betonwerkstein, "*Misrach*—Ort der friedlichen Begegnung," http://www.infob.de/index.php?to=misrach (accessed February 1, 2017).

35. Founded in 1852, the Germanisches Nationalmuseum houses the largest collection of Germanic cultural history in the world. It was initiated by the Franconian nobleman Hans Freiherr von und zu Aufseß with the Romantic, nationalistic vision of establishing "a well-ordered general repertory of the entire source material for German history, literature and art." In light of Nuremberg's role during National Socialism—for example, as the site of the notorious annual Nuremberg Rally—this original emphasis on Germanic cultural history was abandoned after the war. The museum proclaims today on its website that it does not wish to present a regimented road map through Germanic cultural history but seeks "to investigate art and culture in German-speaking areas in an internationally integrated and innovative way, offering educational experiences in dialogue form." The museum's mission statement goes on to revise the institution's original Romantic-national scheme, replacing it with a linguistic one: "The word 'germanisch' in the museum's name refers to the 'Germanic cultural area,' i.e. those areas in which German was spoken at one time. The founding of the museum intended to document the unity of the German-speaking cultural regions, specifically in view of the failed political unification of German states in 1848—a politically and culturally forward-looking vision." See "History and Architecture," https://www.gnm.de/en/museum/history-and-architecture/ (accessed February 1, 2017).

36. On the history of columns, see Joseph Rykwert, *The Dancing Column: On Order in Architecture* (Cambridge, MA: MIT Press, 1996).

37. United Nations, "Universal Declaration of Human Rights," December 10, 1948, http://www.un.org/en/universal-declaration-human-rights/index.html.

38. The German version of her scathing critique of the declaration appeared in Hannah Arendt, "Es gibt nur ein einziges Menschenrecht," *Die Wandlung* 4 (December 1949): 754–70. An English version (from which I quote) appeared as "The Rights of Man: What Are They?," *Modern Review* 3, no. 1 (1949): 24–37. For a detailed consideration of Arendt's position on the concept of human rights, see Peg Birmingham, *Hannah Arendt and Human Rights: The Predicament of Common Responsibility* (Bloomington: Indiana University Press, 2006); and Christoph Menke, "The 'Aporias of Human Rights' and the 'One Human Right': Regarding the Coherence of Hannah

Arendt's Argument," in "Hannah Arendt's Centenary: Political and Philosophical Perspectives, Part I," special issue, *Social Research* 74, no. 3 (2007): 739–62.

39. For a detailed discussion of Arendt's position, see Menke, "The 'Aporias of Human Rights,'" 740.

40. Arendt, "The Rights of Man," 31.

41. Ibid., 33.

42. Ibid., 30, 37, 36.

43. Nuremberg Human Rights Center, "About Us," http://www.menschen rechte.org/lang/en/ueber-uns (accessed August 8, 2017).

44. My translation. See "Rede zur Eröffnung der Straße der Menschenrechte," https://www.nuernberg.de/imperia/md/menschenrechte/dokumente /karavan-rede-1993_neu.pdf (accessed January 13, 2017).

45. My translation. See ibid.

46. In an interview with journalist Akiva Eldar, Karavan stated, "At the center of my work, above all else, is man, his viewpoint and his connection to the environment. Everything is created for his sake." There is some irony if not contradiction in these words as Karavan seems to endorse the idea that the world was "created" for humans, but he often states his principled secular worldview, and we may want to give him the final word on the question of his convictions. Akiva Eldar, "'The Stones Cry Out,'" *Ha-aretz*, December 24, 2010, http://www.haaretz.com/israel-news/the-stones-cry-out-1.332674.

47. Shani Littman, "Citing 'Dictatorship,' Israeli Artist Wants His Work Removed from the Knesset," *Ha-aretz*, June 15, 2016, http://www.haaretz.com/israel -news/1.725248?=&ts=_1501859560622.

48. Dani Karavan, "Even mekir lo tiz'ak [For the stone shall not cry out of the wall]," *Ha-aretz*, April 30, 2006, *https://www.haaretz.co.il/news/health/1.1102086.*

49. See Gideon Efrat, "Shorashim vaakira [Roots and uprooting]," December 23, 2010, https://gideonofrat.wordpress.com/2010/12/23/שורשים-ועקירה.

50. Robert Storr, "Interview with Gerhard Richter," in Storr and Richter, *Gerhard Richter*, 183.

51. See, e.g., the report by B'Tselem, "Some 1,000 Olive Trees Uprooted to Build Bypass Road on 'Azzun Village Land," *Settlements*, February 1, 2017, http:// www.btselem.org/settlements/20170201_nabi_elyas_bypass_road_land _confiscation.

52. Primo Levi, *Survival in Auschwitz: The Nazi Assault on Humanity,* trans. Stuart Woolf (New York: Touchstone, 1993), 11.

CODA: OUR POETIC AGE

1. Frederick Beiser, *The Romantic Imperative: The Concept of Early German Romanticism* (Cambridge, MA: Harvard University Press, 2003), 20.

2. Isaiah Berlin, *The Roots of Romanticism* (Princeton, NJ: Princeton University Press, 1999).

3. *World Development Report 2016: Digital Dividends* (Washington, DC: International Monetary Fund, 2016).

4. See, for example, P. W. Singer and Emerson T. Brooking, *Likewar: The Weaponization of Social Media* (Boston: Houghton Mifflin Harcourt, 2018).

5. Michel Serres, *Thumbelina: The Culture and Technology of Millennials* (London: Rowman and Littlefield International, 2015).

6. Whitney Museum of American Art, "Laura Poitras: Astro Noise," *http://whitney.org/Exhibitions/LauraPoitras* (accessed July 5, 2017).

7. Mike Newton, "Laura Poitras' Astro Noise: Reliving a War That Never Ends," *The Indypendent*, March 3, 2016, https://indypendent.org/2016/03/laura -poitras-astro-noise-reliving-a-war-that-never-ends/.

8. This information is taken from the leaflet distributed at the exhibition. The same description appears on the Whitney's website; see Whitney Museum of American Art, "Laura Poitras: Astro Noise."

9. There is a vast literature on the use of drones in armed conflicts today. For a preliminary orientation, see, e.g., John Kaag and Sarah Kreps, *Drone Warfare*, War and Conflict in the Modern World (Cambridge: Polity, 2014); and Scott Shane, "Drone Strike Statistics Answer Few Questions, and Raise Many," *New York Times*, July 3, 2016, https://www.nytimes.com/2016/07/04/world /middleeast/drone-strike-statistics-answer-few-questions-and-raise-many.html.

10. Spencer Ackerman, "41 Men Targeted but 1,147 People Killed: US Drone Strikes—the Facts on the Ground," *The Guardian*, November 24, 2014, https://www.theguardian.com/us-news/2014/nov/24/-sp-us-drone -strikes-kill-1147.

11. Jay Sanders, "Introduction," in *Astro Noise: A Survival Guide for Living under Total Surveillance*, ed. Laura Poitras (New York: Whitney Museum of Art, 2016), 33 (emphasis added).

12. Doreen St. Felix, "The Lenny Interview: Laura Poitras," *Lenny*, April 29, 2016, http://www.lennyletter.com/culture/interviews/a360/the-lenny-inter view-laura-poitras/. "In real-time," noted Jordan Carver, the screen near the exit drives home "the treacherous moral landscape in which the entire drone program sits. Here people are not necessarily people, they have been reduced to a data stream that only accounts for basic biological functioning." Jordan Carver, "Signal to Astro Noise," *Avery Review*, March 2016, http://averyreview .com/issues/14/astro-noise. "It is an exercise in table-turning," wrote Steven Zeitchik: "Visitors believe they are safely distanced observers—only to suddenly learn they are the subject." Steven Zeitchik, "Filmmaker Laura Poitras Turns Her Anti–Big Brother Activism into Fine Art with 'Astro Noise' Museum Installation," *Los Angeles Times*, March 11, 2016, http://www.latimes.com /entertainment/movies/la-et-mn-poitras-astro-noise-20160311-story.html.

13. Stephen Squibb is spot-on when he writes that Poitras exchanged with *Bed Down Location* the appeal to conscience "for a proposition that seems both more radical and less abstract. Not Oh, isn't it awful, but This could be you." Stephen Squibb, "Moving Targets: The Work of Laura Poitras," *Artforum International* 54, no. 6 (2016): 207.

14. Eyal Weizman, *The Least of All Possible Evils: Humanitarian Violence from Arendt to Gaza* (London: Verso, 2012), 3–4.

15. Butler, *Frames of War*, esp. 1–33.

16. Ibid., 51.

17. See Bernard Harcourt's review of Laura Poitras's exhibition catalogue: "Bernard E. Harcourt Reviews Astro Noise," *Critical Inquiry*, September 23, 2016, http://criticalinquiry.uchicago.edu/bernard_harcourt_reviews_astro_noise/. Harcourt's consideration of Poitras's work is rather critical since he is concerned with Poitras's emphasis on the contemporary surveillance state as the main perpetrator: " 'The antagonist of the film [*Citizenfour*] is the state,' Poitras writes in her journal on 18 November 2012 (p. 82). From the private entries, it is clear that Orwell's dystopia was the theoretical reference point. Reading and rereading it all through February and March 2013, quoting passages from the novel in her journal, *1984* serves as the theoretical and practical spine of her work. . . . The antagonist today is not only the state; it is also all of us, as well, who expose ourselves on Facebook, YouTube, Twitter, LinkedIn, Pinterest, Google+, Tumbler, Snapchat, and Vine, who search and buy online, stream Netflix, and share images on Instagram, leaving digital traces everywhere—we who give ourselves away to total surveillance. And not only us but our gadgets and devices as well—our smartphones that emit GPS data and allow Facebook to cull data from all the other apps. Plus now the Pokemon GO virtual reality game has become another such powerful entry point into a treasure trove of personal information and interconnected geolocated data." Referring to the title of the book written to accompany the exhibition, *Astro Noise (Astro Noise: A Survival Guide for Living under Total Surveillance)*, he writes: "What we need is a survival guide to our exhibitory age and our expository society—not just to the surveillance state." See also his larger study of the "expository society": Bernard E. Harcourt, *Exposed: Desire and Disobedience in the Digital Age* (Cambridge, MA: Harvard University Press, 2015).

18. Sanders, "Introduction," 34.

19. George Packer, "The Holder of Secrets: Laura Poitras's Closeup View of Edward Snowden," *New Yorker*, October 20, 2014, http://www.newyorker.com/magazine/2014/10/20/holder-secrets.

20. Helen Regan, "*Citizenfour* Filmmaker Laura Poitras Is Suing the U.S. over Years of Alleged Harassment," *Time*, July 13, 2015, http://time.com/3956685/laura-poitras-lawsuit-u-s-government-citizenfour-harassment/.

21. Laura Poitras, "The Program," *New York Times*, August 22, 2012, http://www.nytimes.com/2012/08/23/opinion/the-national-security-agencys-domestic-spying-program.html?_r=2.

22. Unsure about the legitimacy of this unidentified source, Greenwald initially ignored Snowden's approach. Roy Greenslade, "How Edward Snowden Led Journalist and Film-Maker to Reveal NSA Secrets," *The Guardian*, August 19, 2013, https://www.theguardian.com/world/2013/aug/19/edward-snowden-nsa-secrets-glenn-greenwald-laura-poitras.

23. Laura Poitras, "Berlin Journal," in Poitras, *Astro Noise: A Survival Guide*, 95.

24. Arendt, *Human Condition*, 178.

25. Ibid.

26. Sanders, "Introduction," 35.

27. Clare Foran, "'Astro Noise': When Mass Surveillance Is Art," *The Atlantic*, February 10, 2016, https://www.theatlantic.com/entertainment/archive/2016/02/laura-poitras-whitney-surveillance/460359/.

28. Sarah Lyall, "Laura Poitras Prepares 'Astro Noise' for the Whitney Museum," *New York Times*, January 27, 2016, https://www.nytimes.com/2016/01/31/arts/design/laura-poitras-prepares-astro-noise-for-the-whitney-museum.html?_r=0.

29. Zeitchik, "Filmmaker Laura Poitras."

30. Rorty, *Philosophy as Poetry*, 11.

31. Bill Chappell, "Senate Approves USA Freedom Act, Obama Signs It, after Amendments Fail," National Public Radio, June 2, 2015, https://www.npr.org/sections/thetwo-way/2015/06/02/411534447/senateis-poised-to-vote-on-house-approved-usa-freedom-act.

32. Tamsin Shaw, "Edward Snowden Reconsidered," *New York Review of Books Daily*, September 13, 2018, https://www.nybooks.com/daily/2018/09/13/edward-snowden-reconsidered/.

33. Ibid.

34. Alia Wong, "The Renaissance of Student Activism," *The Atlantic*, May 21, 2015, https://www.theatlantic.com/education/archive/2015/05/the-renaissance-of-student-activism/393749/.

35. Adorno, "The Essay as Form," 151.

36. Putnam, *Ethics without Ontology*, 22.

37. Rorty, *Philosophy as Poetry*, 3.

38. Rorty, *Ethics for Today*, 15.

39. Oakeshott, "The Voice of Poetry."

40. On the link between pragmatism and Latour's recent thought, see Antoine Hennion, "From ANT to Pragmatism: A Journey with Bruno Latour at the CSI," trans. Stephen Muecke, *New Literary History* 47, no. 2–3 (2016): 289–308.

41. Bruno Latour, *We Have Never Been Modern*, trans. Catherine Porter (Cambridge, MA: Harvard University Press, 1993).

42. Bruno Latour, "An Attempt at a 'Compositionist Manifesto,'" *New Literary History* 41 (2010): 475.

43. Ibid., 474.

44. Rita Felski, *The Limits of Critique* (Chicago: University of Chicago Press, 2015), 12.

45. Rita Felski, "Introduction," *New Literary History* 47, no. 2–3 (2016): 222.

46. Ibid. Felski draws here on Yves Citton, *L'avenir des humanités: Économie de la connaissance ou cultures de l'interprétation* (Paris: Découverte, 2010).

47. Bruno Latour, "Life among Conceptual Characters," *New Literary History* 47, no. 2–3 (2016): 474.

Bibliography

Ackerman, Spencer. "41 Men Targeted but 1,147 People Killed: US Drone Strikes—the Facts on the Ground." *The Guardian*, November 24, 2014. https://www.theguardian.com/us-news/2014/nov/24/-sp-us-drone-strikes-kill-1147.

Aderet, Ofer. "The Roma Holocaust Memorial That Wasn't Built in a Day." *Haaretz*, September 14, 2012. http://www.haaretz.com/israel-news/the-roma-holocaust-memorial-that-wasn-t-built-in-a-day-1.464974.

Adorno, T. W. "The Essay as Form." Translated by Bob Hullot-Kentor and Frederic Will. *New German Critique* 32 (Spring–Summer 1984): 151–71.

Alter, Robert, ed. *The Poetry of Yehuda Amichai*. New York: Farrar, Straus and Giroux, 2015.

Anderson, Elizabeth. "Dewey's Moral Philosophy." In *The Stanford Encyclopedia of Philosophy*, Spring 2014 ed., edited by Edward N. Zalta. http://plato.stanford.edu/archives/spr2014/entries/dewey-moral/.

André, Robert. *Gespräche von Text zu Text: Celan, Heidegger, Hölderlin*. Hamburg: Meiner, 2001.

Arendt, Hannah. *Denktagebuch: 1950 bis 1973*. Edited by Ursula Ludz and Ingeborg Nordmann. 2 vols. Munich: Piper Verlag, 2002.

———. *Eichmann in Jerusalem: A Report on the Banality of Evil*. New York: Penguin Books, 1994.

———. "Es gibt nur ein einziges Menschenrecht." *Die Wandlung* 4 (December 1949): 754–70.

———. *The Human Condition*. Chicago: University of Chicago Press, 1958.

———. "Introduction." In *Auschwitz: A Report on the Proceedings against Robert Karl Ludwig Mulka and Others before the Court at Frankfurt*, by Bernd Naumann, translated by Jean Steinberg, xi–xxx. London: Pall Mall, 1966.

————. *Lectures on Kant's Political Philosophy.* Edited and with an interpretive essay by Ronald Beiner. Chicago: University of Chicago Press, 1982.

————. *The Life of the Mind.* 2 vols. New York: Harcourt Brace Jovanovich, 1978.

————. "On Hannah Arendt." In *Hannah Arendt: The Recovery of the Public World,* edited by Melvyn A. Hill, 301–39. New York: St. Martin's Press, 1979.

————. "The Rights of Man: What Are They?" *Modern Review* 3, no. 1 (1949): 24–37.

————. "Thinking and Moral Considerations: A Lecture." In "Fifty Years of Social Research: Continental and Anglo-American Perspectives," special issue, *Social Research* 51, no. 1/2 (1984): 7–37.

————. "Walter Benjamin: 1892–1940." In *Men in Dark Times,* by Hannah Arendt, 153–206. New York: Harcourt, Brace and World, 1968.

————. "'What Remains? The Language Remains': A Conversation with Günter Gaus." In *Hannah Arendt: The Last Interview and Other Conversations,* by Hannah Arendt, 1–38. Brooklyn, NY: Melville House, 2013.

Aristotle. *Nicomachean Ethics.* Translated by Roger Crisp. Cambridge: Cambridge University Press, 2000.

Augé, Marc. *Non-places: Introduction to an Anthropology of Supermodernity.* Translated by John Howe. London: Verso, 1995.

Balaban, Oded. "Praxis and Poiesis in Aristotle's Practical Philosophy." *Journal of Value Inquiry* 24 (1990): 185–98.

Baldwin, James. "A Letter to My Nephew." *The Progressive,* January 1, 1962. https://progressive.org/magazine/letter-nephew/.

Balibar, Étienne, Barbara Cassin, and Sandra Laugier. "Praxis." In *Dictionary of Untranslatables: A Philosophical Lexicon,* edited by Barbara Cassin, Steven Randall, and Emily S. Apter, 820–32. Princeton, NJ: Princeton University Press, 2014.

Bargad, Warren, and Stanley F. Chyet, trans. *Israeli Poetry: A Contemporary Anthology.* Bloomington: Indiana University Press, 1986.

Behabib, Seyla. *The Reluctant Modernism of Hannah Arendt.* London: Sage, 1996.

Beiser, Frederick. *The Romantic Imperative: The Concept of Early German Romanticism.* Cambridge, MA: Harvard University Press, 2003.

Belz, Corinna, dir. *Gerhard Richter: Painting.* Berlin: Zero One Film, 2011. Film. 97 min.

Benjamin, Walter. "On the Concept of History." In *Selected Writings,* vol. 4, *1938–1940,* edited by Howard Eiland and Michael W. Jennings, 389–400. Cambridge, MA: Belknap Press, 2003.

Bense, Max. "Über den Essay und seine Prosa." *Merkur* 1, no. 3 (1947): 414–24.

Berlin, Isaiah. *The Roots of Romanticism*. Princeton, NJ: Princeton University Press, 1999.

Betonwerkstein. "*Misrach*—Ort der friedlichen Begegnung." Accessed February 1, 2017. http://www.infob.de/index.php?to=misrach.

Birmingham, Peg. *Hannah Arendt and Human Rights: The Predicament of Common Responsibility*. Bloomington: Indiana University Press, 2006.

Brauneis, Wolfgang, and Hans-Jürgen Hafner. "Das Richtersche Rakel-Treatment." *Perlentaucher*, July 7, 2016. https://www.perlentaucher.de/essay/gerhard-richter-birkenau-problematik-eines-werkzyklus.html.

Brockhaus, Christoph, *Dani Karavan Maʾalot: Museumsplatz Köln, 1979–86*. Cologne: Museen der Stadt Köln, 1986.

B'Tselem. "Some 1,000 Olive Trees Uprooted to Build Bypass Road on ʾAzzun Village Land." *Settlements*, February 1, 2017. http://www.btselem.org/settlements/20170201_nabi_elyas_bypass_road_land_confiscation.

Buber, Martin. *I and Thou*. Translated by Walter Arnold Kaufmann. New York: Charles Scribner's Sons, 1970.

Buchloh, Benjamin H. D. *Gerhard Richter's Birkenau-Paintings: Amnesia and Anamnesis*. Cologne: Verlag der Buchhandlung Walther König, 2016.

Butin, Hubertus. "Gerhard Richter and the Reflection on Images." In *Gerhard Richter: Editionen/Editions 1965–2004; Catalogue Raisonné*, edited by Stefan Gronert and Hubertus Butin, 9–69. Ostfildern-Ruit, Germany: Hatje Cantz, 2004.

Butler, Judith. *Frames of War: When Is Life Grievable?* New York: Verso, 2009.

Carver, Jordan. "Signal to Astro Noise." *Avery Review*, March 2016. http://averyreview.com/issues/14/astro-noise.

Celan, Paul. *Die Gedichte: Kommentierte Gesamtausgabe in einem Band*. Frankfurt am Main: Suhrkamp, 2003.

———. *Gesammelte Werke in fünf Bänden*. Edited by Beda Allemann, Stefan Reichert, and Rolf Bücher. Frankfurt am Main: Suhrkamp, 1983.

———. *The Meridian: Final Version—Drafts—Materials*. Edited by Bernhard Böschenstein and Heino Schmull. Translated by Pierre Joris. Stanford, CA: Stanford University Press, 2011.

———. *Selected Poems and Prose of Paul Celan*. Translated by John Felstiner. New York: W. W. Norton, 2001.

Chaouli, Michel. *Thinking with Kant's "Critique of Judgment."* Cambridge, MA: Harvard University Press, 2017.

Chappell, Bill. "Senate Approves USA Freedom Act, Obama Signs It, after Amendments Fail." National Public Radio, June 2, 2015. https://www.npr.org/sections/thetwo-way/2015/06/02/411534447/senateis-poised-to-vote-on-house-approved-usa-freedom-act.

Chevalier, Jean. "Circle." In *The Penguin Dictionary of Symbols*, by Jean Che-

valier and Alain Gheerbrant, translated by John Buchanan-Brown, 195–200. London: Penguin, 1994.

Citton, Yves. *L'avenir des humanités: Économie de la connaissance ou cultures de l'interprétation.* Paris: Découverte, 2010.

Collet, Gabrielle. *Z(e)ro Spaces: Poïesis and the Art of Collaborative Creativity.* New York: Atropos, 2014.

Culler, Jonathan. *Theory of the Lyric.* Cambridge, MA: Harvard University Press, 2015.

Curley, John J. *A Conspiracy of Images: Andy Warhol, Gerhard Richter, and the Art of the Cold War.* New Haven, CT: Yale University Press, 2013.

Dancy, Jonathan. *Ethics without Principles.* Oxford: Clarendon Press, 2006.

Dewey, John. *John Dewey, the Later Works, 1925–1953.* Vol. 10, *1934,* edited by Jo Ann Boydston and Larry A. Hickman. Carbondale: Southern Illinois University Press, 1987.

———. *The Middle Works, 1899–1924.* Vol. 12, *Reconstruction in Philosophy,* edited by Jo Ann Boydston. Carbondale: Southern Illinois University Press, 1982.

———. *The Middle Works, 1899–1924.* Vol. 14, *Human Nature and Conduct,* edited by Jo Ann Boydston. Carbondale: Southern Illinois University Press, 1983.

Didi-Huberman, Georges. *Bilder trotz allem.* Munich: Fink Verlag, 2007.

———. *Images in Spite of All.* Translated by Shane B. Lillis. Chicago: University of Chicago Press, 2008.

———. *Images malgré tout.* Paris: Minuit, 2004.

Efrat, Gideon. "Shorashim vaakira." December 23, 2010. https://gideonofrat .wordpress.com/2010/12/23/שורשים-ועקירה/.

Einstein, Albert. *The Human Side.* Edited by Helen Dukas and Banesh Hoffman. Princeton, NJ: Princeton University Press, 1981.

Eldar, Akiva. "'The Stones Cry Out.'" *Ha-aretz,* December 24, 2010. http:// www.haaretz.com/israel-news/the-stones-cry-out-1.332674.

Elger, Dietmar. *Gerhard Richter: A Life in Painting.* Translated by Elizabeth M. Solaro. Chicago: University of Chicago Press, 2002.

———. *Gerhard Richter: Catalogue Raisonné.* Vols. 1–5. Ostfildern, Germany: Hatje Cantz, 2011.

Elger, Dietmar, and Kerstin Küster, eds. *Gerhard Richter: Fotografie und Malerei—Malerei als Fotografie Acht Texte zu Gerhard Richters Medienstrategie.* Cologne: Verlag der Buchhandlung Walther König, 2011.

Elger, Dietmar, and Hans-Ulrich Obrist, eds. *Gerhard Richter—Text: Writings, Interviews and Letters, 1961–2007.* London: Thames and Hudson, 2009.

Endlich, Stefanie. "Homage to the Sinti and Roma." *Kunststadt Stadtkunst* 60 (2013): 24–25. https://www.bbk-kulturwerk.de/con/kulturwerk/upload /kioer/kssk/skks_60_web.pdf.

Eshel, Amir. "Between Cosmos and *Makom*: Inhabiting the World and Searching for the Sacred Space in Jewish Literature." *Jewish Social Studies* 9, no. 3 (2003): 121–38.

———. "Eternal Present: Poetic Figuration and Cultural Memory in the Poetry of Yehuda Amichai, Dan Pagis, and Tuvia Rübner." *Jewish Social Studies* 7, no. 1 (2000): 141–66.

———. *Futurity: Contemporary Literature and the Quest for the Past*. Chicago: University of Chicago Press, 2013.

———. "Ha-koakh ha-shaket: Poetika ve-etika be-shirat Dan Pagis." In *Dan Pagis: Mehkarim u-teudot*, edited by Hannan Hever, 60–79. Jerusalem: Mossad Biyalik, 2016.

———. "Paul Celan's Other: History, Poetics, and Ethics." *New German Critique* 91 (Winter 2004): 57–77.

———. *Zeit der Zäsur: Jüdische Dichter im Angesicht der Shoah*. Heidelberg: C. Winter, 1999.

Fanon, Frantz. *The Wretched of the Earth*. New York: Grove Press, 1968.

Fassbind, Bernard. *Poetik des Dialogs: Voraussetzungen dialogischer Poesie bei Paul Celan und Konzepte von Intersubjektivität bei Martin Buber, Martin Heidegger und Emmanuel Levinas*. Munich: Fink, 1995.

Felski, Rita. "Introduction." *New Literary History* 47, no. 2–3 (2016): 215–29.

———. *The Limits of Critique*. Chicago: University of Chicago Press, 2015.

Felstiner, John. *Paul Celan: Poet, Survivor, Jew*. New Haven, CT: Yale University Press, 1995.

Fenollosa, Ernest. "The Chinese Written Character as a Medium for Poetry." In *Instigations*, by Ezra Pound. Freeport, NY: Books for Libraries Press, 1967.

Foran, Clare. "'Astro Noise': When Mass Surveillance Is Art." *The Atlantic*, February 10, 2016. https://www.theatlantic.com/entertainment/archive/2016/02/laura-poitras-whitney-surveillance/460359/.

Fraser, Giles. "Making Peace Means Leaving the Protected Place Where We Are Right." *The Guardian*, November 16, 2012. https://www.theguardian.com/commentisfree/belief/2012/nov/16/israel-palestine-making-peace-protected-right.

Friedel, Helmut, ed. *Gerhard Richter: Birkenau*. Cologne: Buchhandlung Walther König, 2016.

Friedel, Helmut, and Gerhard Richter. *Atlas*. Cologne: Verlag der Buchhandlung Walther König, 2006.

Genossar, Yaira. "Dan Pagis—Likro be-shem, linkot emda." *Iton 77*, no. 38 (1983): 32–33.

German Federal Ministry of Justice and Consumer Protection. "Basic Law for the Federal Republic of Germany." Accessed July 5, 2017. https://www.gesetze-im-internet.de/englisch_gg/englisch_gg.html#p0021.

Germanisches National Museum. "History and Architecture." Accessed February 1, 2017. https://www.gnm.de/en/museum/history-and-architecture/.

Godfrey, Mark. "A Curtain of Trees." Filmed November 2011 at Tate Modern, London. Video. https://www.gerhard-richter.com/en/videos/talks/a-curtain-of-trees-50.

Gordon, Peter E. "Heidegger in Black." *New York Review of Books*, October 9, 2014. http://www.nybooks.com/articles/2014/10/09/heidegger-in-black/.

Gosetti-Ferencei, Jennifer Anna. *Heidegger, Hölderlin, and the Subject of Poetic Language: Toward a New Poetics of Dasein*. New York: Fordham University Press, 2004.

Gourgouris, Stathis. "Poiēsis." In *The Princeton Encyclopedia of Poetry and Poetics*, edited by Roland Greene, Stephen Cushman, Clare Cavanagh, Jahan Ramazani, and Paul Rouzer, 1070–72. Princeton, NJ: Princeton University Press, 2012.

Greene, Roland. *Post-Petrarchism: Origins and Innovations of the Western Lyric Sequence*. Princeton, NJ: Princeton University Press, 1991.

Greenslade, Roy. "How Edward Snowden Led Journalist and Film-Maker to Reveal NSA Secrets." *The Guardian*, August 19, 2013. https://www.theguardian.com/world/2013/aug/19/edward-snowden-nsa-secrets-glenn-greenwald-laura-poitras.

Gruber, Mayer I. "Angels." In *The Oxford Dictionary of the Jewish Religion*, edited by R. J. Zwi Werblowsky and Geoffrey Wigoder, 48–50. New York: Oxford University Press, 1997.

Harcourt, Bernard E. "Bernard E. Harcourt Reviews Astro Noise." *Critical Inquiry*, September 23, 2016. http://criticalinquiry.uchicago.edu/bernard_harcourt_reviews_astro_noise/.

———. *Exposed: Desire and Disobedience in the Digital Age*. Cambridge, MA: Harvard University Press, 2015.

Harpham, Geoffrey Galt. *Shadows of Ethics: Criticism and the Just Society*. Durham, NC: Duke University Press, 1999.

Hayot, Eric. "The Humanities as We Know Them Are Doomed: Now What?" *Chronicle of Higher Education*, July 1, 2018. https://www.chronicle.com/article/The-Humanities-as-We-Know-Them/243769.

Heidegger, Martin. "The Origin of the Work of Art." In *Poetry, Language, Thought*, translated by Albert Hofstadter, 15–86. New York: Harper and Row, 1975.

———. *Überlegungen VII–XI (Schwarze Hefte 1938/39)*. Frankfurt am Main: Vittorio Klostermann, 2014.

———. *Was heißt Denken?* In *Gesamtausgabe*. Frankfurt am Main: Vittorio Klostermann, 1975.

———. *What Is Called Thinking?* Translated by J. Glenn Gray. New York: Harper and Row, 1968.

Hennion, Antoine. "From ANT to Pragmatism: A Journey with Bruno Latour at the CSI." Translated by Stephen Muecke. *New Literary History* 47, no. 2–3 (2016): 289–308.

Hever, Hannan, ed. *Dan Pagis: Mehkarim u-teudot.* Jerusalem: Mossad Biyalik, 2016.

Hoffmann-Curtius, Kathrin, Sigrid Philipps, and Anthony Mathews. *Judenmord: Art and the Holocaust in Post-war Germany.* London: Reaktion Books, 2018.

Jauss, Hans Robert, and Michael Shaw. "Poiesis." *Critical Inquiry* 8, no. 3 (1982): 591–608.

Kaag, John, and Sarah Kreps. *Drone Warfare.* War and Conflict in the Modern World. Cambridge: Polity, 2014.

Kafka, Franz. *The Trial.* Translated by Breon Mitchell. New York: Schocken Books, 1999.

———. *The Zürau Aphorisms of Franz Kafka.* Translated by Michael Hofmann. New York: Schocken Books, 2006.

Kant, Immanuel. *Critique of the Power of Judgment.* Translated by Paul Guyer and Eric Matthews. Cambridge: Cambridge University Press, 2000.

———. *Kritik der Urteilskraft.* Edited by Heiner Klemme. Hamburg: Felix Meiner, 2006.

Karavan, Dani. "Even mekir lo tiz'ak." *Ha-aretz,* April 30, 2006. https://www.haaretz.co.il/news/health/1.1102086.

———. "Ma'alot." In *Dani Karavan Ma'alot: Museumsplatz Köln, 1979–86,* by Christoph Brockhaus, 31–36. Cologne: Museen der Stadt Köln, 1986.

———. *Mifgash.* Dani Karavan. Accessed January 19, 2017. http://www.danikaravan.com/portfolio-item/germany-mifgash/.

———. "Rede zur Eröffnung der Straße der Menschenrechte." Accessed January 13, 2017. https://www.nuernberg.de/imperia/md/menschenrechte/dokumente/karavan-rede-1993_neu.pdf.

Karavan, Dani, Fritz Jacobi, Mordechai Omer, Jule Reuter, and Noa Karavan Cohen. *Dani Karavan: Retrospektive.* Berlin: Wasmuth, 2008.

Karavan, Dani, Marc Scheps, Pierre Restany, and Manfred Schneckenburger. *Makom.* Tel Aviv: Muze'on Tel Aviv, 1982.

Klinger, Florian. *Theorie der Form: Gerhard Richter und die Kunst des pragmatischen Zeitalters.* Munich: Carl Hanser Verlag, 2013.

Kluge, Alexander. *Chronik der Gefühle.* 2 vols. Frankfurt am Main: Suhrkamp, 2000.

Latour, Bruno. "An Attempt at a 'Compositionist Manifesto.'" *New Literary History* 41 (2010): 471–90.

———. "Keynote Address." Filmed at "Seeing/Sounding/Sensing" symposium, MIT, Cambridge, MA, September 2014. Video transcript. http://arts.mit.edu/wp-content/uploads/2014/12/Symposium2014_Video-3.pdf.

———. "Life among Conceptual Characters." *New Literary History* 47, no. 2–3 (2016): 463–76.

———. *We Have Never Been Modern*. Translated by Catherine Porter. Cambridge, MA: Harvard University Press, 1993.

———. "Why Has Critique Run out of Steam? From Matters of Fact to Matters of Concern." *Critical Inquiry* 30, no. 2 (2004): 225–48.

Lefkovits, Ivan, ed. *"Mit meiner Vergangenheit lebe ich": Memoiren von Holocaust-Überlebenden*. 16 vols. Berlin: Jüdischer Verlag im Suhrkamp Verlag, 2016.

Lehmann, Jürgen, and Christine Ivanović, eds. *Kommentar zu Paul Celans "Die Niemandsrose."* Heidelberg: C. Winter, 1997.

Leitch, Vincent B. "Feminist Criticism—Critical Theory, Poetics, and Politics." In *American Literary Criticism from the Thirties to the Eighties*, by Vincent B. Leitch, 315–24. New York: Columbia University Press, 1988.

Lethen, Helmut. "Dein Herz sei Stein, dein Auge ein Apparat." *Frankfurter Allgemeine Zeitung*, February 11, 2008.

Levi, Primo. *Survival in Auschwitz: The Nazi Assault on Humanity*. Translated by Stuart Woolf. New York: Touchstone, 1993.

Littman, Shani. "Citing 'Dictatorship,' Israeli Artist Wants His Work Removed from the Knesset." *Ha-aretz*, June 15, 2016. http://www.haaretz.com /israel-news/1.725248?=&ts=_1501859560622.

Locke, Stefan. "Als die Klinik zur Sterbeanstalt wurde." *Frankfurter Allgemeine Zeitung*, August 28, 2017.

Lorberbaum, Yair. *In God's Image: Myth, Theology, and Law in Classical Judaism*. New York: Cambridge University Press, 2015.

Lotz, Christian. *The Art of Gerhard Richter: Hermeneutics, Images, Meaning*. London: Bloomsbury Academic, 2015.

Lyall, Sarah. "Laura Poitras Prepares 'Astro Noise' for the Whitney Museum." *New York Times*, January 27, 2016. https://www.nytimes.com/2016/01/31/arts /design/laura-poitras-prepares-astro-noise-for-the-whitney-museum .html?_r=0.

Lyon, James K. "Paul Celan and Martin Buber: Poetry as Dialogue." *PMLA* 86, no. 1 (1971): 110–20.

———. *Paul Celan and Martin Heidegger: An Unresolved Conversation, 1951– 1970*. Baltimore: Johns Hopkins University Press, 2006.

Martin, Elaine. *Nelly Sachs: The Poetics of Silence and the Limits of Representation*. Berlin: De Gruyter, 2011.

Menke, Christoph. "The 'Aporias of Human Rights' and the 'One Human Right': Regarding the Coherence of Hannah Arendt's Argument." In "Hannah Arendt's Centenary: Political and Philosophical Perspectives, Part I," special issue, *Social Research* 74, no. 3 (2007): 739–62.

Misak, Cheryl. "To My Best Belief: Just What Is the Pragmatic Theory of Truth?" *Aeon*, August 7, 2018. https://aeon.co/ideas/to-my-best-belief -just-what-is-the-pragmatic-theory-of-truth.

Newton, Mike. "Laura Poitras' Astro Noise: Reliving a War That Never Ends." *The Indypendent*, March 3, 2016. https://indypendent.org/2016/03/laura -poitras-astro-noise-reliving-a-war-that-never-ends/.

Niv, Tal. "So What If the Israeli Left Is Right?" *Ha-aretz*, July 29, 2014. https:// www.haaretz.com/opinion/.premium-so-what-if-were-right-1.5257179 ?=&ts=_1533573870722.

Nuremberg Human Rights Center. "About Us." Accessed August 8, 2017. http://www.menschenrechte.org/lang/en/ueber-uns.

Oakeshott, Michael. "The Voice of Poetry in the Conversation of Mankind." In *Rationalism in Politics and Other Essays*, by Michael Oakeshott, 488– 541. Indianapolis, IN: Liberty Press, 1991.

Obrist, Hans Ulrich, Georges Didi-Huberman, Dieter Schwarz, and Gerhard Richter. *Gerhard Richter: Pictures/Series*. Riehen, Basel, Switzerland: Fondation Beyeler, 2014.

Osborne, Peter. "Non-places and the Spaces of Art." *Journal of Architecture* 6 (Summer 2001): 183–94.

Packer, George. "The Holder of Secrets: Laura Poitras's Closeup View of Edward Snowden." *New Yorker*, October 20, 2014. http://www.newyorker.com /magazine/2014/10/20/holder-secrets.

Pagis, Ada. *Lev Pitomi*. Tel Aviv: Am Oved, 1995.

Pagis, Dan. *Kol ha-shirim*. Tel Aviv: Hakibbutz Hameuhad, 1991.

———. *The Selected Poetry of Dan Pagis*. Translated by Stephen Mitchell. Berkeley: University of California Press, 1996.

———. Marko. *Poetisches Denken und die Frage nach dem Menschen: Grundzüge einer poetologischen Anthropologie*. Freiburg: Verlag Karl Alber, 2012.

Peacocke, Antonia. "What Poetry Teaches (and Philosophy Doesn't)." Unpublished manuscript, May 15, 2018. https://antoniapeacocke.com/research-2/.

Pendas, Devin O. *The Frankfurt Auschwitz Trial, 1963–1965: Genocide, History, and the Limits of the Law*. Cambridge: Cambridge University Press, 2006.

Phelan, James K. "Rhetorical Literary Ethics and Lyric Narrative: Robert Frost's 'Home Burial.'" *Poetics Today* 25, no. 4 (2004): 627–51.

Plato. *Republic*. In *Complete Works*, edited by John M. Cooper. Indianapolis, IN: Hackett, 1997.

Poitras, Laura. "The Program." *New York Times*, August 22, 2012. http:// www.nytimes.com/2012/08/23/opinion/the-national-security-agencys -domestic-spying-program.html?_r=2.

Putnam, Hilary. *Ethics without Ontology*. Cambridge, MA: Harvard University Press, 2004.

Rabinow, Paul. *Unconsolable Contemporary: Observing Gerhard Richter*. Durham, NC: Duke University Press, 2017.

Rastany, Pierre. *Dani Karavan*. Tel Aviv: Sifriat-Poalim and Tel Aviv Museum of Art, 1990.

———. *Dani Karavan*. Translated by Jean Marie Clarke and Caroline Beamish. Munich: Prestel-Verlag, 1992.

Rauterberg, Hanno. "'Birkenau': Schlussgemalt." *Zeit Online*, February 11, 2016. http://www.zeit.de/2016/05/birkenau-gerhard-richter-schoah-drei -buecher.

Regan, Helen. "*Citizenfour* Filmmaker Laura Poitras Is Suing the U.S. over Years of Alleged Harassment." *Time*, July 13, 2015. http://time.com/3956685/laura -poitras-lawsuit-u-s-government-citizenfour-harassment/.

Reinders, Johannes. "Imago Dei as a Basic Concept in Christian Ethics." In *Holy Scriptures in Judaism, Christianity, and Islam*, edited by H. M. Vroom and Jerald D. Gort, 187–204. Amsterdam: Rodopi, 1996.

Reinders, Johannes, and Douglas John Hall. *Imaging God: Dominion as Stewardship*. Eugene, OR: Wipf and Stock, 2004.

Reiniger, Franziska. "Inside the Epicenter of the Horror—Photographs of the *Sonderkommando*." Accessed October 27, 2016. https://www.yadvashem.org /articles/general/epicenter-horror-photographs-sonderkommando.html.

Richter, Gerhard. *Birkenau*. Cologne: Verlag der Buchhandlung Walther König, 2015.

Richter, Gerhard, Hans Ulrich Obrist, and David Britt. "Conversation with Jan Thorn-Prikker." In *The Daily Practice of Painting: Writings and Interviews, 1962–1993*, by Gerhard Richter, 183–206. Cambridge, MA: MIT Press, 1995.

Richter, Gerhard, and Nicholas Serota. "I Have Nothing to Say and I'm Saying It: Conversation between Gerhard Richter and Nicholas Serota." In *Gerhard Richter: Panorama*, by Gerhard Richter, Mark Godfrey, Nicholas Serota, Dorothée Brill, Camille Morineau, and Achim Borchardt-Hume, 25. London: Tate Publishing, 2011.

Rorty, Richard. *Achieving Our Country: Leftist Thought in Twentieth-Century America*. Cambridge, MA: Harvard University Press, 1998.

———. "Dewey and Posner on Pragmatism and Moral Progress." *University of Chicago Law Review* 74, no. 3 (2007): 915–27.

———. *An Ethics for Today: Finding Common Ground between Philosophy and Religion*. New York: Columbia University Press, 2011.

———. "Ethics without Principles." In *Philosophy and Social Hope*, by Richard Rorty, 72–90. New York: Penguin Books, 1999.

———. "Grandeur, Profundity, and Finitude." In *Philosophy as Cultural Politics: Philosophical Papers*, by Richard Rorty, 4:73–88. Cambridge: Cambridge University Press, 2007.

———. *Philosophy and Social Hope.* New York: Penguin Books, 1999.

———. *Philosophy as Poetry.* Charlottesville: University of Virginia Press, 2016.

———. "Response to James Conant." In *Rorty and His Critics*, edited by Robert Brandom, 342–50. Malden, MA: Blackwell, 2000.

———. *Take Care of Freedom and Truth Will Take Care of Itself: Interviews with Richard Rorty.* Edited by Eduardo Mendieta. Stanford, CA: Stanford University Press, 2006.

Rothberg, Michael. *The Implicated Subject: Beyond Victims and Perpetrators.* Stanford, CA: Stanford University Press, 2019.

Rovelli, Carlo. *Reality Is Not What It Seems: The Journey to Quantum Gravity.* Translated by Simon Carnell. New York: Riverhead Books, 2017.

Ruthe, Ingeborg. "Auschwitz, Feuer, Ascheregen." *Frankfurter Rundschau*, March 4, 2015. https://www.fr.de/kultur/kunst/auschwitz-feuer-ascheregen -11645953.html.

Rykwert, Joseph. *The Dancing Column: On Order in Architecture.* Cambridge, MA: MIT Press, 1996.

Sanders, Jay. "Introduction." In *Astro Noise: A Survival Guide for Living under Total Surveillance*, edited by Laura Poitras, 25–35. New York: Whitney Museum of Art, 2016.

Scheps, Marc. "An Axis for the Future." In *Dani Ḳaravan ḥoref 97 Ramat Gan Yiśraʾel*, by Dani Karavan, Meir Ahronson, and Smadar Schindler, 102–12. Ramat Gan: Muzeʾon le-omanut Yiśreʾelit, 1997.

Schlegel, Friedrich. *Kritische Schriften und Fragmente: Studienausgabe in sechs Bänden.* Paderborn: Schöningh, 1988.

———. *Philosophical Fragments.* Translated by Peter Firchow. Minneapolis: University of Minnesota Press, 1991.

Schmidt, Benjamin M. "Sapping Attention." July 2018. http://sappingattention .blogspot.com/2018/07/mea-culpa-there-is-crisis-in-humanities.html.

Schoenberner, Gerhard. *Der Gelbe Stern: Die Judenverfolgung in Europa 1933 bis 1945.* Hamburg: Rütten and Loening, 1960.

Schüle, Andreas. "Made in the 'Image of God': The Concepts of Divine Images in Gen 1–3." *Zeitschrift für die Alttestamentliche Wissenschaft* 117, no. 1 (2005): 1–20.

Schwerin, Christoph Graf von. "Bittere Brunnen des Herzens: Erinnerungen und Paul Celan." *Der Monat* 2 (1981): 73–81.

Serres, Michel. *Thumbelina: The Culture and Technology of Millennials.* London: Rowman and Littlefield International, 2015.

Shane, Scott. "Drone Strike Statistics Answer Few Questions, and Raise Many." *New York Times*, July 3, 2016. https://www.nytimes.com/2016/07/04/world /middleeast/drone-strike-statistics-answer-few-questions-and-raise -many.html.

Shatz, Adam. "A Poet's Palestine as a Metaphor." *New York Times*, December 22, 2001. https://www.nytimes.com/2001/12/22/books/a-poet-s-palestine-as-a-metaphor.html.

Shaw, Tamsin. "Edward Snowden Reconsidered." *New York Review of Books Daily*, September 13, 2018. https://www.nybooks.com/daily/2018/09/13/edward-snowden-reconsidered/.

Sheehan, Thomas. "Heidegger and the Nazis." *New York Review of Books*, June 16, 1988. https://www.nybooks.com/articles/1988/06/16/heidegger-and-the-nazis/.

Shelley, Percy Bysshe. "A Defence of Poetry." In *Shelley's Poetry and Prose*, 2nd ed., edited by Donald H. Reiman and Neil Fraistat, 509–35. New York: W. W. Norton, 2002.

Singer, P. W., and Emerson T. Brooking. *Likewar: The Weaponization of Social Media*. Boston: Houghton Mifflin Harcourt, 2018.

Sommer, Allison Kaplan. "Controversy Rages over Female Singers at Israeli Memorial Ceremonies." *Ha-aretz*, May 4, 2016. http://www.haaretz.com/israel-news/.premium-1.717651.

Sontag, Susan. *As Consciousness Is Harnessed to Flesh: Journals and Notebooks, 1964–1980*. New York: Farrar, Straus and Giroux, 2012.

——. *On Photography*. London: Penguin Books, 1979.

Sparr, Thomas. *Celans Poetik des hermetischen Gedichts*. Heidelberg: C. Winter, 1989.

——. "Das Gespräch im Gedicht." *Neue Zürcher Zeitung*, November 23, 1990.

Squibb, Stephen. "Moving Targets: The Work of Laura Poitras." *Artforum International* 54, no. 6 (2016): 203–9.

Stewart, Susan. *Poetry and the Fate of the Senses*. Chicago: University of Chicago Press, 2002.

St. Felix, Doreen. "The Lenny Interview: Laura Poitras." *Lenny*, April 29, 2016. http://www.lennyletter.com/culture/interviews/a360/the-lenny-interview-laura-poitras/.

Stone, Dan. "The Sonderkommando Photographs." *Jewish Social Studies* 7, no. 3 (2001): 132–48.

Storr, Robert, and Gerhard Richter. *Gerhard Richter: Doubt and Belief in Painting*. New York: Museum of Modern Art, 2003.

Susman, Margarete. *Das Buch Hiob und das Schicksal des jüdischen Volkes*. Zurich: Steinberg Verlag, 1948.

Ullrich, Wolfgang. "Debatte um Gerhard Richter: Finde Bedeutung!" *Art: Das Kunstmagazin*, May 4, 2015. https://ideenfreiheit.files.wordpress.com/2015/04/debatte-um-gerhard-richter-finde-bedeutung-art.pdf.

United Nations. "Universal Declaration of Human Rights." December 10, 1948. http://www.un.org/en/universal-declaration-human-rights/index.html.

Vendler, Helen. *Poets Thinking: Pope, Whitman, Dickinson, Yeats.* Cambridge, MA: Harvard University Press, 2004.

Vico, Giambattista. *The New Science of Giambattista Vico.* Translated by Thomas Goddard Bergin and Max Harold Fisch. 1948. Reprint, Ithaca, NY: Cornell University Press, 1984.

Voss, Julia, and Peter Geimer. "Man kann Auschwitz nicht abmalen." *Frankfurter Allgemeine Zeitung*, February 25, 2016. http://www.faz.net/aktuell /feuilleton/kunst/gerhard-richter-im-interview-ueber-gemaeldezyklus -birkenau-14088410.html.

Weber, Werner. "Laudatio." Peace Prize of the German Book Trade. Frankfurt am Main: Börsenverein des Deutschen Buchhandels, 1965. http:// www.friedenspreis-des-deutschen-buchhandels.de/sixcms/media .php/1290/1965_sachs.pdf.

Weizman, Eyal. *The Least of All Possible Evils: Humanitarian Violence from Arendt to Gaza.* London: Verso, 2012.

Whitney Museum of American Art. "Laura Poitras: Astro Noise." Accessed July 5, 2017. http://whitney.org/Exhibitions/LauraPoitras.

Wiedemann, Barbara, ed. *Paul Celan, die Gedichte: Kommentierte Gesamtausgabe in einem Band.* Frankfurt am Main: Suhrkamp, 2003.

———, ed. *Paul Celan, Nelly Sachs: Briefwechsel.* Frankfurt am Main: Suhrkamp, 1993.

Wittgenstein, Ludwig. *Culture and Value.* Edited by Georg Henrik von Wright and Heikki Nyman. Translated by Peter Winch. Chicago: University of Chicago Press, 1980.

———. "Vermischte Bemerkungen." In *Werkausgabe*, by Ludwig Wittgenstein, 8:445–575. Frankfurt am Main: Suhrkamp Verlag, 1990.

Wittmann, Rebecca. *Beyond Justice: The Auschwitz Trial.* Cambridge, MA: Harvard University Press, 2005.

Wolfson, Elliot. *The Duplicity of Philosophy's Shadow: Heidegger, Nazism, and the Jewish Other.* New York: Columbia University Press, 2018.

Wong, Alia. "The Renaissance of Student Activism." *The Atlantic*, May 21, 2015. https://www.theatlantic.com/education/archive/2015/05/the-renaissance -of-student-activism/393749/.

World Development Report 2016: Digital Dividends. Washington, DC: International Monetary Fund, 2016.

Yacobi, Tamar. "Fiction and Silence as Testimony: The Rhetoric of Holocaust in Dan Pagis." *Poetics Today* 26, no. 2 (2005): 209–55.

Zeitchik, Steven. "Filmmaker Laura Poitras Turns Her Anti–Big Brother Activism into Fine Art with 'Astro Noise' Museum Installation." *Los Angeles Times*, March 11, 2016. https://www.latimes.com/entertainment/movies/la-et -mn-poitras-astro-noise-20160311-story.html.

Zwicky, Jan. *Lyric Philosophy.* Toronto: University of Toronto Press, 1992.

Illustration Credits

Page 71, Gerhard Richter, *Fotos aus Magazinen (Photographs from Magazines)*, 66.7 cm × 51.7 cm. *Atlas*, sheet 21 (1967) © Gerhard Richter 2018 (20062018).

Page 73, Gerhard Richter, *Reichstag*, 71 × 51.7 cm. *Atlas*, sheet 648 (1997) © Gerhard Richter 2018 (20062018).

Page 75, Visitor to the exhibition *Gerhard Richter, Birkenau* (Frieder Burda Museum, Baden-Baden) in front of Gerhard Richter *Studien für Birkenau (Studies for Birkenau)*, 50 × 70 cm. *Atlas*, sheets 807 and 808 (2013). Sheet 808 presents the *Sonderkommando* photographs from Didi-Huberman's *Images malgré tout*. Photo: Amir Eshel.

Page 79, Gerhard Richter, *Birkenau*, CR 937-1 to 937-4, preliminary version 1, 2014. Photograph projected onto canvas, 260 × 200 cm. © Gerhard Richter 2018 (20062018).

Page 80, Gerhard Richter, *Birkenau*, CR 937-1 to 937-4, preliminary version 2, summer 2014. Drawing on canvas, 260 × 200 cm. © Gerhard Richter 2018 (20062018).

Page 81, Gerhard Richter, *Birkenau*, CR 937-1 to 937-4, preliminary version 3, 2014. Oil on canvas, 260 × 200 cm. © Gerhard Richter 2018.

Page 82, Gerhard Richter, *Birkenau*, CR 937-1 to 937-4, preliminary version 4, 2014. Oil on canvas, 260 × 200 cm. © Gerhard Richter 2018.

Page 83, Visitors to the exhibition *Gerhard Richter, Birkenau* (Frieder Burda Museum, Baden-Baden) in front of reproductions of the *Sonderkommando* photographs. Photo: Amir Eshel.

Page 88, Visitor to the exhibition *Gerhard Richter, Birkenau* (Frieder Burda Museum, Baden-Baden), observing the painting *Birkenau* CR 937-4. Photo: Amir Eshel.

Page 89, Visitor to the exhibition *Gerhard Richter, Birkenau* (Frieder Burda Museum, Baden-Baden), observing the framed panels of layout for *Fotos für das Buch War Cut* (Photos for the book *War Cut*). Gerhard Richter, *Atlas*, sheets 667–74. Photo: Amir Eshel.

Page 90, Visitors to the exhibition *Gerhard Richter, Birkenau* (Frieder Burda Museum, Baden-Baden) discuss Birkenau CR 937 B. Photo: Amir Eshel.

Page 91, General view of the exhibit *Gerhard Richter, Birkenau* (Frieder Burda Museum, Baden-Baden). In the foreground is a table with copies of *"Mit meiner Vergangenheit lebe ich"—Memoiren von Holocaust-Überlebenden*. Photo: Amir Eshel.

Page 92, Cover of *"Mit meiner Vergangenheit lebe ich"—Memoiren von Holocaust-Überlebenden*.

Page 101, Dani Karavan, *The City Gate*, 1963. Wrought iron, 4 × 6 × 0.6 m. Entrance to the Tel Aviv Court of Justice. Photo: Amir Eshel.

Page 105, Dani Karavan, concrete relief, 1962–67. Tel Aviv Court of Justice. The inscription is from Exodus 23:6–7: "Keep thee far from a false matter; and the innocent and righteous slay thou not: for I will not justify the wicked." Photo: Amir Eshel.

Page 106, Dani Karavan, concrete relief, 1962–67. Tel Aviv Court of Justice. The inscription reads "Justice Justice." Photo: Amir Eshel.

Page 107, Dani Karavan, *Justice the Measuring Line and Righteousness the Plumb Line*, 1963–64. White concrete, detail. Tel Aviv Court of Justice. Photo: Amir Eshel.

Page 110, Dani Karavan, *Environment Made of Natural Materials and Memories*, 1977, *documenta 6*. White concrete, water, light, grass. Kassel, Germany. Photo: © Studio Dani Karavan.

Page 111, Dani Karavan, *Maʿalot*, 1980–86. Sunlight, grass, trees, red brick, white concrete, railway track, granite, cast iron. Extends from the Cologne Cathedral Square to the Rhine Park. View from the bank of the Rhine, Cologne, Germany. Photo: Amir Eshel.

Page 112, Dani Karavan, *Maʿalot*, 1980–86. Granite and iron, 10.8 m high. View of the six rectangular blocks. Photo: Amir Eshel.

Page 114, Dani Karavan, *Maʿalot*, 1980–86. View of circular pond at the bottom of the stairs and the tip of the line of railway tracks through the entire artistic environment. Cologne, Germany. Photo: Amir Eshel.

Page 116, Dani Karavan, *Mifgash*, 2004–5. Water, grass, white Carrara marble, red bricks, text, 1.5 × 4.5 × 4.5 m. Villa Lemm, Berlin, Germany. Photo: © Studio Dani Karavan.

Page 119, Dani Karavan, *Grundgesetz 49*, 1997–2002. Grass, tree, paving stones, Corten steel, glass, artificial light, text, 7 × 30 × 50 m. Berlin, Germany. The Reichstag is in the background. Photo: Amir Eshel.

Page 120 (top), Dani Karavan, *Grundgesetz 49*, 1997–2002. Grass, tree, paving stones, Corten steel, glass, artificial light, text, 7 × 30 × 50 m. Berlin, Germany. Family conversation. Photo: Amir Eshel.

Page 120 (bottom), Dani Karavan, *Grundgesetz 49*, 1997–2002. Grass, tree, paving stones, Corten steel, glass, artificial light, text, 7 × 30 × 50 m. Berlin, Germany. Reflecting on the German Basic Law. Photo: Amir Eshel.

Page 121, Dani Karavan, *Memorial to the Sinti and Roma Victims of National Socialism*, 2000–2012. Water, grass, flowers, trees, granite, iron, glass,

text, sound, 2.5 × 60 × 60 m. Berlin, Germany. The Reichstag in the background is reflected in the circular pond. Photo: Amir Eshel.

Page 122, Inauguration ceremony for *Memorial to the Sinti and Roma Victims of National Socialism*, 2012. Berlin, Germany. Photo: © Marko Priske.

Page 125, Dani Karavan, *Mizrach*, 1997–2005. White concrete, text, 1 × 11 × 18 m. Regensburg, Germany. Photo: © Uwe Moosburger.

Page 126, Dani Karavan, *Mizrach*, 1997–2005. White concrete, text, 1 × 11 × 18 m. Regensburg, Germany. Photo: Amir Eshel.

Page 128, Dani Karavan, *The Way of Human Rights*, 1989–93. Oak tree, white concrete, text (thirty articles of the Universal Declaration of Human Rights), 8 × 8 × 185 m. Nuremberg, Germany. Photo: © Roman Mensing.

Page 130, Dani Karavan, *The Way of Human Rights*, 1989–93. Oak tree, white concrete, text (thirty paragraphs of the Universal Declaration of Human Rights), 8 × 8 × 185 m. Nuremberg, Germany. Photo: Amir Eshel.

Page 132, Dani Karavan, *The Way of Human Rights*, 1989–93. Oak tree, white concrete, text (thirty paragraphs of the Universal Declaration of Human Rights), 8 × 8 × 185 m. Nuremberg, Germany. Photo: Amir Eshel.

Page 135, Dani Karavan, *Har Homa*, 1997. Olive tree, soil, water, air. Museum of Israeli Art, Ramat Gan, Israel. Photo: © Studio Dani Karavan.

Page 137, Dani Karavan, *Effects of Good and Bad Government*, 2002. Installation for exhibition Pardes, IVAM (Institut Valencià d'Art Modern), Valencia, Spain. Photo: © Studio Dani Karavan.

Page 147, Laura Poitras, *Bed Down Location*, 2016. In the final gallery of the installation, a screen shows an infrared image of people watching *Bed Down Location*. Photo: © Praxis Films/Laura Poitras.

Index

SQUARE ONE
First-Order Questions in the Humanities

Series Editor: **PAUL A. KOTTMAN**

Lightning Source UK Ltd.
Milton Keynes UK
UKHW021046011219
354474UK00006B/69/P